EVOLUTION OF
HAVILAND CHINA
DESIGN

NORA TRAVIS

4880 Lower Valley Road, Atglen, PA 19310 USA

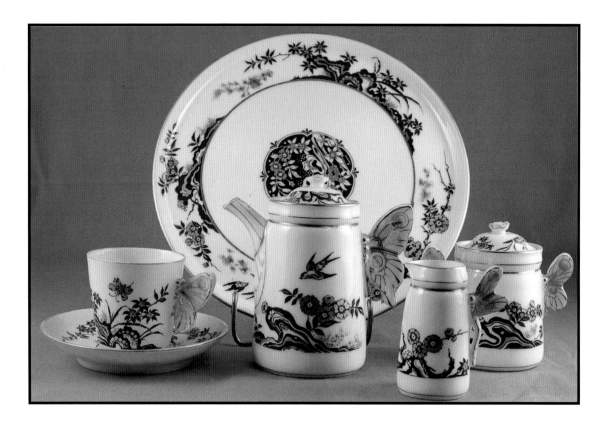

Library of Congress Cataloging-in-Publication Data

Travis, Nora.
Evolution of Haviland china design / by Nora Travis.
p. cm.
Includes bibliographical references and indexes.
ISBN 0-7643-1097-6 (hardcover)
1. Haviland china--Design. I. Title.
NK4399.H4 T725 2000
738.2'0944'66--dc21 00-020891

Designed by Bonnie M. Henlsey
Type set in University Roman Bd/Souvenir Lt BT

ISBN: 0-7643-1097-6
Printed in China
1 2 3 4

Published by Schiffer Publishing Ltd.
4880 Lower Valley Road
Atglen, PA 19310
Phone: (610) 593-1777; Fax: (610) 593-2002
E-mail: Schifferbk@aol.com
Please visit our web site catalog at **www.schifferbooks.com**

This book may be purchased from the publisher.
Include $3.95 for shipping. Please try your bookstore first.
We are always looking for authors to write books on new and related subjects.
If you have an idea for a book please contact us at the address above.
You may write for a free printed catalog.

In Europe, Schiffer books are distributed by Bushwood Books
6 Marksbury Avenue Kew Gardens
Surrey TW9 4JF England
Phone: 44 (0)208-392-8585; Fax: 44 (0)208-392-9876
E-mail: Bushwd@aol.com
Free postage in the UK., Europe; air mail at cost.

Price Guide

The prices for the Haviland pieces shown in this book have been listed in a range from low to high. Prices vary from region to region, seller to seller and by the condition of the item. In dinnerware, some patterns are more in demand than others and, therefore, command a higher price. In regard to unusual pieces, prices can fluctuate even more, depending on how rare the item is.

I have tried to get as close to the actual prices as possible, but again, this is a guide and all of the above must be taken into consideration. Neither the author nor the publisher assumes any responsibility for any losses that a collector may incur while using this guide.

Table of Contents

Acknowledgments

I want to thank all those that allowed me to photograph their special pieces: Rev. and Mrs. John Andrae, Roy Bettencourt, Joe Boes, Jane Danis, Mark and Eta Dunning, Donna Hafer, Doug Hammerling, David and Jan Haviland, Maggie Hoehn, Tim Needler, Richard Osterberg, Richard Owen, Jeanne Paul, Carolyn Quinlin, Robert A. Rorex, Dick Rossman, Nancy Russell, Earl and Beulah Steifthau, Dr. W. J. Tomasini, Malcolm E. Varner, Lee and Marjorie Walker, Larry Wenner, and those others who wished to remain anonymous. Without their help, this book would not have been possible.

Thanks again to my daughter, Patricia Anders, who acted as my editor once more. Without her assistance, this book would not be as readable as it is.

I neglected in the last book to acknowledge Dick and Dona Schleiger for their great help in pattern identification. Without the Schleiger Pattern Identification books, we Haviland matchers would have a difficult time. At this writing, there are six volumes of *200 Patterns of Haviland* available. The seventh should be available soon. These books may be purchased by writing to Dona Schleiger at 1626 Crestview Road, Redlands, CA 92734-6460.

Preface

The more I learn and read about Haviland china, the more I realize how much there is to know and still yet to discover. With the opening of the Haviland Archives in the University of Iowa library in Iowa City in April 1998, the public now has access to more information than ever. The Internet is a great source for acquiring 1880s advertisements for Haviland china—an important source for the names of patterns and pieces, and how the pieces were sold and distributed.

The Haviland Collectors Internationale Foundation has been working to track the various companies that sold Haviland china during the major years of production, 1893-1918. By doing this research, we hopefully will be able to tell when and where certain patterns were sold, thus narrowing down the years of production for these patterns.

My previous book, *Haviland China: Age of Elegance*, was a basic primer for Haviland china. I have tried to dig further into the creation of this beautiful dinnerware over the years with the Haviland factories and with the Haviland family. This book illustrates the different eras—from the Japanese influence, through the Art Nouveau period into the Art Deco period. I am addressing design, pottery, and more patterns and shapes of Haviland dining pieces.

For more detailed information, I recommend that you purchase *Celebrating 150 Years of Haviland China 1842-1992* from the Haviland Collectors Internationale Foundation, P. O. Box 11632, Milwaukee, WI 53211. Also visit their website at www.havilandcollectors.com.

If you any questions regarding Haviland china, you may contact me by writing to P.O. Box 6008, PMB #161, Cerritos, CA 90701, by telephone (714) 521-9283 or by E-mail at: Travishrs@aol.com. Web site: www.HavilandChinaReplace.com.

Genealogy of the Havilands

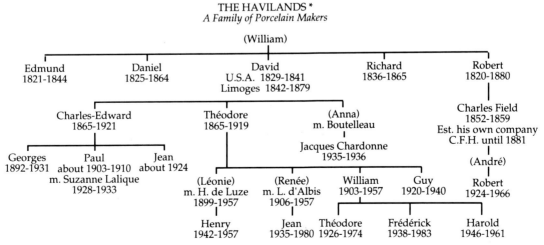

THE HAVILANDS *
A Family of Porcelain Makers

* The dates indicate an individual's participation in the business.
The names in parentheses were not involved in the business.

Taken from J. d'Albis, <u>Haviland</u>, p. 8

Part 1: History of the Haviland China Manufacturers

The Formative Years—1842 to 1872

David Haviland (1814-1879) first worked with his six brothers in their china shop in New York City selling tableware—primarily Staffordshire and creamware. Looking for a way to make more money and provide a better product, David set sail for France in 1840, eventually making his way to the small town of Limoges, 200 miles southeast of Paris.

Kaolin, a fine, pure white clay, had been discovered in the region about 1770. This brought many porcelain manufacturers into the area, as well as the craftsmen necessary for making the elaborate designs and molds. David quickly realized that this was the place where he would have his porcelain made. He tried to place an order for dinnerware and tea sets made in the prevailing English designs and shapes, but the porcelain factories told him that his order was impossible to make as they did not have the proper molds. Since he was an ambitious and progressive businessman, David set about having molds made with which the French could work. He also requested that they be decorated in the English style that the Americans preferred, with larger dinner plates and plainer decoration. However, he was told that the French artists did not decorate in the English style.

Faced with these problems, David Haviland hired several art teachers to train a group of 100 talented artists in the English style of porcelain painting. He realized that he was faced with a monumental problem and would need to live in Limoges if he were to realize his dream of making beautiful French Limoges porcelain to sell in America.

In 1841, David sailed with his wife, Mary, and their first son, Charles Edward (1839-1921), to Foecy in the province of Berry to stay with friends, the Pilluvyt family, until he could find a home for his family. They, like the Havilands, were china makers. David finally settled his family in Limoges in April 1842 and in September, their second son, Theodore (1842-1919), was born.

Before David Haviland came to Limoges, all porcelain had been shipped to Paris for decorating. In 1847 he decided to open his own decorating studio in Limoges, and by 1853 succeeded in getting permits from the French government to build his own porcelain factory. This was to be a subsidiary of the New York firm. Originally the china import company in New York was called D.G. and D. Haviland, but in 1852 changed to Haviland Brothers and Company when their younger brother, Robert joined the firm.

Figure 1. Early coffeepot, cobalt and gold with factory hand painted floral decoration. Haviland & Company, 1853. Mark A. $550-750.

Figure 2. Large sugar bowl, 6¼" tall, with factory hand painted floral decoration. This piece is very crudely done and appears to be one of the first pieces made by Haviland & Company. The handles are uneven, and the porcelain is irregular on the surface. 1853. Mark A. $75-125.

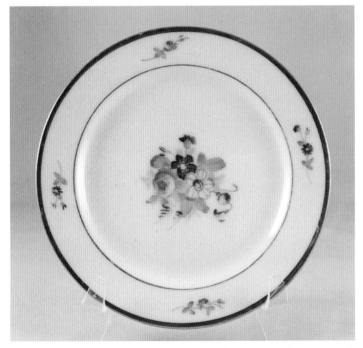

Figure 3. Plate, 7½", unmarked, part of a tea set with sugar bowl in Fig. 2. Plate is better workmanship than sugar bowl. Haviland & Company, 1853. $25-30.

By May 1855, David had the muffle kilns and decoration workshops in full operation. He was instrumental in uniting the production of white ware with the decorating process, which in turn produced major changes in the manufacturing process of porcelain in Limoges. He hired skilled teachers and apprentices for both shops so that he would be able to create only the best and truest in ceramic art.

Prior to that time, only England and Germany had their white ware and decorating workshops in the same location. The decorator's Guilds in Paris, however, insisted that the unpainted pieces be brought to them for decorating. This allowed the decorators to market the products with their own back stamp. Having a combination of white ware and decorating workshop under one roof was considered radical behavior at that time and the Haviland Company nearly caused a riot in Limoges. Artisans, brought from Paris, rebelled at Haviland's change in decorating methods and styles. For a while, pupils and teachers could only go about in bands in order to protect themselves from assault. Eventually the problems were smoothed out and the factory was able to resume operation.

France had never seen anything like this American and his innovative ideas for creating such unique porcelain. Where the French porcelain makers had been and would continue to be bound by tradition, adhering to the practices of their forefathers, Haviland kept changing. The success of the Haviland Company inspired the French and European companies to compete for a portion of the American and international trade.

But with America's Civil War came a dramatic decline in the importation of French porcelain. Since many of their customers were in the southern states, Haviland Brothers & Company was forced to close its doors in 1863. David Haviland saw this as an opportunity to open his own porcelain manufacturing business in Limoges, France, named Haviland & Company.

David set about constructing larger kilns to fire the porcelain white ware, and in 1865, as soon as production was ready to resume, he brought his two sons, Charles Edward, now age 25, and Theodore, age 23, into the business. Charles Edward was an astute entrepreneur, even at such a young age, and within a year or two of joining the firm, was soon running the entire company. As soon as trade relations resumed with the United States, Charles sent Theodore to America to handle the marketing and distribution of the china. With the end of the Civil War in 1865, sales increased rapidly. To keep up with orders, David was forced to subcontract the mak-

ing of the white ware to other companies. That is why sometimes today one can find an early piece with only the Haviland decorator mark on it.

With Charles Edward at the helm, production increased dramatically. He was a brilliant man who was always looking for ways to create better designs and faster production. He was one of the first porcelain manufacturers to purchase a special machine, invented by Francois Faure, which calibrated the making of a perfect plate. In some instances, it is still in use today. Haviland & Company was the only American-owned porcelain company in Limoges, and the difference revealed itself through innovative industrialization. Every other porcelain company in Limoges had their eye on Haviland, watching to see what new methods of manufacturing were installed at the factory. David had hired the best decorators and modelers that he could afford, and Charles Edward hired no less than the best.

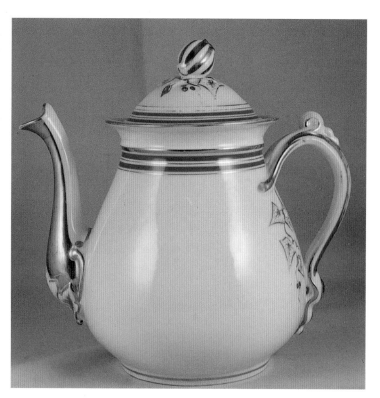

Figure 5. Coffeepot with green and gold bands as well as a squash finial with leaves embossed near base of spout and handle, 8½" to finial, in the Lierre Shape. Haviland & Company, 1853. Mark A. $225-275.

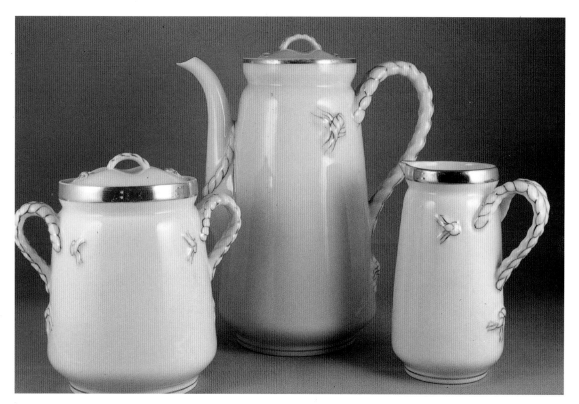

Figure 4. Coffee Set in the Rope Shape. Coffeepot, 9½" to top of finial; sugar bowl, 6¼" and creamer, 5¾". Because of its large size, the sugar bowl is often mistaken for a biscuit or cracker jar. (Biscuit or cracker jars have no handles.) In the 1860s sugar came in 9-10 pound loaves and needed to be broken into pieces, thus the need for large sugar bowls. Granulated sugar was not invented until the 1880s. Haviland & Company, 1876-1889. Marks D and g. Three piece set $400-450.

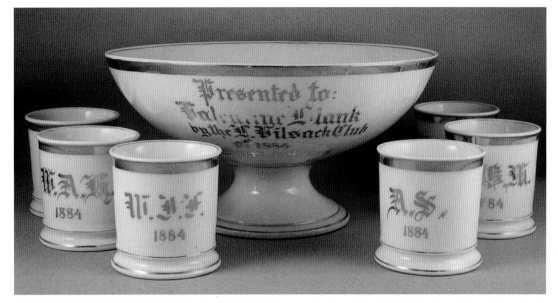

Figure 6. Hot toddy or punch bowl with twelve mugs. Hand painted with gold trim and lettering. Bowl reads *Presented to Valentine Flank (sp.) by the Filsack Club of 1884, January 1, 1888.* Some letters are hard to read. Bowl is by Haviland & Company. Mark F. Mugs are by Charles Field Haviland & Company. Each mug has a different set of initials, plus the date of 1884. Mark C-3. It is interesting that the club put the founding date, 1884, in the name of their club. The Filsack Club may have been a college, sports, riding, or gentlemen's club. $1200-1500.

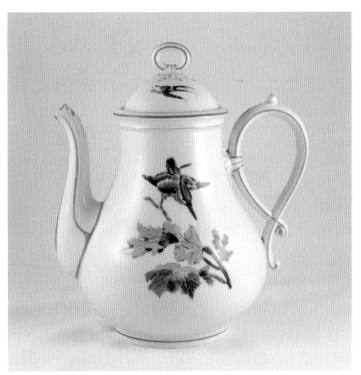

Figure 7. Coffeepot with unusual handle, 8½" to finial. Engraved colored transfers with hand painted filled-in designs. A different design with birds on the back. Haviland & Company, 1879-1883. Marks F and d. $250-325.

Figure 8. Large water pitcher. Haviland & Company, 1876-1889. Marks D and g. $175-275.

Figure 11. Cuspidor with burgundy and gold bands, 8". Haviland & Company, 1876-1889. Mark F. $150-250.

Figure 9. Large water pitcher in the Antique shape. Haviland & Company, 1853. Mark A. $225-325.

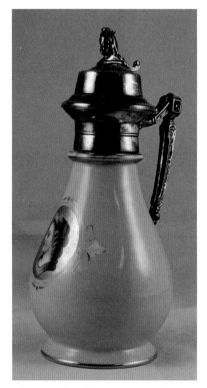

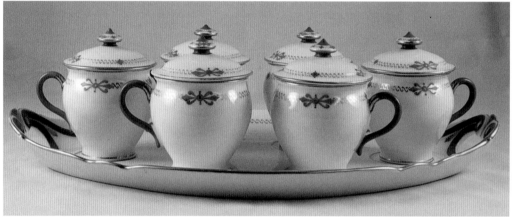

Figure 12. Set of six covered Pot de Crème cups with undertray in the Ruby shape. They are unmarked but definitely made by Haviland & Company, 1853-1865. $1000-1200.

Figure 10. Claret jug with silver top, 7". Haviland & Company. Mark A plus printed on the bottom *patented Oct 25th, 1865-July 1, 1873.* $600-800.

Figure 13. Drinking cup, called a Mazagran, used for coffee and brandy, in Moss Rose pattern. Unmarked Haviland & Company, dated about 1860s. $100-150.

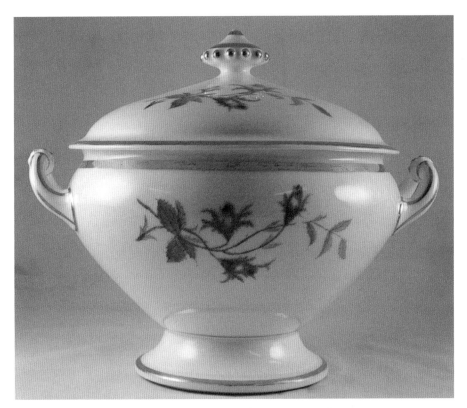

Figure 14. Large round soup tureen, Moss Rose pattern in the Ruby shape. Haviland & Company, 1865. Mark B. $300-450.

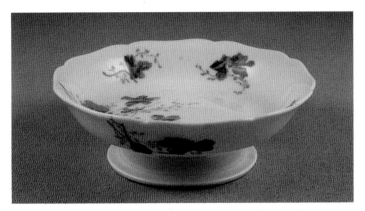

Figure 15. Small footed comport, 5½", in unidentified pattern. Haviland & Company, 1887. Marks G and g. $65-75.

The Developing Years—1870s to 1880s

Charles Edward married a middle-class French girl who died in 1873 at only 30 years of age. Four years later, when he was 38, he married Helene, a young girl of 17 who came from an important Parisian family. Her father was the famous art critic, Philippe Burty. Charles Edward was interested in art and was fast becoming a significant collector of art and books. With his marriage to Helene Burty, he split his time between Paris and Limoges, building a home on the Rue de Villiers in Paris.

Living in Paris at this time was to be in the middle of the art world and in the middle of the Impressionist Movement. Through introductions by his father-in-law, he was able to spend a great deal of time with Cezanne, Pizarro,

Manet, Monet, Renoir, and many of the other artists of that time. This close association with these Parisian artists and writers, such as Emile Zola, strongly influenced Charles Edward in the design and form of the pieces of porcelain produced by Haviland & Company. He became a great collector of Japanese prints and, being an astute businessman with a keen eye for beauty, was able to duplicate the artistry of line and form from these prints, transforming them onto porcelain to be sold to the Western world. It was during this time that he became acquainted with Felix Bracquemond, an engraver of some importance in the Artists' Circle. He had won many awards with his engravings and etchings, and was much admired by his peers.

Charles Edward Haviland hired Felix Bracquemond in 1872 to manage his workshop. This workshop had been established in the Auteuil section of Paris to attract artists who were reluctant to leave Paris for Limoges. The Haviland studio at Auteuil was the center where ceramists and avant-garde painters like Chaplet and Gauguin came into contact with each other. Instead of canvas, these famous artists were hired to paint on porcelain, which proved to be a difficult medium as colors and design changed in firing. Bracquemond signed a ten-year contract with Charles Edward to manage the Auteuil studio, but because of differences with Charles, he worked only nine years. Charles was a demanding owner and insisted on having the final approval on every design. He felt he had a good eye for what would sell and no one else could contradict him. Charles Edward assumed control over the studio, and continued to employ only the most gifted of artists such as Pallandre, Lindeneher, and the Dammouse brothers, Eduoard and Albert.

Charles Edward became an important member of the French community. He managed the largest porcelain company in Limoges, employed the greatest number of workers, and was considered a brilliant American businessman. Because of this achievement, and although he never became a citizen of France, he was awarded the Legion d'honneur chevalier grade in 1897 and raised to the rank of commander in 1912 by the French government.

David Haviland had written up a contract in 1867 between himself and his two sons, in which he and Charles retained two-fifths of the business and Theodore only one-fifth. Theodore had spent many years in America marketing the porcelain that was shipped over from France; and upon his father's death in 1879, he returned to France with his wife, Julie, whom he had married in 1874. He took charge of manufacturing, but

had a difficult time working for his brother. Charles insisted *everything* be done in his strictly regimented way, and Theodore felt he had no say whatever in design or in manufacturing style. Under his brother's leadership, he was just an employee.

Theodore had gone to America when he was 23 years old and spent the majority of the time traveling across the country to all the china shops, hoping to convince every household in America that they could not live without this special dinnerware. He tried several marking strategies to further his goal. If a large store would order so many different sets of Haviland china, he would have their company name printed along with the Haviland backmark. He would also sell them exclusive patterns (by adding a border or a special trim) to be manufactured just for their stores. These patterns are the most difficult to locate today as not many of them were sold around the country. (Because of these store markings, the Haviland Collectors Internationale Foundation is currently conducting research on the various backmarks attributed to these individual stores, trying to ascertain how long the stores were in operation, where they were located, and what

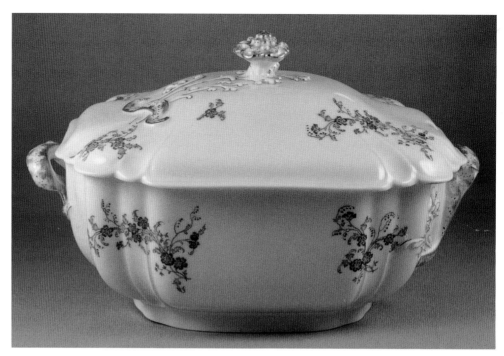

Figure 17. Rectangle soup tureen in unidentified pattern on Henri II shape. Haviland & Company, 1876-1889. Marks F and c. $350-450.

patterns they sold. This will be an ongoing project for many years, but should give us much information as it will narrow down dates of production on certain patterns and show the type of style that various communities purchased.)

Theodore had been primarily on his own in America, living and working in New York City, only returning to France during the summers, during slack sales times. He would spend his time in Limoges meeting with factory workers, maintaining contact with the foremen, and discussing new ideas and plans with David and Charles Edward. Moving to Limoges removed his independence and he was at the beck and call of his brother in all things, whether business or personal.

The Changing Years—1890s to 1970s

In 1891, Theodore and Charles Edward decided to dissolve their partnership. Haviland & Company closed its doors on December 31, 1891, and reopened the following day under the same name, but with Charles Edward and his eldest son, George, running the new operation. To avoid confusing their customers, they changed the backmark from just *H & Co.* to *Haviland & Co.* and advertisements now read, *Buy genuine Haviland.*

Theodore Haviland purchased twelve acres on the Place David Haviland in Limoges and went about setting up his own company, formally inaugurating his factory on August

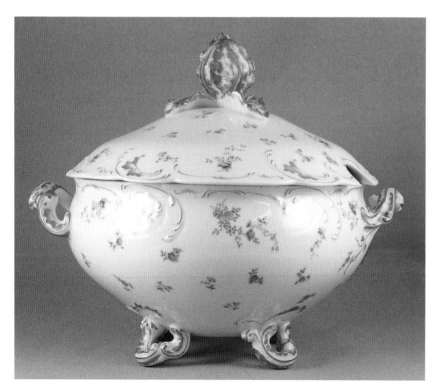

Figure 16. Soup tureen in Saxon on Claws shape in unidentified pattern. Haviland & Company, 1888-1896. Marks H and c. $500-800.

3, 1893. He built it with the best and most modern equipment available: it contained new electric lithograph presses that could do four times more work than the steam-driven presses used in other factories (one of his kilns is still in existence in Limoges today).

As Charles did not want the name Haviland to be placed on any pieces that Theodore sold, Theodore's first backmarks were of his initials only: *TH*. There was great contention in the first years and probably many lawsuits over rights infringements. Finally, Theodore began placing his decorative mark of *Theodore Haviland, Limoges* on the back of his porcelain, and the two companies engaged in a war of price competition as each fought for their share of the public market. In a 1910 catalog from R. H. Macy Co., Haviland & Company offered a 56-piece dinner set for under $20.00, while Theodore Haviland offered a *101*-piece set of the same quality for the same price.

With his many years in America, Theodore had a keen business sense for creating ornate porcelain dinnerware that would please the American woman. A new paste composition was developed called *porcelaine mousseline*, which allowed for a whiter and thinner dinnerware.

Charles Edward remained at the helm of Haviland & Company until his death in 1921. The leadership then fell to George who had worked with his father for many years, but had not been allowed to show any authority. The company seemed to struggle under his leadership. In 1926 and 1929, two large fires destroyed many patterns and records, along with the Haviland Museum and warehouses. A combination of these calamities and the Great Depression of 1929 led to the closing of Haviland & Company in 1931.

Theodore Haviland brought his son, William, into his company in 1903 and made him a director in 1904. Unlike Charles Edward, Theodore let his son make decisions. When Theodore died in 1919, William became chairman of the board and ran the company with his brother, Guy Haviland, and his two brothers-in-law, H. de Luze and L. d'Albis. They built a strong company that was able to weather World War I and the Great Depression.

By 1921, William became conscious of new trends in living and wanted a cleaner, pared-down style of dinnerware. He was so convinced that the public wanted only his new innovative designs that he instructed his workmen to destroy all of the old molds. These new styles and patterns boosted sales for a while. However, the Great Depression took its toll on the factory. As 70 percent of their pro-

duction was shipped to the United States, the economic low tide there forced a dramatic drop in Haviland sales. Only in 1944 did sales finally level off and start to climb back somewhat; yet production was never again as high as in the golden years.

With the increase in export duties and a second impending world war, William decided it was time to try producing Haviland china in America. In 1936, he opened a plant in New Castle, Pennsylvania, and produced *Theodore Haviland, Made in America* china until 1957. The American china was of a heavier weight and not as good a quality of porcelain. It was not pure white and was of a softer grade, easy to scratch. However, this china was still popular and the company was able to stay in business because of its sales.

In 1941, the Theodore Haviland Company bought the rights to the name of Haviland & Company, which the firm of E. Gerard, Dufraisseix et Abbott (see section on Charles Field Haviland) had bought ten years earlier when Haviland & Company had closed its doors. As soon as production was able to resume in Limoges after World War II, Haviland & Company once again began manufacturing the fine white French porcelain for which it had been famous.

Thus Haviland & Company had come full circle with the purchase of all of the designs, trademarks and rights of the original Haviland & Company created by David Haviland a century before. *Société Anonyme* was formed, bringing both companies back under one name. In 1961, Theodore, William's son, became president, and Theodore's son Frederick became the manager of the New York office. The Haviland family retired from management of the company in 1972.

Figure 18. Large round covered vegetable in Schleiger no. 316C. Theodore Haviland Company, 1892. Mark K. $275-350.

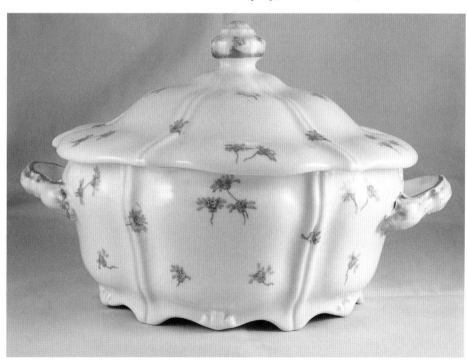

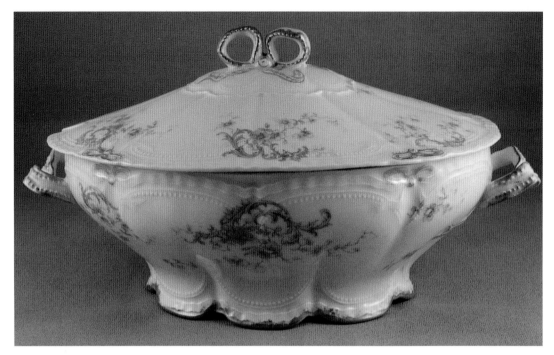

Figure 19. Soup tureen in Schleiger no. 144P on blank no. 124. Theodore Haviland Company, 1895. Mark n. $275-325.

Charles Field Haviland China

Born in New York on August 1, 1832, Charles Field Haviland was the nephew of David Haviland. Robert Barclay Haviland, Charles' father, established a china shop with David and his other brothers in New York in the 1840s. Acting as a liaison with the Limoges workshop that David Haviland had set up, Charles Field sailed to France in 1852. In 1858 he married Marie Louise Mallevergne, the granddaughter of porcelain manufacturer François Alluaud II.

Charles Field left Haviland Bros. & Company in 1859 to form a competing company with his Uncle Richard. He set up a workshop with a staff of eighteen and began decorating the white ware that the Alluaud factory manufactured. He then shipped the finished items to his uncle in New York for distribution. In 1865, after Haviland Bros. & Company was dissolved, Robert Barclay formed a partnership with two men, Messrs. Churchman and England, and his two sons, Frederick and Charles Field. Even with the loss of revenue from the southern states after the American Civil War, Charles Field was kept extremely busy filling orders for the New York Company.

In 1868, after an embittered lawsuit, with Mr. Churchman taking over the entire stock, Charles Field was forced to close shop in Limoges. He decided at that point to manufacture and decorate his own porcelain just as his uncle David was doing. He made a trip to America to reorganize the business in New York and while there took on a new partner, Oliver Gager. The company was then known as Charles Field Haviland & Company and was located at 49 Barclay Street.

Charles Field Haviland & Company and Haviland & Company were the only American companies at the time in Limoges, and they were in constant competition with each other. Both companies made exceptional porcelain and advertised heavily in American magazines for their share of the market. Charles Field Haviland had established his manufacturing plant in Vierzon, a short distance from Limoges where his decorating plant was located; but because of this distance, he was not able to keep up with the orders that were coming in and had to limit the amount of porcelain he could ship to the New York shop.

In 1876, Charles Field took over the Alluaud factory at Casseaux for his mother-in-law. The factory was over sixty years old and in much need of renovation. Charles Field spent a large amount of money trying to upgrade with new experimental kilns, but they did not give the desired results and he was not able to make enough money to cover his losses. His cousin, Charles Edward, advised him to give up the management of the business to another company while retaining a controlling interest. He took his advice and joined in 1881 with Emile Gérard, Jean-Baptiste Dufraisseix, and Morel—known by the initials *GDM*—and retired to become a silent partner. Charles Field Haviland died in 1896.

In the early years of Charles Field Haviland & Company, the high-fired colors had been mainly drab shades of gray, brown, and mauve. The new company put in good working Minton kilns, and under Morel's expertise was able to produce a wide range of bright and lively colors. Morel retired in 1890, but retained an interest in the business.

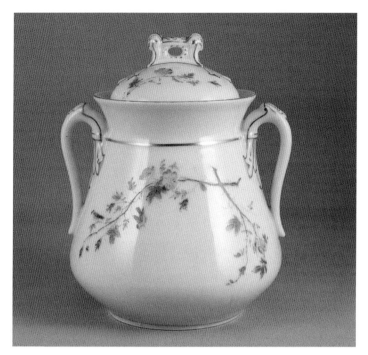

Edgar Abbot had been a partner in the American division with Dufraisseix. In January 1891, the two firms—E. Gérard, Dufraisseix & Company of Limoges and Dufraisseix & Abbot of New York—were consolidated and the entire business incorporated as a *société anonyme* under the corporate title of Porcelaines G.D.A. In 1931, when Haviland & Company went bankrupt and closed its doors, G.D.A. bought the rights to their name and everything that went with it. There is little evidence, however, that many pieces were made under the combined names. G.D.A. continued to produce some of the Haviland patterns with the usual red and green backmarks of the Haviland Company; and in 1941, deciding that they could stand alone on the quality and name of G.D.A., sold all rights to the Theodore Haviland Company—as we have already seen.

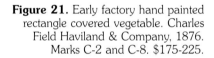

Figure 20. Sugar bowl, 7" high. Charles Field Haviland & Company, 1868. Marks C-1 and C-8. $65-75.

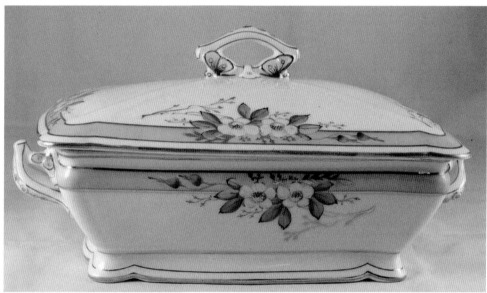

Figure 21. Early factory hand painted rectangle covered vegetable. Charles Field Haviland & Company, 1876. Marks C-2 and C-8. $175-225.

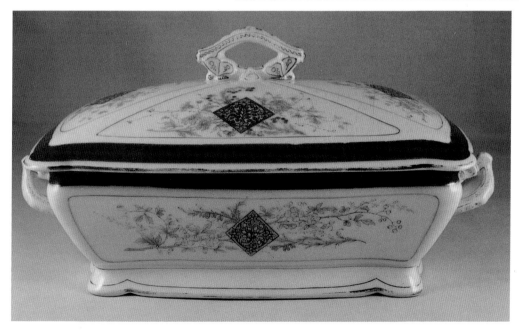

Figure 22. Covered vegetable, 9¼" x 6". Charles Field Haviland & Company, 1876. Mark C-2. $175-225.

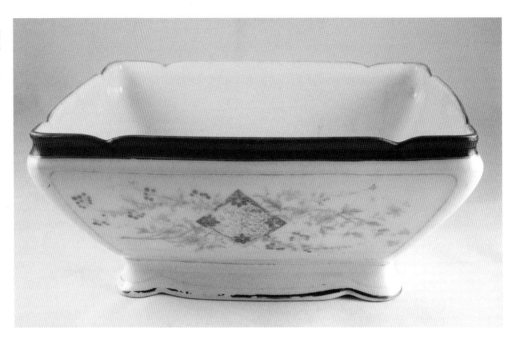

Figure 23. Square open serving bowl, 9", from set in Fig. 22. Charles Field Haviland & Company, 1876. Mark C-2. $125-175.

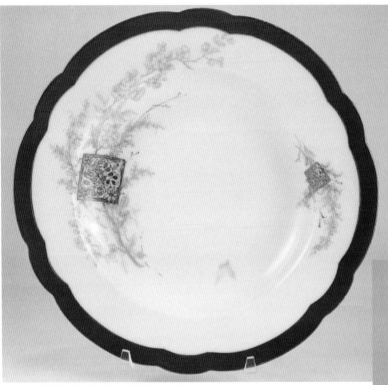

Figure 24. Rimmed soup, 9½", from set in Fig. 22. Charles Field Haviland & Company, 1876. Mark C-2. $40-50.

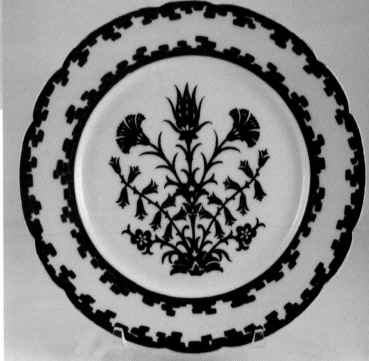

Figure 25. Plate, 8½", red and gold design. Charles Field Haviland & Company, 1882. Marks C-3 and C-8. $50-75.

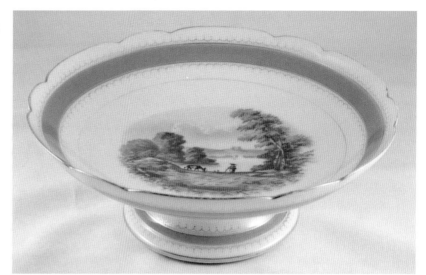

Figure 26. Factory decorated footed comport, 8¾" x 3½". Charles Field Haviland & Company, 1868. Mark C-1. $225-275.

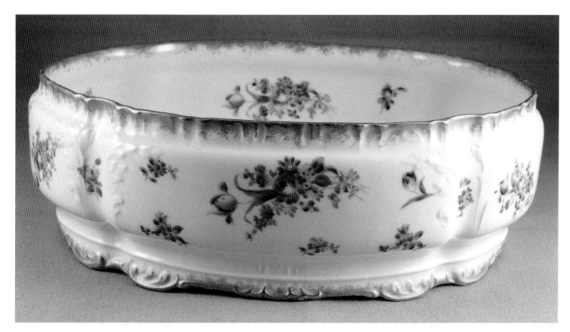

Figure 27. Jardiniere, 12" x 8¼" x 4". Factory decorated with a combination of transfer and hand painting. Has almost a Dresden look. Charles Field Haviland & Company, 1892. Mark C-4. $1000-1500.

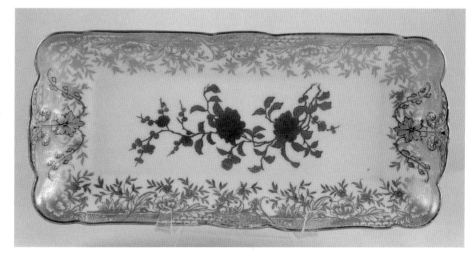

Figure 28. Celery tray with gold and bronze, 11¾" x 5¼". Charles Field Haviland & Company, 1892. Marks C-4 and C-8, for French & Potter Co., Chicago. $125-150.

Figure 29. Rimmed soup with pale green rim, 9",
in unidentified pattern. Charles Field Haviland &
Company, 1892, C-4 and C-8. $45-55.

Figure 30. Large soup tureen, Egyptian motif with shell handles. Charles Field Haviland & Company,
1882. Marks C-3 and C-8. $400-500.

Figure 31. Cobalt and gold soup tureen. Charles Field Haviland & Company, 1882. Marks C-3 and C-8. $400-500.

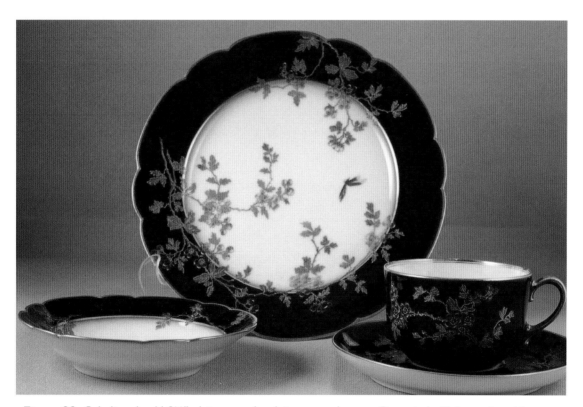

Figure 32. Cobalt and gold 8½" plate, sauce bowl, teacup and saucer. Decorated with leaves in gold, flowers in gold and silver, plus a blue dragonfly on each plate. Charles Field Haviland & Company, 1882. Mark C-3. Three piece set $250-300.

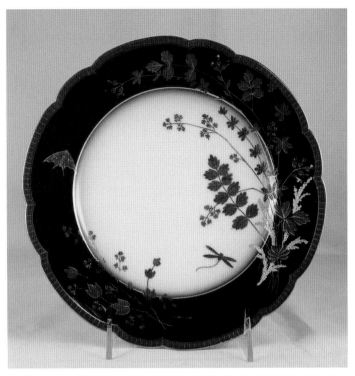

Figure 33. Cobalt and gold plate, 7½". Charles Field Haviland & Company, 1882. Marks C-3 and C-8, plus *Cornish* in gold. $75-85.

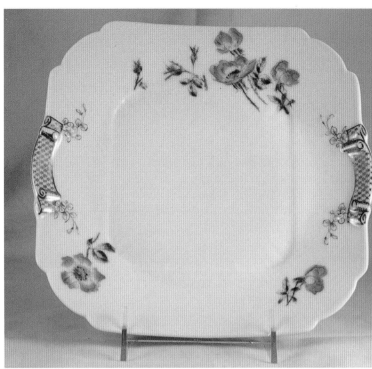

Figure 35. Cake plate, 9", in unidentified pattern. Charles Field Haviland & Company, 1882. Marks C-3 and C-8. $85-95.

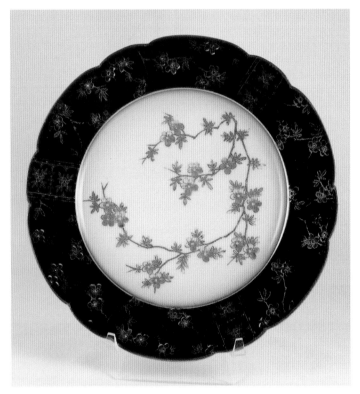

Figure 34. Cobalt and gold plate, 8½". Charles Field Haviland & Company, 1882. Marks C-3 and C-8. $80-95.

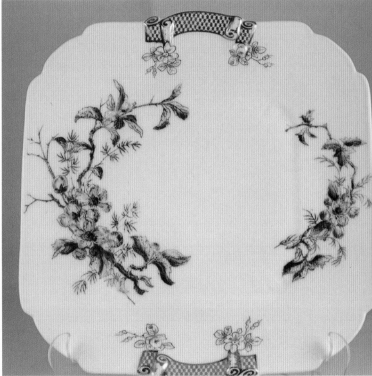

Figure 36. Cake plate, 9", in unidentified pattern. Charles Field Haviland & Company, 1882. Marks C-3 and C-8. $85-95.

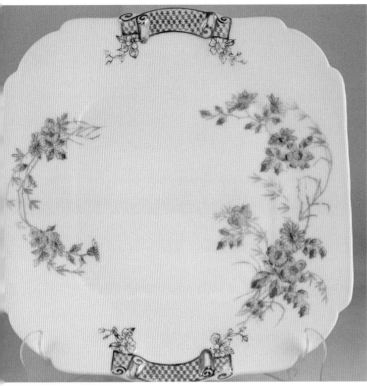

Figure 37. Cake plate, 9", in Schleiger no. 1301A. Charles Field Haviland & Company, 1892. Marks C-4 and C-8. $85-95.

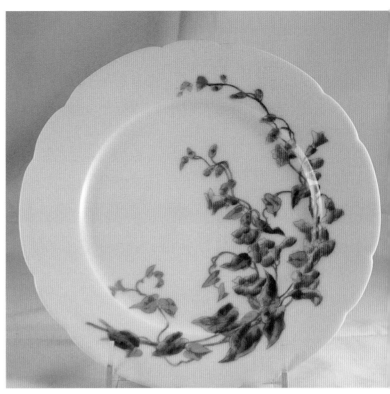

Figure 39. Plate, 8½", in unidentified pattern. Charles Field Haviland & Company, 1876. Marks C-2 and C-8. $25-35.

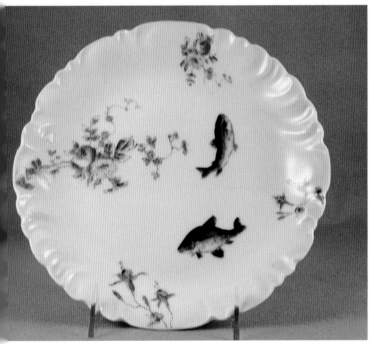

Figure 38. Fish plate, 8½", probably a multifloral pattern with different flowers on each plate as well as different fish. Charles Field Haviland & Company, 1892. Mark C-4. $65-75.

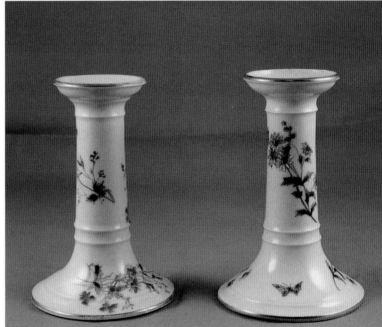

Figure 40. Pair of candlesticks in multifloral design, 6". Charles Field Haviland & Company, 1876. Mark C-2. Pair $250-350.

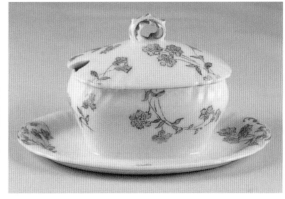

Figure 41. Mustard pot with lid and attached underplate in Schleiger no. 372. Charles Field Haviland & Company, 1892. Marks C-4 and C-8. $125-150.

Figure 42. Pancake server in pattern identified in Margaret Head's book on Charles F. Haviland as no. 58. Charles Field Haviland & Company, 1882. Marks C-3 and C-8. $165-225.

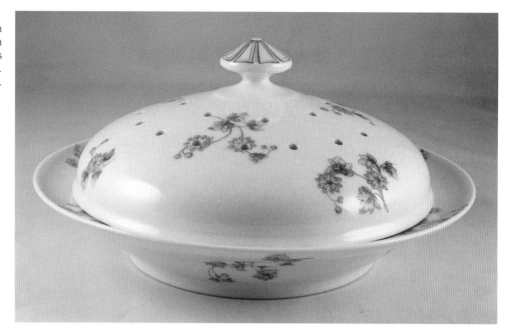

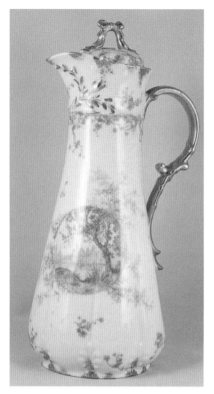

Figure 43. Tall chocolate pot, 11", in unidentified pattern. Charles Field Haviland & Company, 1892. Marks C-4 and C-8. $275-350.

Figure 44. Teapot in unidentified pattern, 7½". Charles Field Haviland & Company, 1892. Marks C-4 and C-8. $200-250.

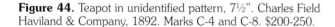

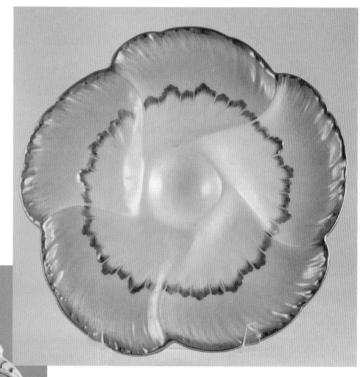

Figure 45. Oyster plate, 9". Charles Field Haviland & Company, 1892. Marks C-4 and C-8. $125-225.

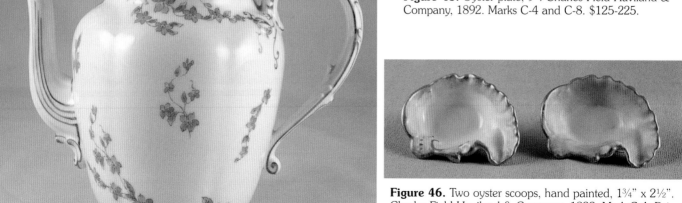

Figure 46. Two oyster scoops, hand painted, 1¾" x 2½". Charles Field Haviland & Company, 1892. Mark C-4. Pair $125-150.

Figure 47. Handled ice relish or nappy, 4" x 5". Charles Field Haviland & Company, 1892. Mark C-4. $50-75.

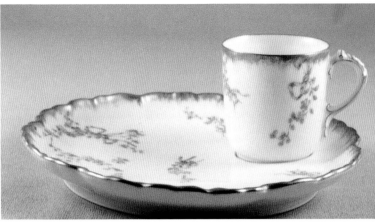

Figure 50. Tea and toast set in unidentified pattern. Charles Field Haviland & Company, 1892. Marks C-4 and C-8. $145-165.

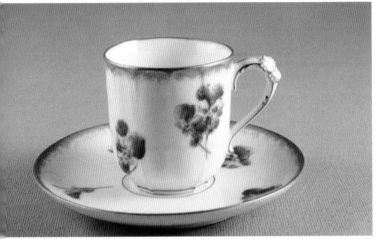

Figure 48. After-dinner coffee cup and saucer, cup 2¼", in unidentified pattern. Charles Field Haviland & Company, 1892. Mark C-4 and C-8. $40-50.

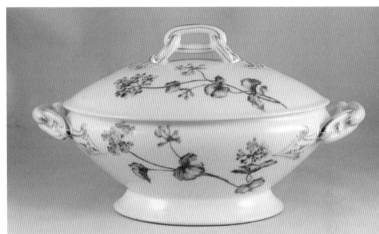

Figure 51. Oval covered casserole, 8½" x 10", in unidentified pattern. Charles Field Haviland & Company, 1868. Mark C-1 impressed and C-8. $125-175.

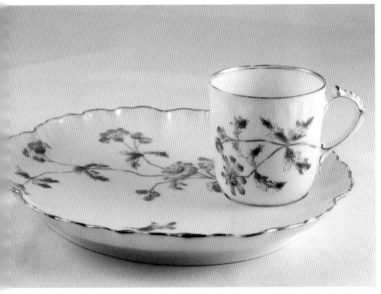

Figure 49. Tea and toast set in Schleiger no. 1131. Charles Field Haviland & Company, 1882. Marks C-3 and C-8. $145-165.

Figure 52. Tray with unglazed bottom, 10½" x 12½", in unidentified pattern. Charles Field Haviland & Company, 1892. Mark C-4. $95-125.

Figure 53. Bowl, 8" x 7", in unidentified pattern. There is a definite molding of a turtle with feet and head on the rim. Perhaps this was for turtle soup, which was a common soup in the 1880s. Charles Field Haviland & Company, 1892. Marks C-4 and C-8. $45-60.

Figure 55. Oyster plate in unidentified pattern, 7½". Charles Field Haviland & Company, 1900. Marks C-5 and C-8. $125-175.

Figure 56. Plate, 8½". Charles Field Haviland & Company, 1882. Marks C-3 and C-8. $25-30.

Figure 54. Shallow serving bowl, 9¼", in unidentified pattern. Charles Field Haviland & Company, 1900. Marks C-5 and C-8. $95-125.

Figure 57. Plate, 8½", in pattern identified by Margaret Head as no. 88. Charles Field Haviland & Company, 1882. Marks C-3 and C-8. $25-30.

Figure 59. Coupe plate, 8", flat with ruffled raised edge in a variation of Schleiger no. 195M on Schleiger blank no. 178. Charles Field Haviland & Company, after 1900. Mark GDA Limoges-CFH in ribbon. $30-35.

Figure 58. Plate, 8½" in unclassified pattern. Charles Field Haviland & Company, after 1900. Marks C-5 and C-8. $25-30.

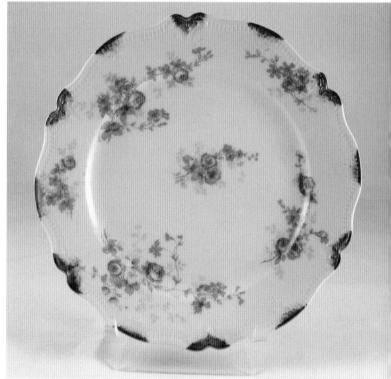

Figure 60. Plate, 7½", identified by Margaret Head in her book as no. 112 on blank no. 5. Charles Field Haviland & Company, after 1900, C-5 and C-8. $22-28.

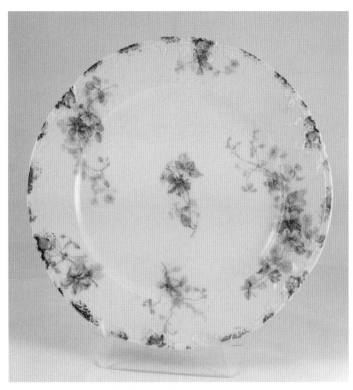

Figure 61. Plate, 7½", identified by Margaret Head as a variation of no. 40. Charles Field Haviland & Company, after 1900. Marks C-5 and C-8. $22-28.

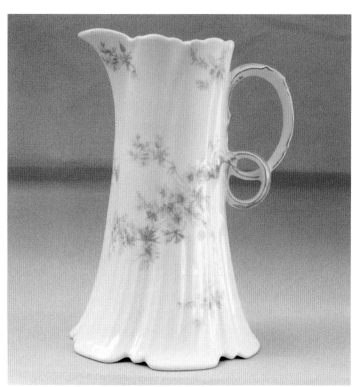

Figure 63. Lemonade pitcher with ribbon handle, 8", in unidentified pattern. Charles Field Haviland & Company, 1892. Marks C-4 and C-8. $225-275.

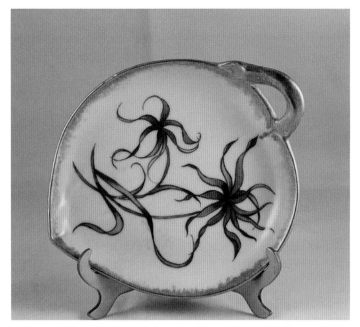

Figure 62. Leaf dish with handle, 6", hand painted. Charles Field Haviland & Company, 1892. Mark C-4. $45-60.

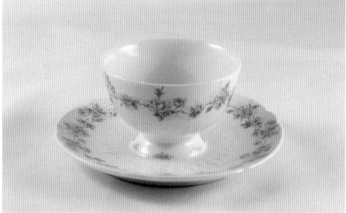

Figure 64. Small sorbet with attached underplate, *The Fontainbleau*. Charles Field Haviland & Company, after 1900. Marks C-5 and C-8. $75-95.

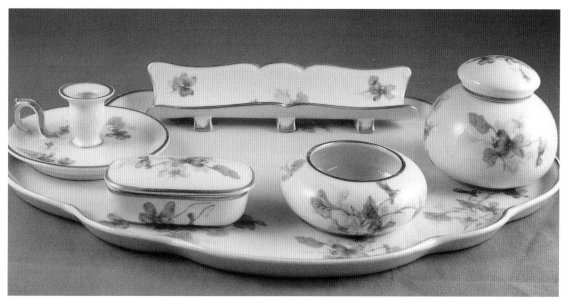

Figure 65. Desk set. Pieces on tray from center back clockwise—pen holder, ink pot, open pot for paper clips or misc., stamp holder and candleholder. In unidentified pattern. Charles Field Haviland & Company, after 1900. Marks C-5 and C-8. $750-1150.

Figure 66. Punch cup, 5". Charles Field Haviland & Company, after 1900. Marks C-5 and C-8, plus decorated for the Vollmer-Jantzen Co. $35-45.

Figure 67. Puff box in unidentified pattern. Charles Field Haviland & Company, after 1900. Marks C-5 and C-8 for Toronto, Winnipeg. $100-150.

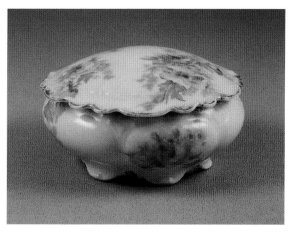

Figure 68. Small ramekin baker with unglazed bottom, 4½", in unidentified pattern. Charles Field Haviland & Company, 1882. Marks C-3 plus printed in a box *Porcelaines a feu CFH Limoges*. $45-65.

Part 2: Evolution of Design

Botanical and Multifloral Designs

From the start of the nineteenth century, flowers seem to be the first decorations placed on European porcelain. These were hand-painted and usually placed around the rim or in the center of the plate. When David Haviland first opened his decorating studio in Limoges, his earliest patterns were either a simple band in gold, a solid colored band with gold, or a simple floral bouquet.

As the factory grew and the techniques improved, floral patterns became more involved. Chromolithography replaced the metal-plate engravings. Through this new process, developed in part by Felix Bracquemond, the factory was able to transfer its designs to a special paper made of powdered ceramic decorating materials. This paper is called a transfer, decalcomania, or just decal. It is placed on the porcelain and then fired. In firing, the excess paper burns away, leaving the pattern fused to the porcelain.

In the mid-nineteenth century, Americans and Europeans were traveling the globe, looking for knowledge in all forms. Botany, or the study of plants and flowers, became a new fascination for the Victorians. Haviland hired artists to reproduce exact designs of flowers to place on the dinnerware and decorative items. These designs became popular during the 1860s and continued for many years. The first designs were placed in the center of the cups, plates, and serving pieces. Each piece had a different flower illustrated, usually in bright colors, and sometimes a different flower on the reverse side of the serving pieces—the unifying factor in a tea or dinner service being the colored border and the shape of the porcelain.

When Charles Edward came into Haviland & Company, he brought with him his love of the Japanese style of art. The Japanese decorative arts weave throughout the evolution of design, and one cannot address any style during the period from 1860s to 1930s without seeing its major influence. Charles Edward saw that the simple floral designs were looking outdated and hired artists to create new ones. Many of the artists came from the Sèvres Manufactory as Haviland hired only the best: Felix Bracquemond, Albert and Eduoard Dammouse, and Pallandre, to name a few.

The talented brothers, Eduoard and Albert Dammouse, were hired by Haviland & Company to design new dinnerware. Having been trained as a sculptor before devoting himself to ceramics, Albert was always working to develop new and distinctive translucent pastes. He was responsible for designing the cream-colored Vermicelli shape and blank. He became an expert with the use of colored enamels, as we see in the beautiful Dammouse pieces shown here. These also fall into the cross-category of *Japonisme* and multifloral patterns. Eduoard worked as a painter for the factory from 1876 until 1885.

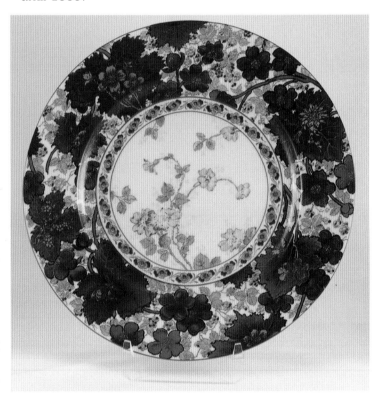

Figure 69. Plate, 10¼". *Reproduction of an original plate by Edouard Dammouse, painter and ceramist—19th century French school, Haviland Museum* written in French on back of plate. Haviland & Company. Mark s, 1958. $100-125.

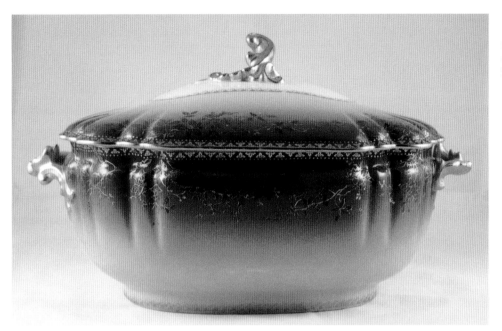

Figure 70. Soup tureen in the Richelieu shape. In these gold designed patterns, each piece has a different leaf or floral pattern. Haviland & Company, 1876-1889. Marks F and g. $325-425.

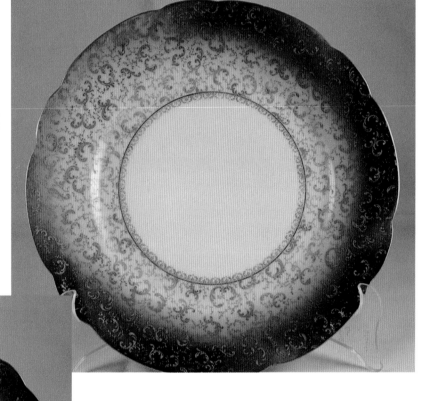

Figure 71. Plate, 8½", with shaded background and gold pattern. Each plate in the set has a slightly different leaf or flower in gold. Haviland & Company, 1888-1896. Marks H and c. $95-125.

Figure 72. Plate, 8½", with shaded background and gold pattern. Haviland & Company, 1888-1896. Marks H and c. $95-125.

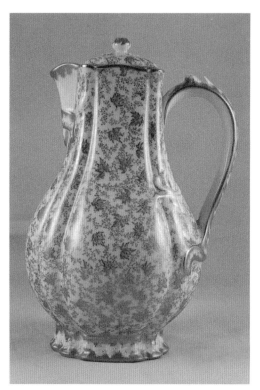

Figure 73. Chocolate pot, gold pattern on white Henri II shape. Haviland & Company, 1888-1896. Marks H and c. $325-425.

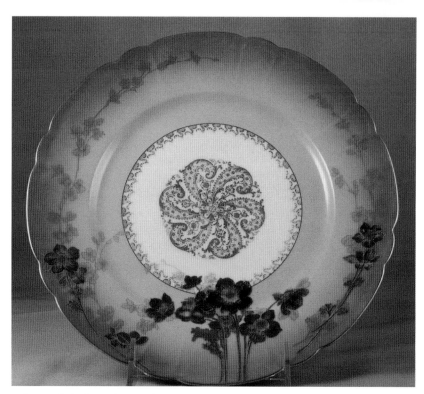

Figure 75. One of a set of twelve, shaded deep to light rose with gold medallion in center, 9½", on Schleiger blank no. 14, designed by Eduard Dammouse. There are three different patterns, repeated four times. Haviland & Company, 1876-1878. Marks F & c. Each $125-150.

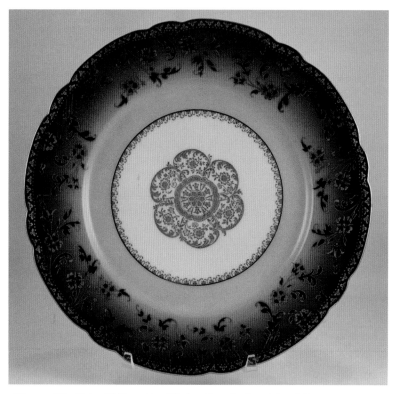

Figure 74. Plate, 9½", unidentified pattern in the style of Dammouse. Haviland & Company, some plates in set have just Marks I & c, others F plus *Haviland & Co. pour B.E. Bedell & Co., 866 Broadway, New York.* $95-125.

30

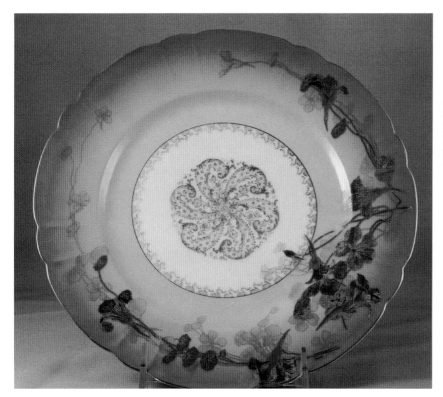

Figure 76. One of a set of twelve, shaded deep to light rose with gold medallion in center, 9½", on Schleiger blank no. 14, designed by Eduard Dammouse. Haviland & Company, 1876-1878. Marks F & c. Each $125-150.

Figure 77. One of a set of twelve, shaded deep to light rose with gold medallion in center, 9½", on Schleiger blank no. 14, designed by Eduard Dammouse. Haviland & Company, 1876-1878. Marks F & c. Each $125-150.

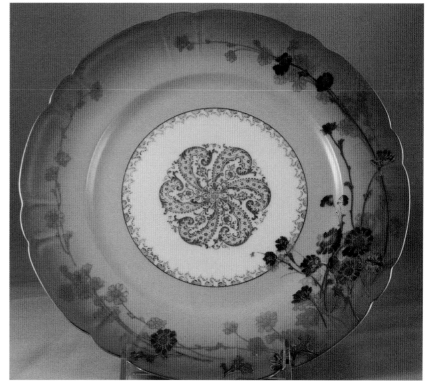

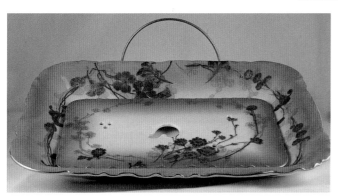

Figure 78. Asparagus platter with drain in same pattern and color as Fig. 75-77 but on Marseilles shape, by Edouard Dammouse. Haviland & Company, 1888-1896. Marks H and c. $350-500.

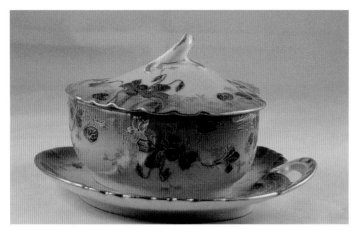

Figure 79. Covered bouillon in the same Dammouse pattern and color as Fig. 78, Marseilles shape. Haviland & Company, 1888-1896. Marks H and c. $125-150.

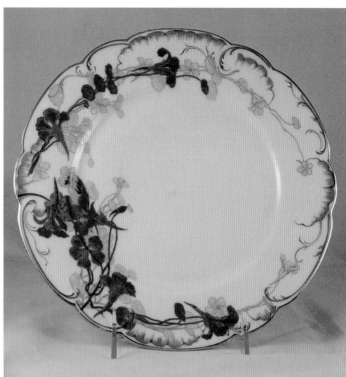

Figure 82. Plate in white and green, 9½", by Dammouse on the Marseilles blank, Schleiger no. 9. Haviland & Company, 1888-1896. Marks H and c. $125-150.

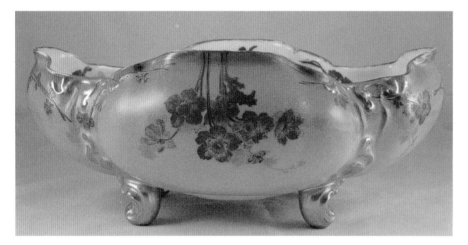

Figure 80. Footed orange bowl, 11½" x 9½", in shaded orange color by Dammouse. Oranges were pealed and served in this bowl, but it was also used for salad. The old 1880s catalogs show it being used for both purposes. Haviland & Company, 1876-1879. Marks F and c. $400-550.

Figure 81. Open oval vegetable bowl in white and green by Dammouse on the Marseilles blank. Haviland & Company, 1888-1896. Marks H and c. $150-200.

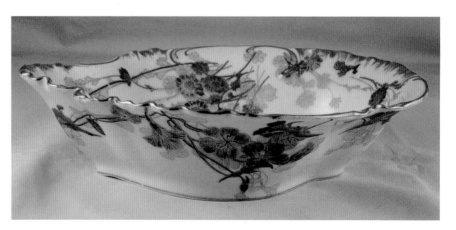

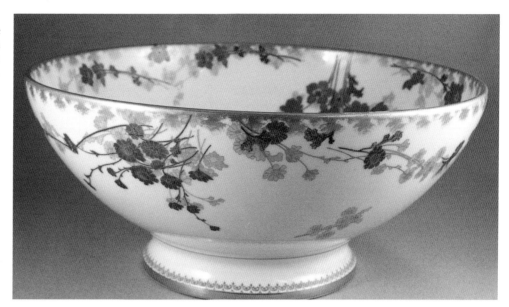

Figure 83. Large punch bowl in white and green, by Dammouse, on smooth blank, 13". Haviland & Company, 1876-1878. Mark c. $1000-1200.

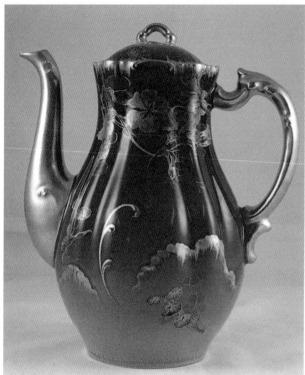

Figure 84. Coffeepot in cobalt and gold, by Dammouse, on Marseilles shape. Haviland & Company, 1888-1896. Marks H and c for Frank Haviland. $600-750.

Figure 85. Plate, 9½", shading from brown to tan, Schleiger blank no. 14, in multifloral pattern with four different floral patterns in set. Haviland & Company, 1888-1896. Marks H and c. $95-125.

Haviland & Company created what we are now calling *multiflorals*. These were made up of twelve different floral patterns, in a somewhat *Japonisme* design, with the unifying factor being the decoration around the rim, or just the shape of plate if there was no different rim. These sets of twelve were sold as course plates and it was popular to serve each course with a different theme. Some were done as a set of six and doubled with two of each pattern instead of twelve.

Some of the different designs sold were: twelve flowers and twelve fruits by Pallandre; twelve flowers and birds by Bellet; *Service Parisian* by Felix Bracquemond, which was patterned from Hokusai's sketches of the seasons; as well as the famous *Fleur Saxe* by Pallandre based on Saxon or Dresden flowers. One example of this set, shown here, illustrates his use of monochrome, vibrant pink and blue. Pallandre had been a noted floral artist

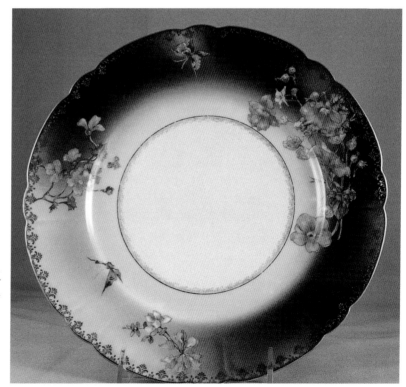

and brought many new designs with him when he came to Haviland & Company. A set called *Fleur Parisian* by Girardin was done in 1886 for the king of Portugal. It is composed of twelve motifs in larger sweeping florals.

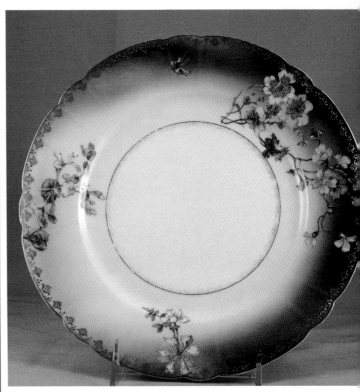

Figure 88. Plate, 9½", shading from brown to tan, Schleiger blank no. 14, in multifloral pattern with four different floral patterns in set. Haviland & Company, 1888-1896. Marks H and c. $95-125.

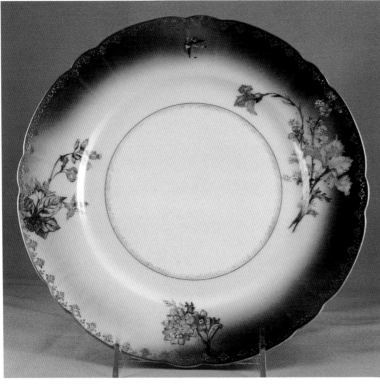

Figure 86. Plate, 9½", shading from brown to tan, Schleiger blank no. 14, in multifloral pattern with four different floral patterns in set. Haviland & Company, 1888-1896. Marks H and c. $95-125.

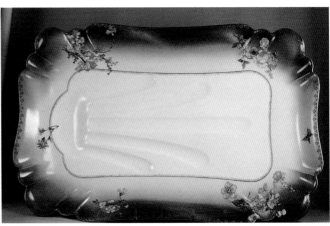

Figure 89. Platter, 13"x 20" in multifloral pattern. Haviland & Company, 1888-1896. Marks H and c. $350-450.

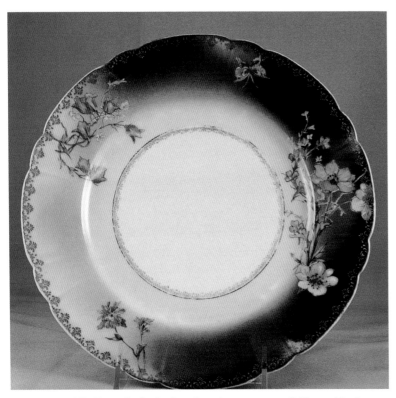

Figure 87. Plate, 9½", shading from brown to tan, Schleiger blank no. 14, in multifloral pattern with four different floral patterns in set. Haviland & Company, 1888-1896. Marks H and c. $95-125.

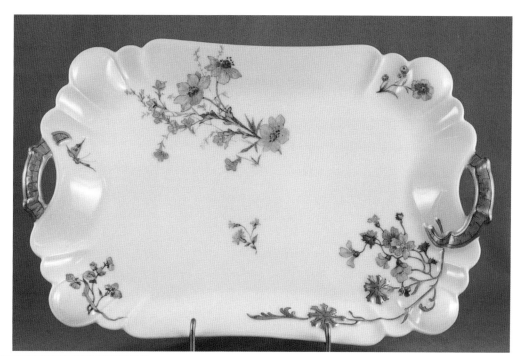

Figure 90. Handled serving platter, 12", multifloral pattern, Schleiger blank no. 14. Haviland & Company, 1876-1889. Marks F and c. $125-150.

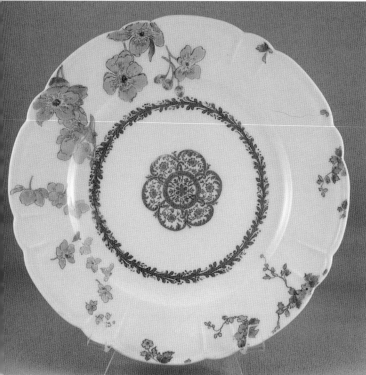

Figure 91. Plate, 9", Schleiger blank no. 14. Haviland & Company, 1876-1889. Marks F and c. $75-95.

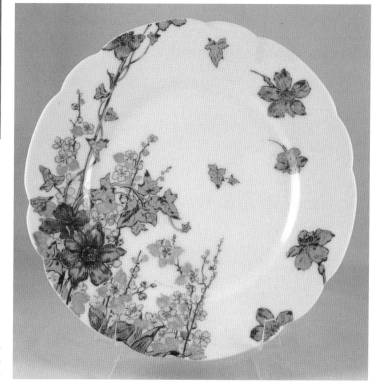

Figure 92. Plate, 8½", unidentified pattern on Schleiger blank no. 4A. This is a very bold multifloral pattern. Haviland & Company, 1876-1889. Marks F and g in turquoise. $35-45.

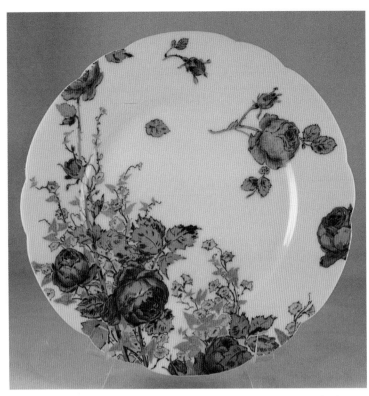

Figure 93. Plate, 8½", unidentified pattern on Schleiger blank no. 4A. This is a very bold multifloral pattern. Haviland & Company, 1876-1889. Marks F and g in turquoise. $35-45.

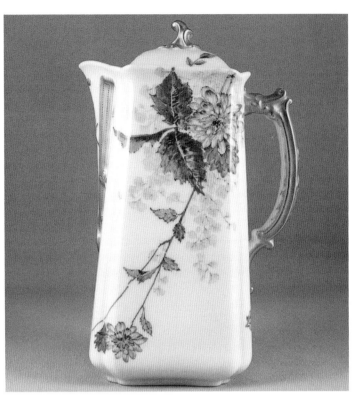

Figure 95. Chocolate pot in unidentified pattern in a multifloral variation, Pompadour shape. Haviland & Company, 1877-1889. Marks G and g. $325-425.

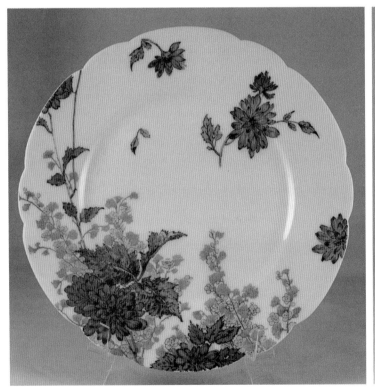

Figure 94. Plate, 8½", unidentified pattern on Schleiger blank no. 4A. This is a very bold multifloral pattern. Haviland & Company, 1876-1889. Marks F and g in turquoise. $35-45.

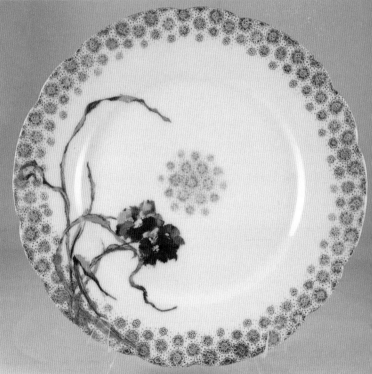

Figure 96. Plate, 8½", one of a series by Pallandre, Schleiger blank no. 4A. Haviland & Company, 1876-1889. Marks F and c. $100-125.

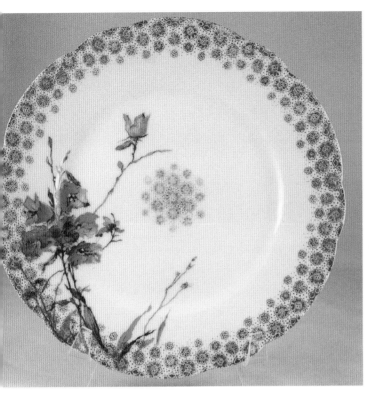

Figure 97. Plate, 8½", one of a series by Pallandre, Schleiger blank no. 4A. Haviland & Company, 1876-1889. Marks F and c. $100-125.

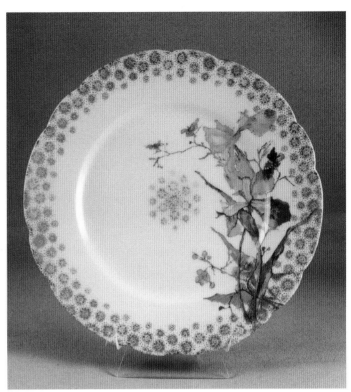

Figure 99. Plate, 8½", one of a series by Pallandre, Schleiger blank no. 4A. Haviland & Company, 1876-1889. Marks F and c. $100-125.

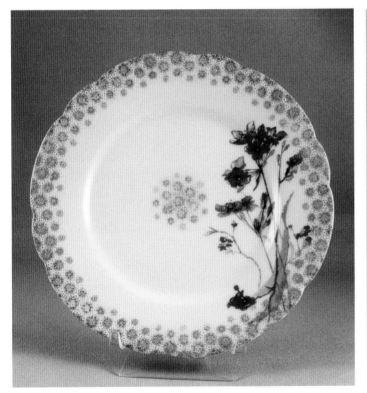

Figure 98. Plate, 8½", one of a series by Pallandre, Schleiger blank no. 4A. Haviland & Company, 1876-1889. Marks F and c. $100-125.

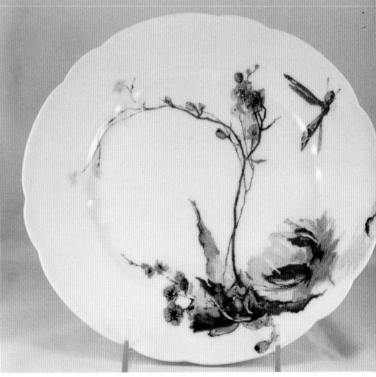

Figure 100. Plate, 9½", designed by Girardin. Haviland & Company, 1885. Mark D plus F and *"E" Rassenfosse, Rue de L'Universite, Liege.* $95-125.

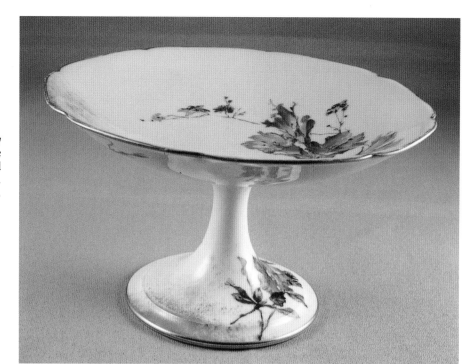

Figure 101. Pedestal comport decorated by Pallandre, 8¾" diameter x 4¾" high. Large flowers also painted on under rim. Haviland & Company, 1886-1889. Marks G and g. $250-350.

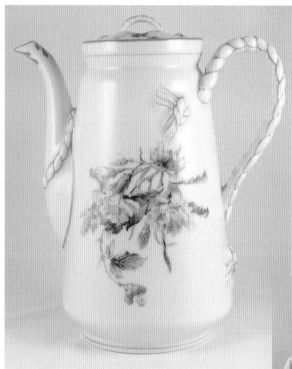

Figure 102. Gray multifloral pattern by Pallandre. Large coffeepot, 9", with braided handle trimmed in pink, Rope shape. Haviland & Company, 1876-1889. Marks D and g plus impressed English registry. $225-325.

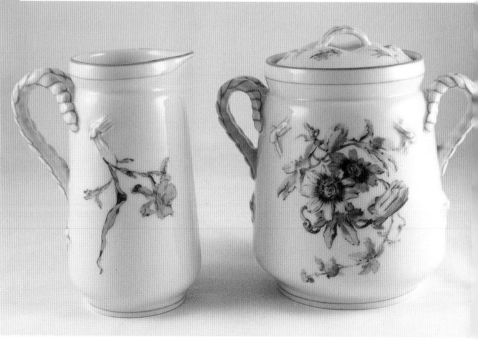

Figure 103. Creamer 5½" and sugar 6", in same multifloral pattern as Fig. 102. Notice the bright blue floral on back side of creamer. Haviland & Company, 1876-1889. Marks D and g plus no. 2025 on bottom of sugar, also letters I-M impressed. Set $125-150.

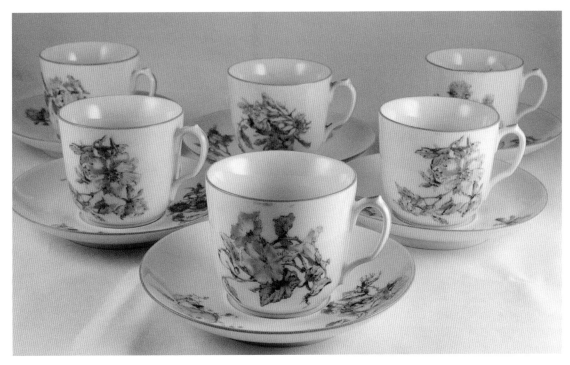

Figure 104. Set of six teacups and saucers for set in Fig. 102-103. Haviland & Company, 1876-1889. Marks D and g. Set of six $275-300.

Figure 105. Cake plate, 9½", for gray multifloral coffee set in Fig. 102. Haviland & Company, 1876-1889. Marks D and g. $75-125.

Figure 106. Dessert plate, 7½", for gray multifloral coffee set, Fig. 102. Haviland & Company, 1876-1889. Marks D and g. $25-35.

Figure 107. Dessert plate, 7½", for gray multifloral coffee set, Fig. 102. Haviland & Company, 1876-1889. Marks D and g. $25-35.

Figure 109. Dessert plate, 7½", for gray multifloral coffee set, Fig. 102. Haviland & Company, 1876-1889. Marks D and g. $25-35.

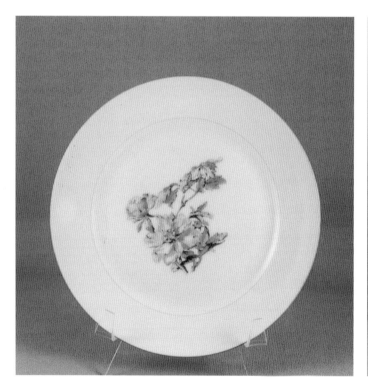

Figure 108. Dessert plate, 7½", for gray multifloral coffee set, Fig. 102. Haviland & Company, 1876-1889. Marks D and g. $25-35.

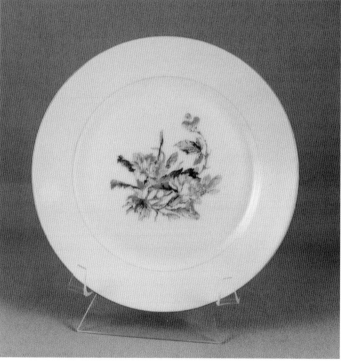

Figure 110. Dessert plate, 7½", for gray multifloral coffee set, Fig. 102. Haviland & Company, 1876-1889. Marks D and g. $25-35.

Figure 111. Plate, 9½", in a multifloral pattern with shadings in orange, Salesman's sample on smooth blank. Haviland & Company, 1894-1931. Marks I and c, plus *Sample #16294...T...u.* $95-125.

Figure 112. Plate, 8½", one of a series of the *Fleur Saxe* multifloral patterns (Saxon or Dresden flowers) by Pallandre. Lithography plus hand painting. The first design created by the Auteuil Studio. Haviland & Company, 1888-1896. Marks H and c. $95-125.

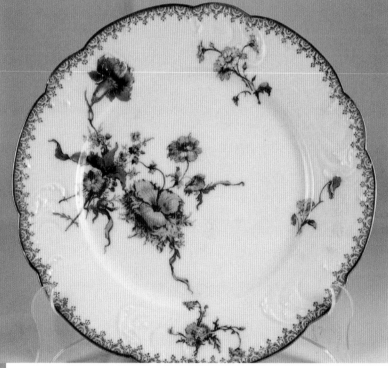

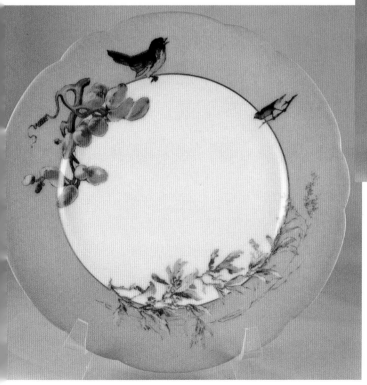

Figure 113. Fruit plate, 8½", with Meadow Visitors. Haviland & Company, 1876-1889. Marks D and blue g. $75-125.

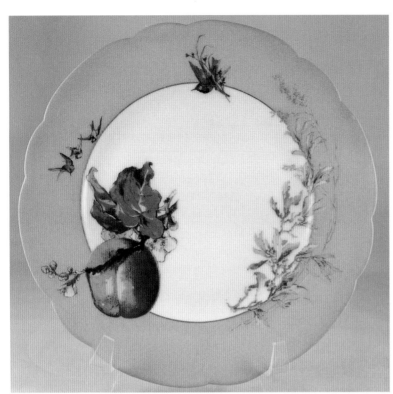

Figure 114. Fruit plate, 8½", with Meadow Visitor. Haviland & Company, 1876-1889. Marks D and blue g. $75-125.

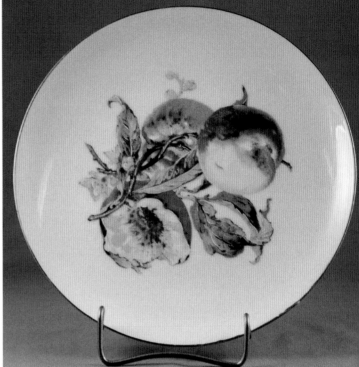

Figure 115. Coupe fruit plate, 9", on smooth blank. Haviland & Company, 1876. Marks F and a, for Gilman Collamore-Importer-131 Broadway, NY. $75-95.

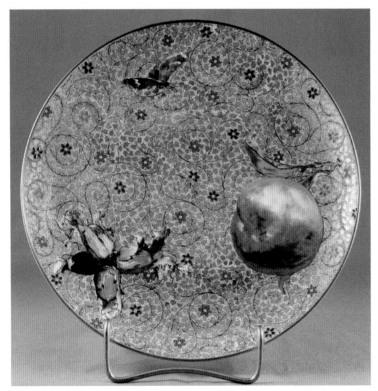

Figure 116. Fruit plate, 8½", with elaborate gold background. Haviland & Company, 1876-1889. Marks D and g for J McD & S. $75-125.

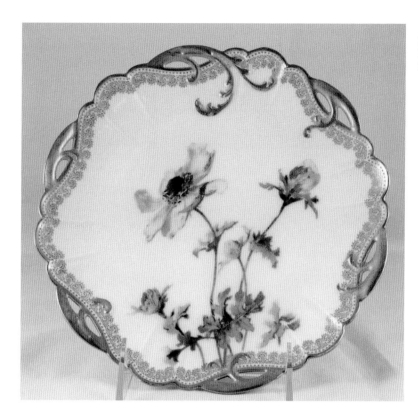

Figure 117. Plate *Anemone*, 8½", in Feu de Four. Haviland & Company, 1893-1894. Marks I and h, plus *Made in France for Maple & Co., London.* $150-250.

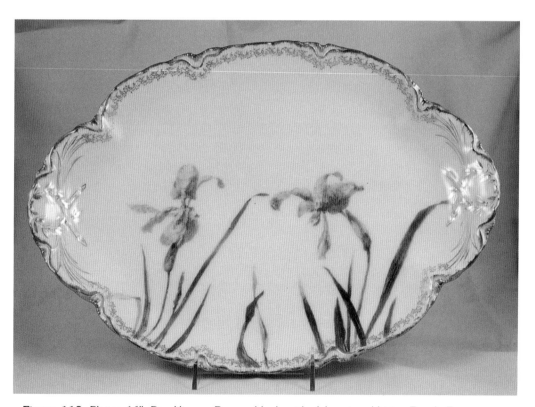

Figure 118. Platter, 16", Day lilies on Ranson blank, with elaborate gold trim, Feu de Four. Haviland & Company, 1893-1894. Marks H and h plus mark c, decorated for Wood, Bicknall & Potter, Providence, RI. $225-325.

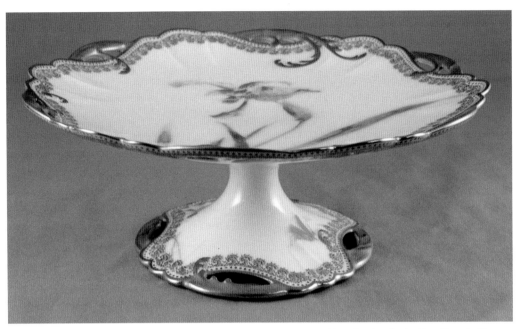

Figure 119. Reticulated Comport, 9" diameter, *Cuprype'dium Famille des Orchidées,* Feu de Four. Haviland & Company, 1893-1894. Marks I and h. $250-350.

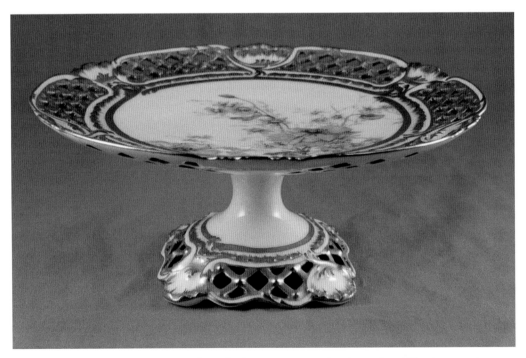

Figure 120. Footed comport with fancy basket-weave cutout border and multifloral pattern in center. Haviland & Company, 1888-1896. Marks H and c *pour C.A. Selzer, Cleveland, OH.* $325-425.

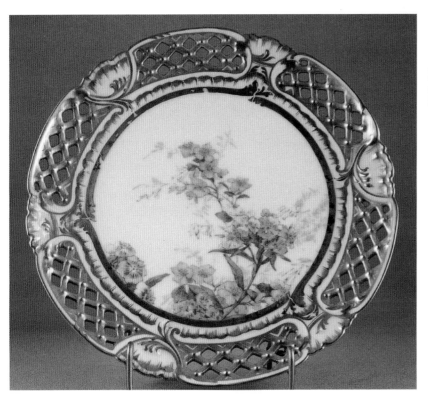

Figure 121. Plate, 8½", with fancy basket-weave cutout border and multifloral pattern in center. Haviland & Company, 1888-1896. Marks H and c. $200-275.

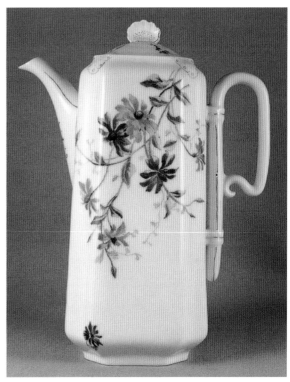

One of the most popular older multifloral patterns is called *Old Blackberry*. Robert A. Rorex, professor at the University of Iowa and past president of the Haviland Collectors Internationale Foundation, has been doing an extensive study into multiflorals. He has been trying to identify and list the various patterns that were grouped into six or twelve individual flowers. Because some of the patterns are similar, this is a large, time-consuming job. However, as with *Old Blackberry*, once the design and definition of the flowers are studied, it becomes recognizable in any of its forms.

Through studying botanical and gardening books, Professor Rorex has found the following twelve flower designs used in *Old Blackberry*: (1) Poppy with cornflowers and wheat, (2) Lilac, (3) Magnolia, (4) Carnation, (5) Chrysanthemum, (6) Honeysuckle, (7) Anemone, (8) Black-eyed Susan, (9) Double Rose, (10) Ranunculus, (11) Tulip, and (12) Dogwood.

Figure 122. Coffeepot in Old Blackberry pattern, Schleiger no. 1154E, with clam shell finial. Haviland & Company, 1876-1889. Marks F and g. $275-425.

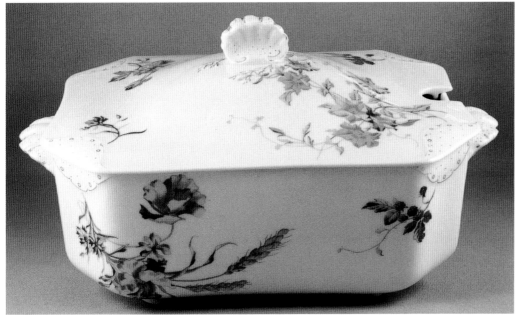

Figure 123. Napkin fold soup tureen with clam shell handles in Old Blackberry pattern, Schleiger no. 1154E. Haviland & Company, 1876-1889. Marks F and c. $300-450.

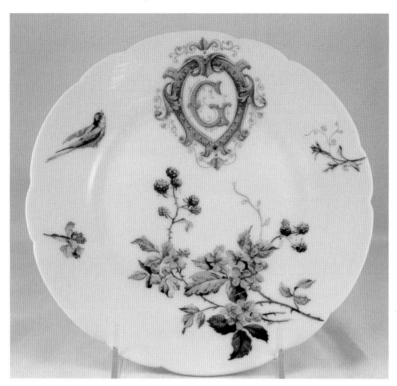

Figure 124. Plate, 8½" Old Blackberry variation, Haviland & Company, for Garnier Opera House, Paris, Vermont Freres, 17 Rue Auber, Paris. $50-75.

Sheets of decals were printed, averaging 12" x 16" in size. The patterns of flowers would have been placed fairly close together on the sheets. If you look at any plates with fairly large flowers, you will notice small sections of other flowers placed to fill in spots at corners, etc. These flowers are similar in placement to the other plates, but not quite identical. Placement was left to the discretion of the artisan. These might have been cut from larger bouquets of the other eleven flowers and used to unify the entire set.

There are two or three other major patterns that are currently being researched. One is sometimes called *Old Pansy*; but it has also been known as *Ragged Pansy, Potpourri, Old Pink and Grey*, or *Flowering Fields*. It is sometimes mistaken for a variation of *Old Blackberry* since it has small berries in the pattern. However, it is not quite as stylized—it appears to be more sketchy and filled with detail. This pattern is known by these various names due to the twelve different flowers in the set. If one could

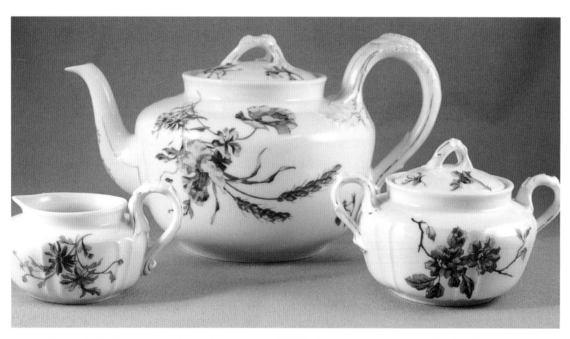

Figure 125. Teapot, creamer and sugar set in Old Blackberry color variation. Haviland & Company, 1876-1889. Marks F and g on teapot. Marks F and d on creamer and sugar set plus, for Clark, Adams & Clark, Boston. Three piece set $325-400.

see them all together on a table at one time, it would be easy to see that they are a set. However, most people find a plate or two and assume that this is the entire pattern. There are complete sets of one pattern, like *Flowering Fields*, because someone started collecting that particular pattern, not realizing it was part of a whole grouping. To make it even more confusing, this pattern comes in various color themes: orange and green, yellow and brown, pink and gray, etc. *Old Blackberry* also comes in color variations, but not quite as dramatic as *Old Pansy*.

Haviland & Company began making dinnerware for the American presidents beginning with the Lincoln administration. Some of the presidents favored botanical and multifloral patterns. One of the plates (shown in Fig. 173) is from the Ulysses S. Grant administration. Each plate is of a different flower with the unifying yellow border and the presidential seal at the top.

Because there are so many beautiful and varied patterns, Haviland multifloral patterns have created a great challenge for collectors—but it is always fun to solve a mystery!

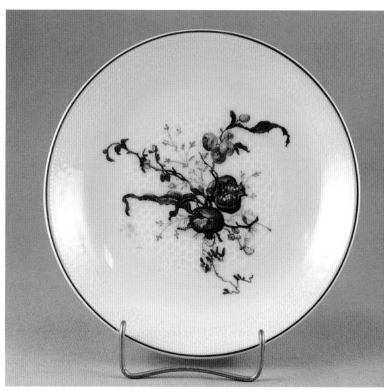

Figure 127. Fruit plate, 8½", Vermicelli bank, Schleiger no. 639. Haviland & Company, 1876-1878. Marks F and c. $75-95.

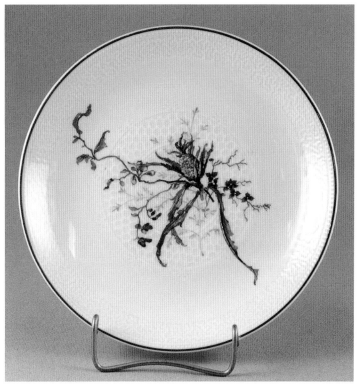

Figure 126. Fruit plate, 8½", Vermicelli blank, Schleiger no. 639. Haviland & Company, 1876-1878. Marks F and c. $75-95.

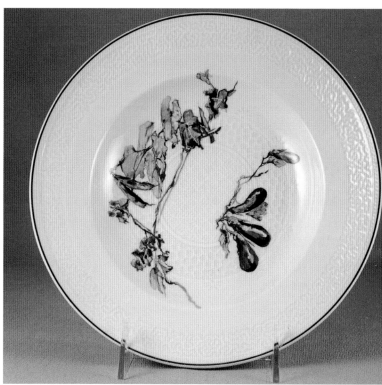

Figure 128. Rimmed soup bowl, 9½", with vegetable pattern on the Vermicelli blank, Schleiger no. 639. Porcelain shape was designed by Albert Dammouse. Haviland & Company, 1876-1889. Marks F and g. $75-125.

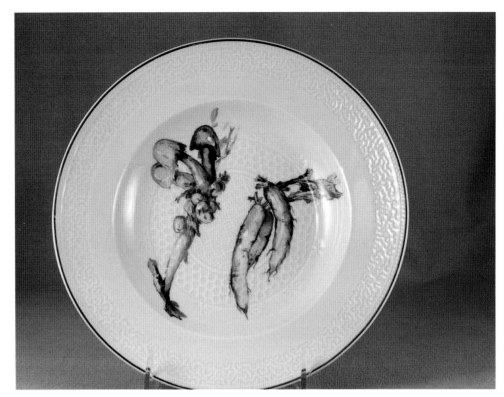

Figure 129. Rimmed soup bowl, 9½", with vegetable pattern on the Vermicelli blank, Schleiger no. 639. Haviland & Company, 1876-1889. Marks F and g. $75-125.

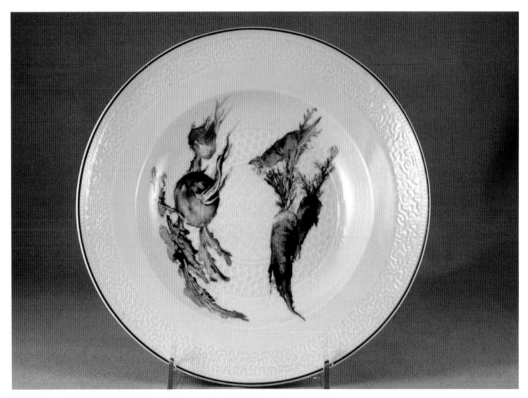

Figure 130. Rimmed soup bowl, 9½", with vegetable pattern on the Vermicelli blank, Schleiger no. 639. Haviland & Company, 1876-1889. Marks F and g. $75-125.

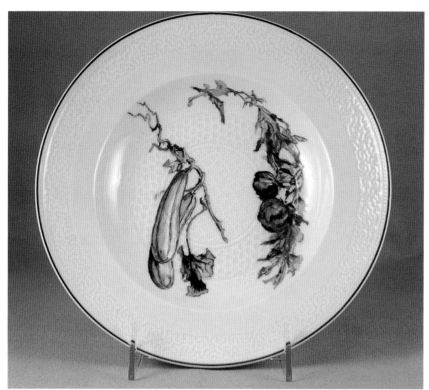

Figure 131. Rimmed soup bowl, 9½", with vegetable pattern on the Vermicelli blank, Schleiger no. 639. Haviland & Company, 1876-1889. Marks F and g. $75-125.

Figure 132. Rectangle casserole with clam finials, napkin fold shape, in multifloral pattern. Haviland & Company, 1876-1889. Marks F and g. $150-200.

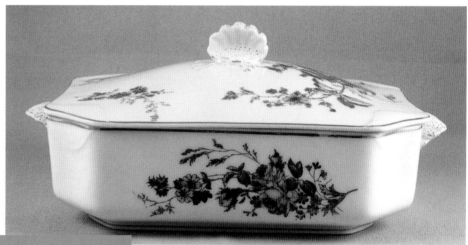

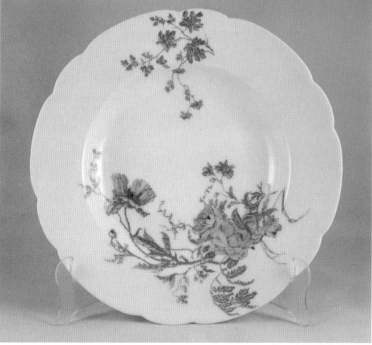

Figure 133. Rim soup, 9½". This multifloral pattern is done in several color schemes as well as on different shapes. Haviland & Company, 1876-1889. Marks F and g. $35-45.

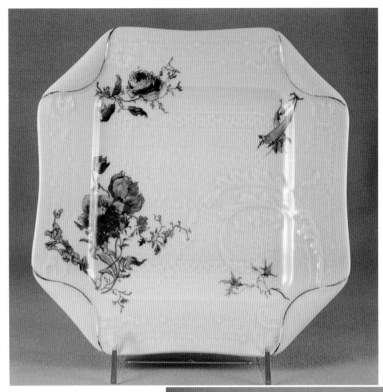

Figure 134. Multifloral pattern napkin fold plate, 8", in Vermicelli design. Haviland and Company, 1876-1889. Marks F and g. $75-125.

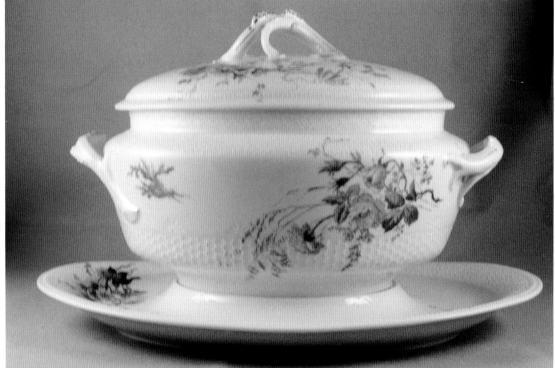

Figure 135. Large soup tureen with stand, in Vermicelli blank on the Wheat shape. Haviland & Company, 1876-1889. Marks F and g. $600-800.

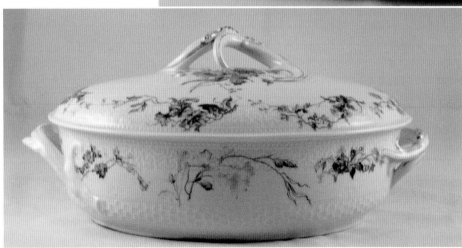

Figure 136. Oval covered vegetable bowl, in Vermicelli blank on the Wheat shape. Haviland & Company, 1876-1889. Marks F and g. $175-225.

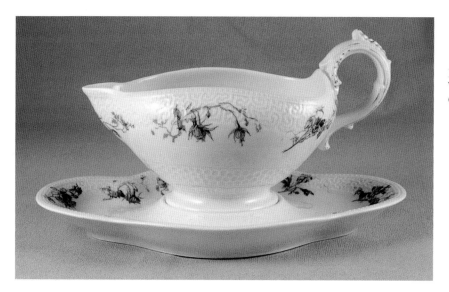

Figure 137. Handled sauce with separate stand, in Vermicelli blank on the Wheat shape. Haviland & Company, 1876-1889. Marks F and g. $175-225.

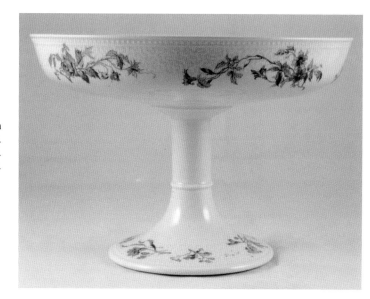

Figure 138. Tall footed comport in Vermicelli blank on the Wheat shape. Haviland & Company, 1876-1889. Marks F and g. $250-350.

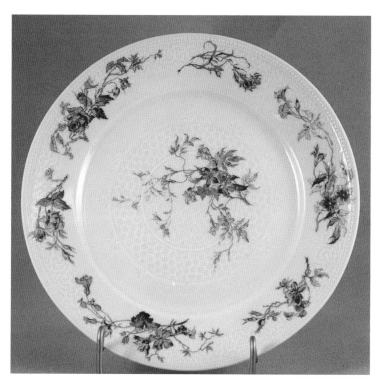

Figure 139. Plate, 8½", on the Vermicelli blank in a variation of Potpourri or Old Pansy. Haviland & Company, 1876-1889. Marks F and g. $50-75.

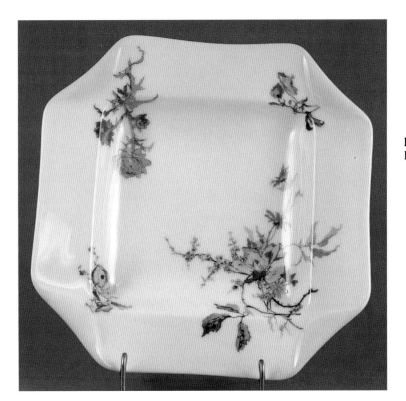

Figure 140. Rimmed soup, 9½", in the napkin fold blank. Haviland & Company, 1876-1889. Mark D and g. $50-75.

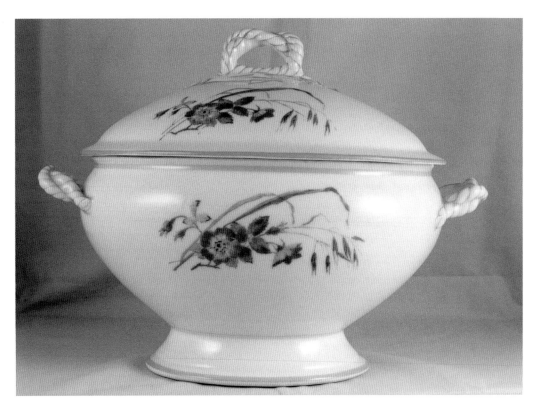

Figure 141. Large soup tureen in early multifloral pattern in the Anchor shape. Haviland & Company, 1876-1889. Marks D and g. $275-375.

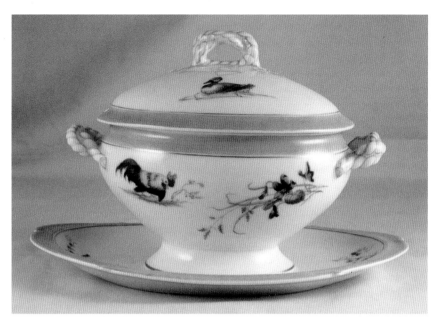

Figure 142. Oval covered sauce with attached underplate, in old multifloral pattern. This pattern also has different barnyard animals on each piece, in the Anchor shape. Haviland & Company, 1876-1889. Marks F and g. $150-225.

Figure 143. Plate, 9½", one of six styles, repeated twice to make up a set of twelve with multiflorals and barnyard animals. Haviland & Company, 1876-1889. Marks F and g. $40-50.

Figure 144. Plate, 9½", from barnyard animal set. Haviland & Company, 1876-1889. Marks F and g. $40-50.

Figure 145. Plate, 9½", from barnyard animal set. Haviland & Company, 1876-1889. Marks F and g. $40-50.

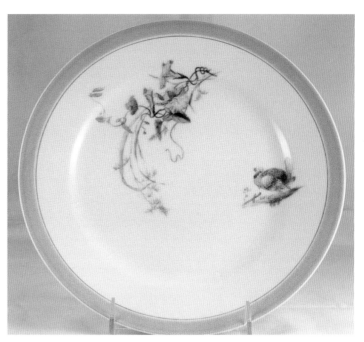

Figure 147. Plate, 9½", from barnyard animal set. Haviland & Company, 1876-1889. Marks F and g. $40-50.

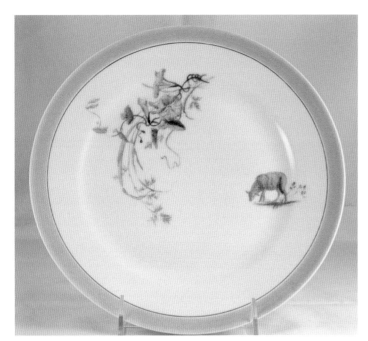

Figure 146. Plate, 9½", from barnyard animal set. Haviland & Company, 1876-1889. Marks F and g. $40-50.

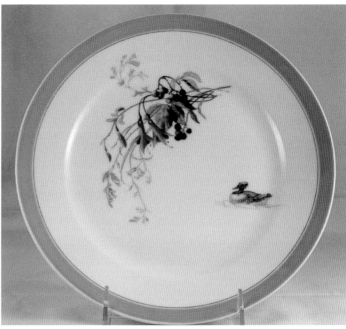

Figure 148. Plate, 9½", from barnyard animal set. Haviland & Company, 1876-1889. Marks F and g. $40-50.

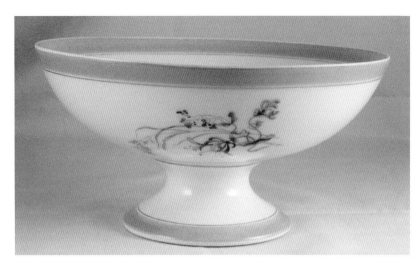

Figure 149. Footed bowl, 9½", with barnyard animal set. Haviland & Company, 1876-1889. Marks F and g. $175-225.

Figure 150. Oval soup tureen with vegetables on a pink and gold paisley border, Cable shape. Haviland & Company, 1876-1889. Marks D and g. $325-425.

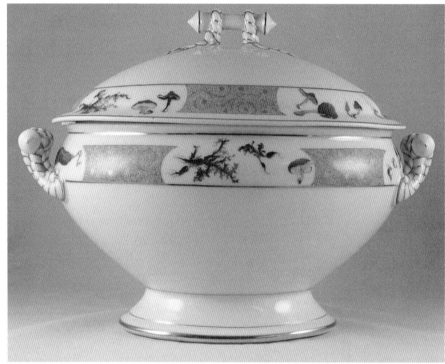

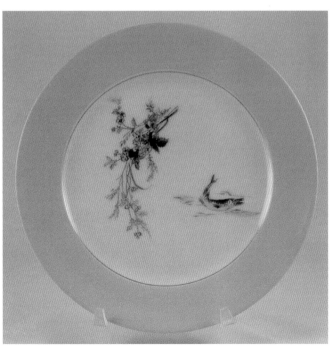

Figure 151. Fish plate, 8", with multifloral pattern and different fish on each plate, one of a set. Haviland & Company, 1876-1889. Marks D and g in black. Each $75-95.

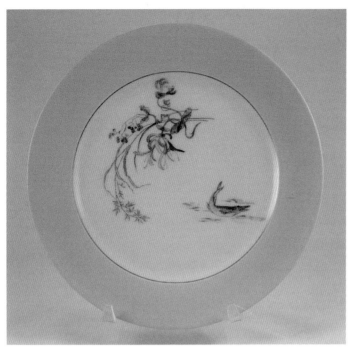

Figure 152. Fish plate, 8", with multifloral pattern and different fish on each plate, one of a set. Haviland & Company, 1876-1889. Marks D and g in black. Each $75-95.

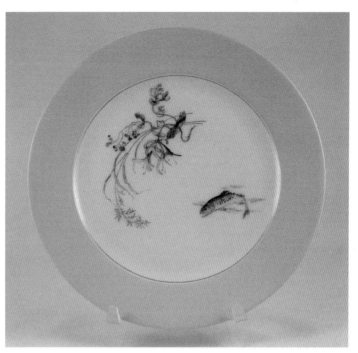

Figure 154. Fish plate, 8", with multifloral pattern and different fish on each plate, one of a set. Haviland & Company, 1876-1889. Marks D and g in black. Each $75-95.

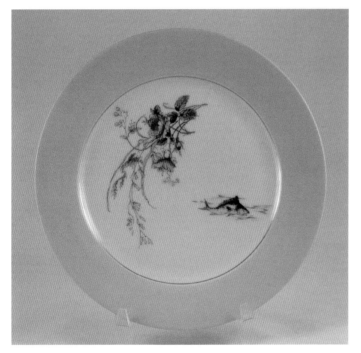

Figure 153. Fish plate, 8", with multifloral pattern and different fish on each plate, one of a set. Haviland & Company, 1876-1889. Marks D and g in black. Each $75-95.

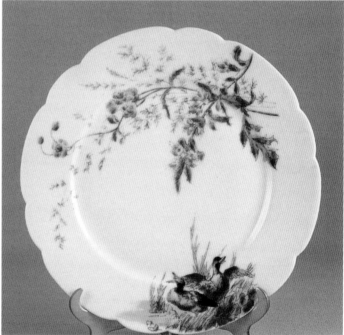

Figure 155. Game plate, 8½", with multifloral pattern and different game birds placed at the bottom of each plate. Haviland & Company, 1876-1889. Marks D and g. $75-95.

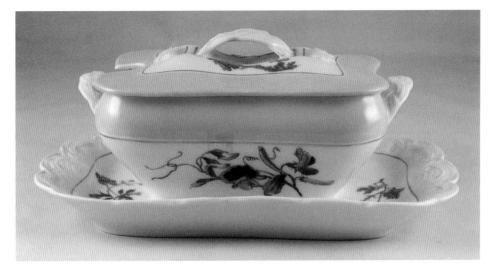

Figure 156. Covered sauce with basket-weave handles. Haviland & Company, 1876-1889. Marks c and g in black. $175-225.

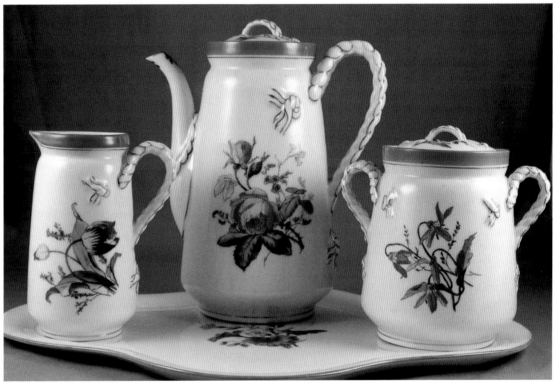

Figure 157. Coffeepot, creamer and sugar on tray in Anchor shape. This multifloral pattern has different flowers on back of each piece. Many of early sets have similar treatment. Haviland & Company, 1876-1889. Marks are impressed English registry plus F and g. Set with tray $500-750.

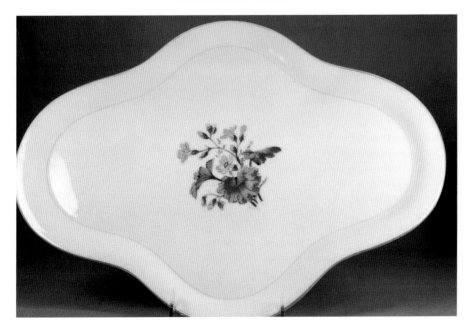

Figure 158. Tray for coffee service in Fig. 157, 12" x 15". Haviland & Company, 1876-1889. Marks F and g. $200-300.

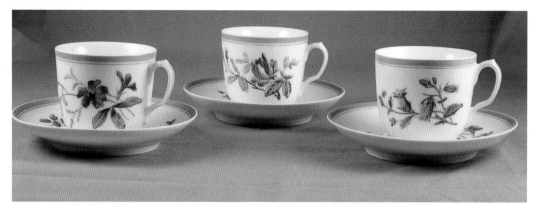

Figure 159. Three teacups and saucers in multifloral patterns in heavy china. Haviland & Company, 1876-1889. Marks C and g. Each $40-50.

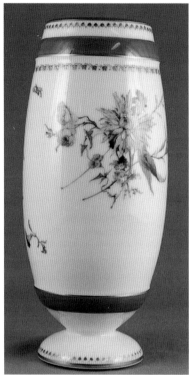

Figure 160. Porcelain vase, 9". Piece not made by Haviland & Company, only decorated by Haviland & Company, 1879-1889. Mark g. $300-500.

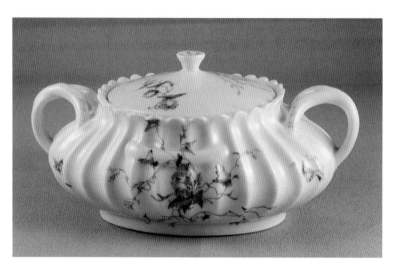

Figure 162. Sugar bowl in Torse shape, 3½" x 6½". Haviland & Company, 1876-1889. Marks are impressed English registry mark plus F and g. $65-75.

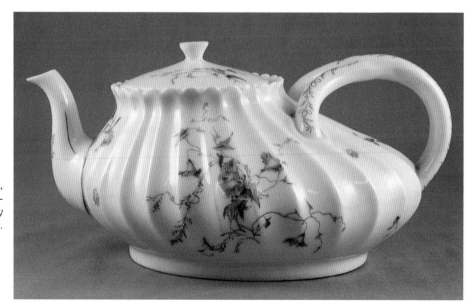

Figure 161. Teapot in Torse shape, multifloral. Haviland & Company, 1876-1889. Marks are impressed English registry mark plus F and g. $250-350.

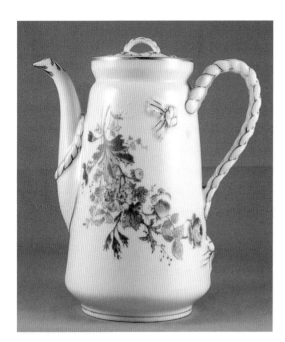

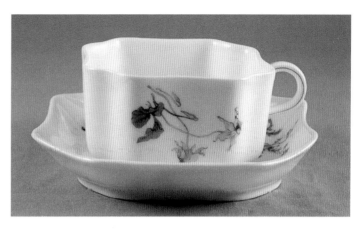

Figure 163. Coffeepot in Anchor shape, 9". Haviland & Company, 1876-1889. Marks are impressed English registry mark plus D and g. $225-275.

Figure 164. Cup and saucer in napkin fold blank, unidentified pattern. Haviland & Company, 1881-1896. Mark H and c for Dillon/Wheat & Hancher Co. $50-75.

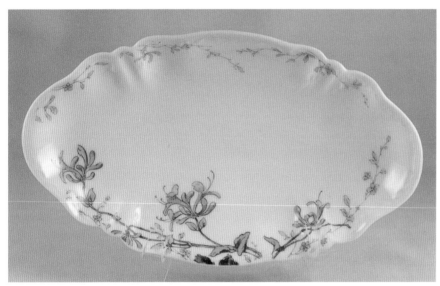

Figure 165. Relish dish, 9½" x 5½", in Lobe shape, unidentified pattern. Haviland & Company, 1876-1889. Marks F and c. $45-65.

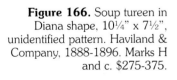

Figure 166. Soup tureen in Diana shape, 10¼" x 7½", unidentified pattern. Haviland & Company, 1888-1896. Marks H and c. $275-375.

Figure 167. Coffee cup and saucer, cup 3½" wide x 2½" high, on smooth blank and no ring in saucer, on what is called Old Pink and Gray, or Old Pansy multifloral. Haviland & Company, 1876-1889. Marks D and g. $45-55.

Figure 168. Square open vegetable in pattern Schleiger no. 486G on Vermicelli blank no. 639. Haviland & Company, 1876-1889. Marks F and g. $75-100.

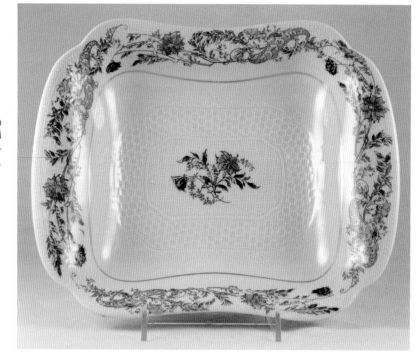

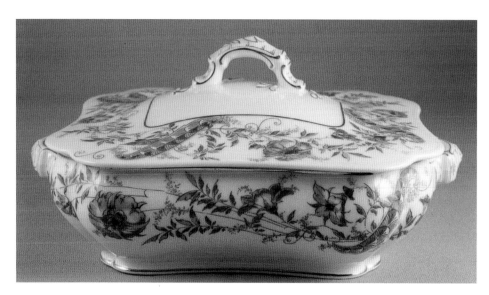

Figure 169. Rectangle covered vegetable, 7½" x 8½", in a variation of Schleiger no. 486 on Pompadour shape. Haviland & Company, 1888-1896. Marks H & *Vermont Marin, 17 Rue Auber, Paris, H & Co., 12 Avenue de L'Opera.* $150-175.

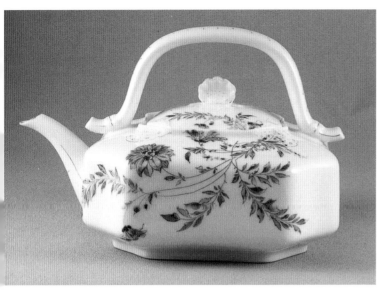

Figure 170. Teapot in another variation of Schleiger no. 486, on napkin fold shape with clam shell finial. Haviland & Company, 1876-1889. Marks F and g. $250-350.

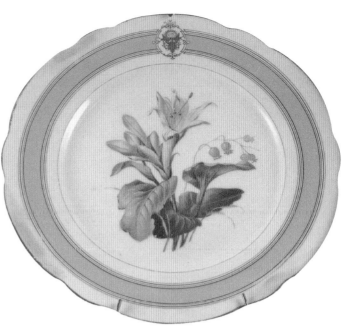

Figure 173. Ulysses S. Grant Presidential plate, 9 3/8", with buff band framed by gold and black lines and overlaid with a version of the Great Seal of the United States in red and gold. Plates and cake stands, but not comports or baskets, are each decorated with a different flower in colors. This was a state dinner service of 587 pieces, purchased in 1870 from J.W. Boteler & Bro., Washington, D.C. Additional pieces were ordered later in the Grant administration. The flowers were done by Lissac, in charge of the decorating department from 1865 to 1885, and one of the finest painters and engravers to be employed by Haviland & Company. This set became known as *The Flower Set*, because all of the many dinner plates painted represent almost every flower native to the United States at the time the set was made, and there were no duplicates in the entire service. Haviland & Company, 1870, none of the plates in the Grant state service have a maker's mark, but all the footed pieces ordered in 1873 are marked in orange-red *FABRIQUÉ PAR HAVILAND & CO./ POUR/ J.W. BOTELER & BROS./ WASHINGTON.* $1000-1500.

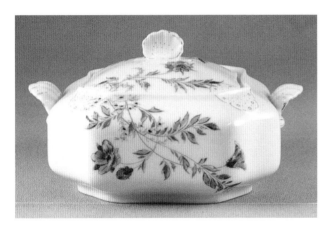

Figure 171. Sugar bowl, same pattern as teapot in Fig. 170, napkin fold with clam finials. Haviland & Company, 1876-1889. Marks F and g. $75-85.

Figure 172. Plate, 9½", multifloral on Torse blank. Haviland & Company, 1887-1889. Marks G and g. $30-35.

Japanese pottery goes back to prehistoric times, but in the early years the Japanese did not trade much in pottery. As time went by, Japan, eager to bring in more revenue, began to look for a way to improve its wares and make porcelain as the Chinese and Koreans had been doing for years. The Imjin War (1592-1598) is nicknamed *The Pottery War* because although no territory changed hands, many potters were taken from Korea to Japan. From the Koreans, the Japanese craftsmen learned the skill of making fine porcelain pieces. When Kaolin was discovered in 1616 near Arita, Japan, this enabled the Korean potters to make glazes similar to those they had produced in their homeland. The Japanese, eager to trade, began to turn out porcelain based on Chinese and Korean models to satisfy European tastes.

In 1853, Commodore Matthew Calbraith Perry was sent to Japan with a letter from President Millard Fillmore seeking to open trade doors between the East and the West. As a result, the Japanese government sent an exhibit to the 1867 World's Fair in Paris. This was the first major display of Japanese art that France had ever seen and this exhibit resulted in a flooding of the Parisian market with Japanese prints and curios. By 1868, there was a sudden surge of Japanese mania, mainly in the area of French decorative arts.

Felix and Marie Bracquemond were close friends with Degas and Manet, among other famous artists. Felix, a well-known artist and engraver in his own right, had been a pupil of Ingres, Delacroix and Guichard, and had exhibited in several group shows in Paris with the other artists of the Impressionist Movement. He is listed in a catalogue of the *Salon de Refusés* in 1872 with his etchings. In 1874, 1879 and 1880, he showed his etchings at the various group shows. Bracquemond even etched a portrait of Manet for the frontispiece of Emile Zola's pamphlet on the artist.

Bracquemond spent a great deal of time at the Café Guerbois talking and sharing with the other artists that gathered there. One of the subjects of wide interest was Oriental art in general. The Parisian artists had studied it at the 1867 World's Fair and were especially interested in the Japanese prints. In 1872, Charles Edward Haviland's father-in-law, Phillipe Burty, was the first to coin the term *Japonisme*. Throughout the 1870s, French decorative arts were inundated by this trend. It was very much evident in the field of ceramics. Many of the artists began collecting Japanese artifacts to use in their paintings as backdrops and accents. This Japanese influence can still been seen today in several of the works by Monet, Manet, and Degas.

The Japanese styles in reality were basic and stark. However, Europe took the Japanese flow and style, mixed it with the current cluttered Western look, and created a look called *Japonisme*. Asymmetry and transformation of nature into a decorative system was applicable to the Western style. Bamboo, cranes, water lilies, wisteria and carp were the standard repertories of Japanese motifs.

As far back as 1856, Felix Bracquemond had discovered a small volume (which had been used for packing china!) called *The Manga* by one of the best-known Japanese color-print artists, Fugaku Hokusai. In this book, he found the most marvelous block print drawings he had ever seen. He was so impressed by Hokusai's drawings that he carried the book around with him for quite a while, showing it to everyone. This book was one of a set of fifteen, and Bracquemond began collecting the albums of Hokusai and his followers to use as designs for his etchings. These Japanese prints were impressive for their graphic style, subtle use of line, decorative qualities, and above all, the way in which their principal subjects were often placed off center.

In 1870, Bracquemond served for six months as a director at the Sèvres Manufactory. He was then hired by Rosseau, owner of a long-established, fashionable store in Paris that sold fine china and glassware. Rosseau was also fascinated with the Japanese designs and hired several artists to design dinnerware for him. While in his employ, Bracquemond designed a dinnerware set now known as *The Rosseau Service*. The designs were taken almost precisely from the Hokusai book—animals, birds, fish and flowers.

Charles Edward Haviland had also been taken with the Japanese designs and was impressed with the Rosseau dinner service that Felix Bracquemond had designed. He hired him in 1872 to head up his studio in Paris. Charles Edward, a great collector, bought many of the prints by Japanese artists so that his artists could copy the wonderful designs. Many of these were copied exactly as the originals had been painted.

Felix Bracquemond introduced major improvements in lithographic techniques, and the generalization of print or transfer allowed for a major change in design style. No more bands and lines, no more little designs of the Limoges *Moss Rose* type. Now patterns of birds, ducks, fish, and flowers—all in a Japanese motif—swirled upon the porcelain. The success of this style was overwhelming. Haviland & Company took part in major exhibits and won several gold medals, along with a wealth of enthusiastic comments from specialized critics.

Bracquemond produced several dinner sets with the Japanese design. One of the most famous was his so-called *Service Parisian*, which featured only Japanese imagery; it was printed by the chromolithographic process and then retouched by hand with enamels. In the mid-1870s, Bracquemond created another set of designs for Haviland called *The Bestiary*—thirty designs showing typical flowers and fauna from a *Japoniste*.

The decorative arts prevailed with a dominance of the Oriental mode, still heavy with Japanese imitation through the 1880s, and finally waned by the 1890s. The invasion of Japanese goods into France bought much criticism that may have been warranted. However, it cannot be denied that Japan had a tremendous influence on nineteenth and twentieth-century decorative arts.

Figure 174. Ice cream platter, 14". Japanese painting of the sun setting on snow. Haviland & Company, shown in the 1879 catalog. Mark g. $800-1000.

Figure 175. Plate with Japanese etching, 7½. Haviland & Company, 1876-1889. Marks C and g. $50-60.

Figure 176. Rimmed soup bowl, decorated with Japanese etching, 9½". These drawings are very similar to the ones done by Japanese artist, Hokusai. Haviland & Company, 1876-1889. Mark F. $60-75.

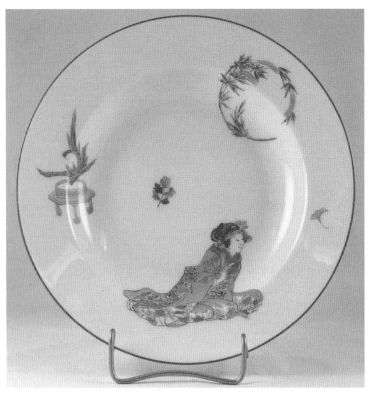

Figure 177. Rimmed soup bowl, decorated with Japanese etching, 9½". Haviland & Company, 1876-1889. Mark F. $60-75.

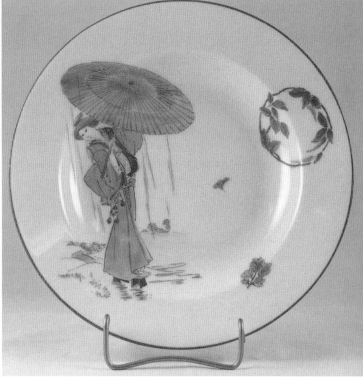

Figure 179. Rimmed soup bowl, decorated with Japanese etching, 9½". Haviland & Company, 1876-1889. Mark F. $60-75.

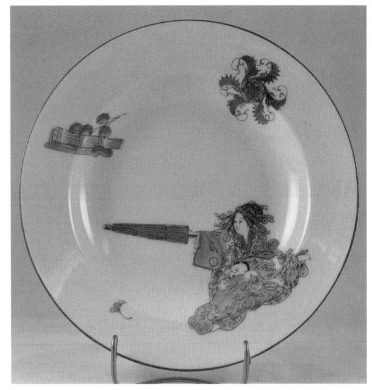

Figure 178. Rimmed soup bowl, decorated with Japanese etching, 9½". Haviland & Company, 1876-1889. Mark F. $60-75.

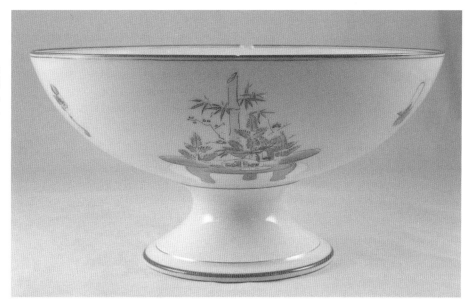

Figure 180. Footed punch bowl with Japanese design, 10" diameter. Haviland & Company, 1876-1889. Marks C and g. $500-700.

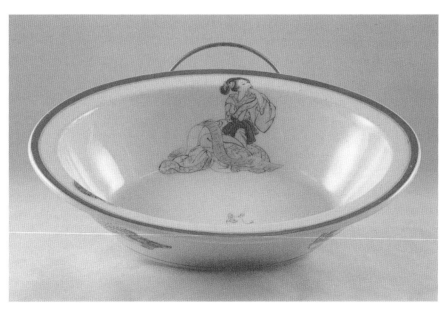

Figure 181. Oval open vegetable decorated with Japanese etching, 9". Haviland & Company, 1876-1889. Marks F and g. $100-125.

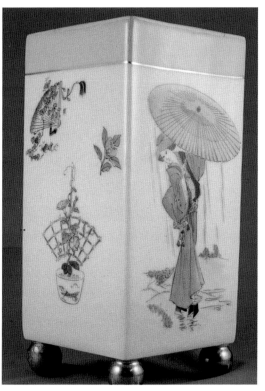

Figure 182. Tall rectangle vase with different Japanese etchings on all four sides, 8". Haviland & Company, 1879-1889, decorator Mark g only, which means that the porcelain vase was not made by Haviland & Company. $500-700.

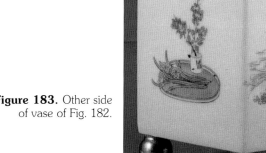

Figure 183. Other side of vase of Fig. 182.

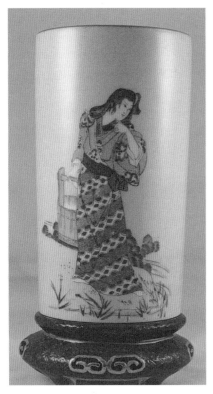

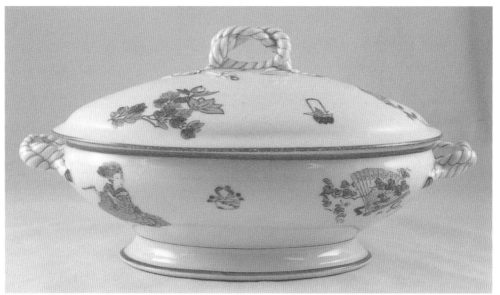

Figure 185. Oval covered vegetable in Japanese design, Anchor shape. Haviland & Company, 1876-1889, impressed English registry mark plus Marks F and d. $150-225.

Figure 184. Porcelain vase in Japanese style, 10". Decorated by Haviland & Company, 1879-1889. Mark g only. $600-800.

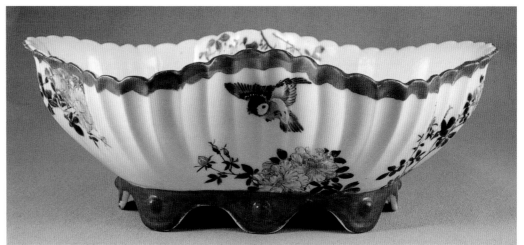

Figure 186. Footed jardiniere in the Torse shape, 11½". An American businessman opened a shop named ICHIBAN in Japan, imported white ware from Haviland & Company, decorated it and then sold it to Japan and other countries. Made by Haviland & Company, 1876-1889, impressed English Registry, the word ICHIBAN and Mark F. $300-500.

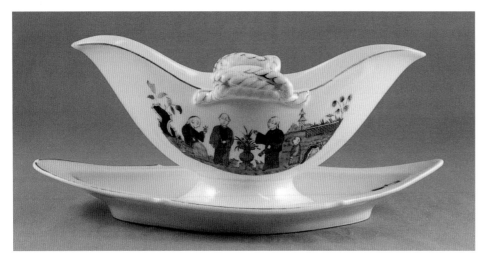

Figure 187. Two-piece sauce dish in the Anchor shape. This may have been decorated by a Japanese company. Porcelain made by Haviland & Company, 1876-1879. Mark C. $175-225.

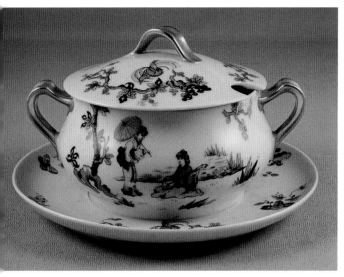

Figure 188. Covered sauce in an Oriental design on smooth blank with attached underplate. Haviland & Company, decorated in France by Frank Haviland for H.G. Stephenson, Barton Arcade, Manchester, Paris-Limoges, 1914-1925. Marks I and A2. $125-150.

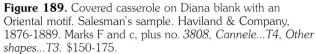

Figure 189. Covered casserole on Diana blank with an Oriental motif. Salesman's sample. Haviland & Company, 1876-1889. Marks F and c, plus no. *3808, Cannele...T4, Other shapes...T3.* $150-175.

Figure 191. Coupe plate, 8½". Haviland & Company, 1894-1931. Marks I & c, plus words *Hand painted* and signed on the front by Morezees. $75-95.

Figure 190. Round covered casserole on smooth blank, unclassified pattern. Haviland & Company, 1894-1931. Marks I & c. $95-125.

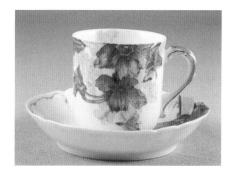

Figure 192. After-dinner coffee cup and saucer in unidentified pattern on Schleiger blank no. 411. Haviland & Company, 1876-1878. Marks F and c. $40-50.

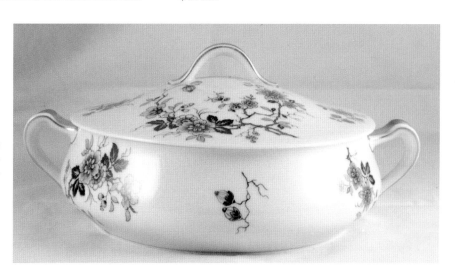

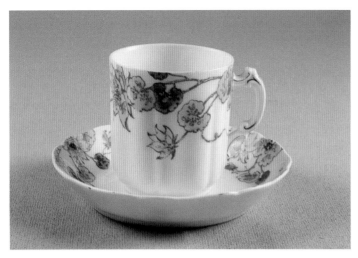

Figure 193. After-dinner cup and saucer, also called a sipper as it has no ring in the saucer. Unidentified pattern on Schleiger blank no. 14. Haviland & Company, 1876-1889. Marks D and g. $40-50.

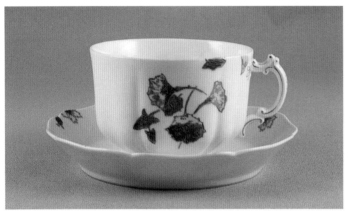

Figure 194. Breakfast coffee cup and saucer, also a sipper. Unidentified pattern on Schleiger blank no. 14. Haviland & Company, dated 1886 on back, plus Marks F and g. $50-60.

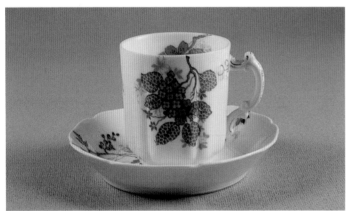

Figure 195. After-dinner coffee cup and saucer, also a sipper. Unidentified pattern on Schleiger blank no. 14. Haviland & Company, 1876-1889. Marks D and g. $40-50.

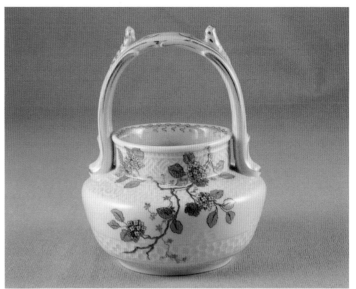

Figure 196. Small handled basket, unidentified pattern on Schleiger blank no. 639 also known as the Vermicelli blank, 3". Haviland & Company, 1876-1889. Marks F and g. Price $400-500.

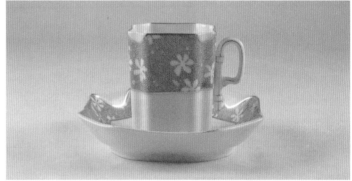

Figure 197. After-dinner coffee cup and saucer. Unidentified pattern in Schleiger blank no. 1118, commonly known as the napkin fold shape. Haviland & Company, 1876-1889. Marks F & g. $50-60.

Figure 198. Plate in napkin fold blank, 8", factory decorated with sea turtle. A salesman's sample. Haviland & Company, 1876-1889. Marks D and g plus *4717 Carre RS + Center.* $175-225.

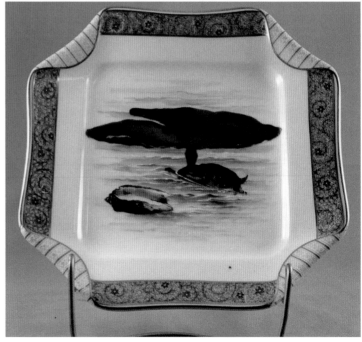

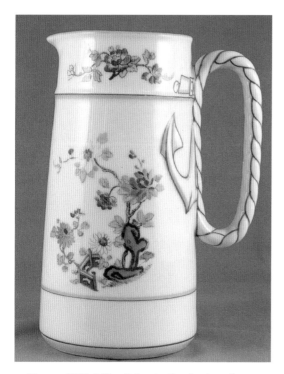

Figure 199. Milk pitcher in the Anchor shape, 8", Japanese design. Haviland & Company, 1876. Marks impressed English Registry plus F and a, for Rice & Burnett, Importers, England. $175-200.

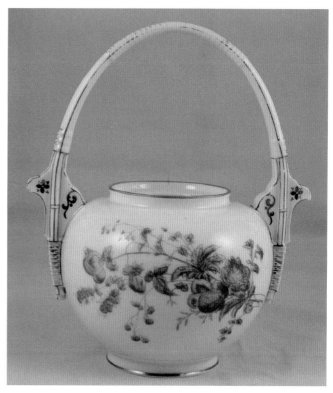

Figure 201. Double spout teapot, 8½" to top of handle. There is a spout on each side of the handle. Lid missing. Pattern is more multifloral, but shape of pot is definitely Oriental. Charles Field Haviland & Company, 1882. Mark C-3. With lid, $400-600.

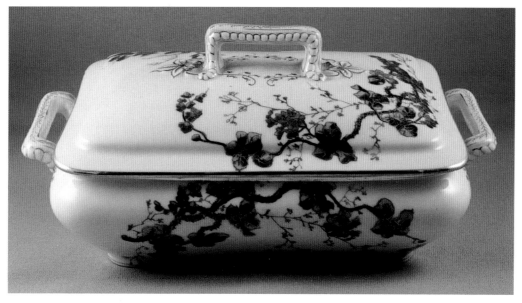

Figure 200. Rectangle covered vegetable in Japanese motif. Charles Field Haviland & Company, 1882. Mark C-3 with initials RB plus impressed Depose mark. $150-200.

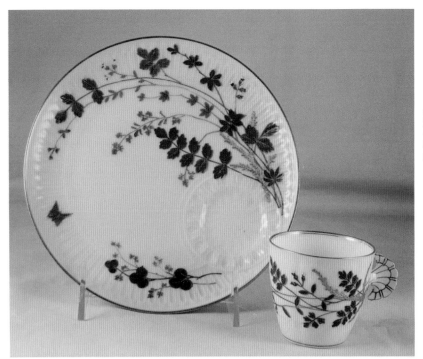

Figure 202. Tea and toast tray, tray 7". Elaborate embossed blank with flower-shaped handle, unidentified pattern. Charles Field Haviland & Company, 1882. Mark C-3. $150-175.

Figure 203. Tea and toast tray, tray 7". Elaborate embossed blank with flower shaped handle, unidentified pattern. Charles Field Haviland & Company, 1882. Mark C-3. $150-175.

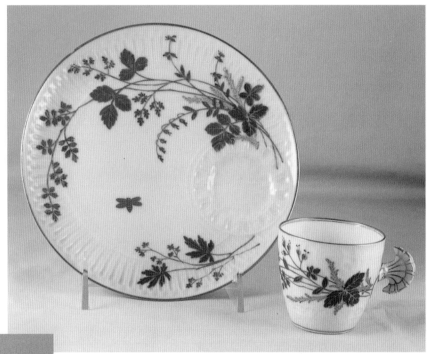

Figure 204. Ice cream plate, Oriental style decoration, 7". Haviland & Company, 1876-1889. Marks F and g. $75-95.

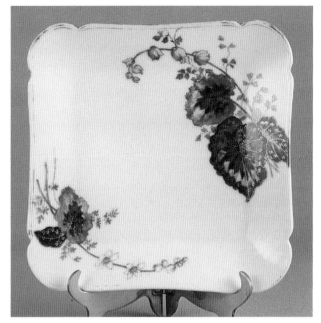

Figure 205. Square plate, 6 5/8", in unidentified pattern. Charles Field Haviland & Company, 1882. Mark C-3. $30-40.

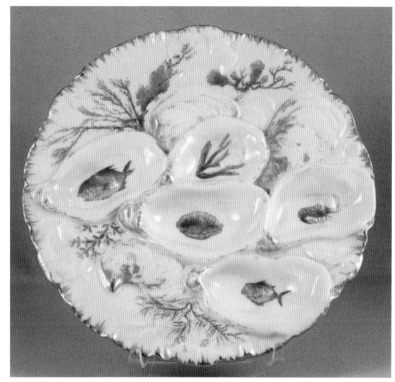

Figure 207. Marine oyster plate, 9", with a celadon glaze. Haviland & Company, 1876-1889. Marks F and g. $225-325.

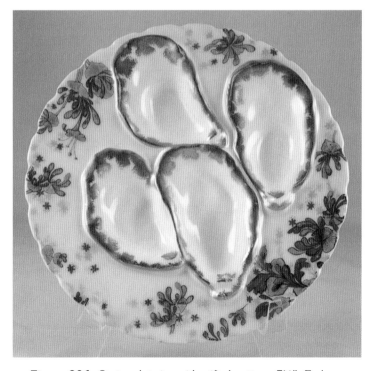

Figure 206. Oyster plate in unidentified pattern, 7¼". Early oyster wells, before 1890s, seem to have an oyster shape. Later oyster wells are mostly round, in the same shape or blank as the rest of the dinnerware pattern they accompany. In the early years, different patterns and styles were bought for each course. The trend in later years was for everything to match. Haviland & Company, 1887-1889. Marks G and g. $200-250.

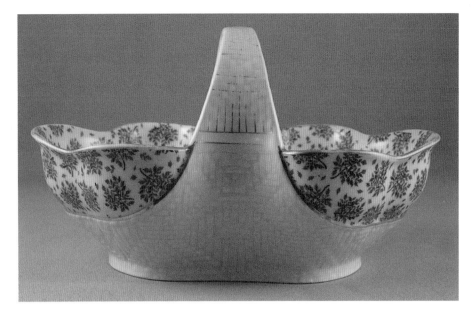

Figure 208. Handled basket in the Osier or basket weave blank, 11½" x 7". Shape and pattern is very Oriental in motif. Haviland & Company, 1876-1889. Marks D and g, plus impressed English registry mark. $450-475.

Figure 209. Teapot in Osier blank, 5". Japanese shape with botanical flowers on top. Haviland & Company, 1876-1889. Marks D and g. $225-325.

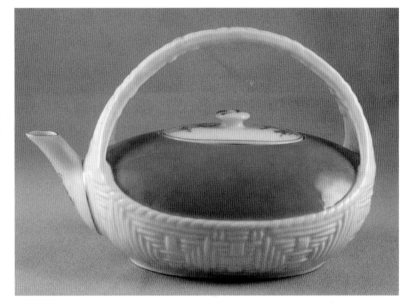

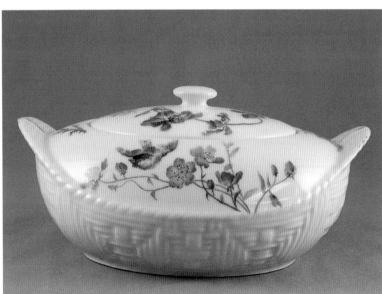

Figure 210. Sugar bowl in Osier blank in unidentified pattern. Haviland & Company, 1876-1883. Marks are impressed English Registry with F and d. $60-75.

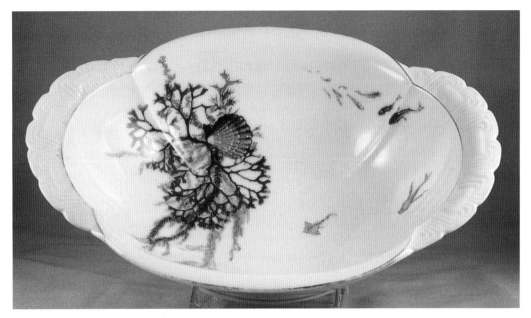

Figure 211. Oval lobster salad bowl, 9½" x 12" with marine life. Haviland & Company, 1876-1878. Marks D and g. $250-350.

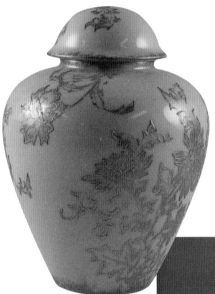

Figure 212. Tea caddy embossed with gold, very similar to Japanese lacquered boxes. Charles Field Haviland & Company, 1882. Mark C-3. $400-600.

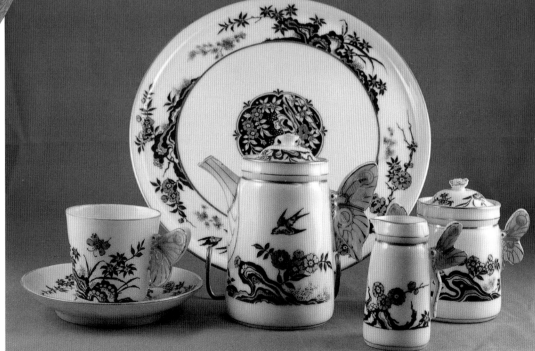

Figure 213. Butterfly-handled solitaire coffee set in the Japanese shrub pattern, 9" tray, 4" pot. Haviland & Company, 1877-1889. Mark E and g. $1000-1500.

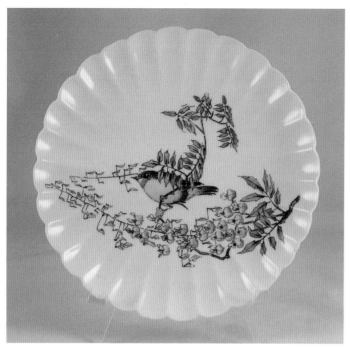

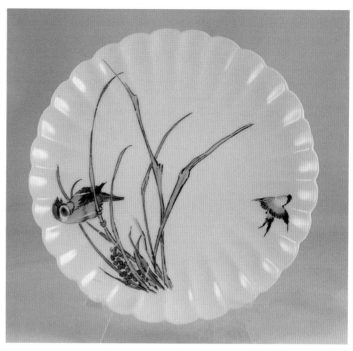

Figure 214. Coupe plate, 7½" on Torse blank, Schleiger no. 413, Oriental design. Haviland & Company, 1876-1889. Marks F and g. $30-45.

Figure 216. Coupe plate, 7½" on Torse blank, Schleiger no. 413, Oriental design. Haviland & Company, 1876-1889. Marks F and g. $30-45.

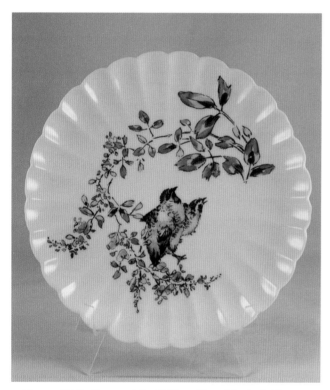

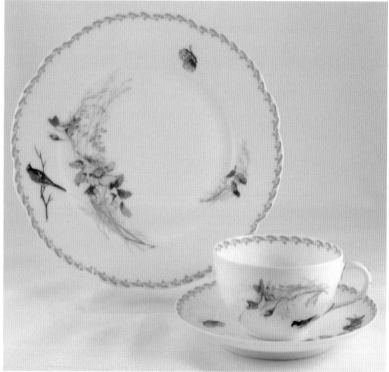

Figure 215. Coupe plate, 7½" on Torse blank, Schleiger no. 413, Oriental design. Haviland & Company, 1876-1889. Marks F and g. $30-45.

Figure 217. Teacup, saucer and 7½" plate in a variation of the Meadow Visitor pattern. Haviland & Company, 1876-1889. Marks F and g in blue. Teacup and saucer $50-70. Plate $45-50.

Figure 218. Round tray with unglazed bottom, 9", Meadow Visitor pattern, smooth blank. Haviland & Company, 1879-1889. Mark g. $150-200.

Figure 219. Hors-d'oeuvre dish, in Anchor shape with handles, Meadow Visitor pattern, 8" x 2". Haviland & Company, 1876-1889. Marks D and g. $175-225.

Figure 220. Oval relish dish, basket-weave shape in Meadow Visitor pattern. Haviland & Company, 1876-1889. Marks F and g. $65-75.

Figure 221. Square covered casserole with basket weave handles in Meadow Visitor pattern. Haviland & Company, 1876-1889. Marks F and g. $175-225.

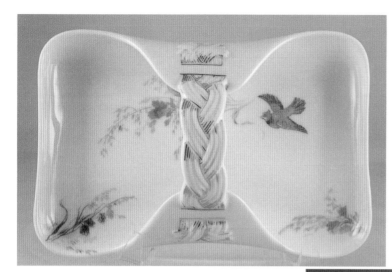

Figure 222. Basket weave handled basket, probably for bonbons, in a variation of a Meadow Visitor pattern, 7½" x 4¾". Haviland & Company, 1876-1889. Marks F and g. $125-150.

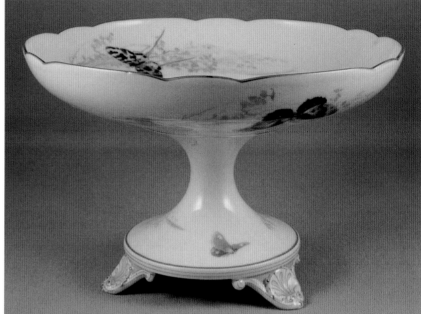

Figure 223. Tall footed comport in Meadow Visitor pattern. Haviland & Company, prior to 1876. Mark a. $250-400.

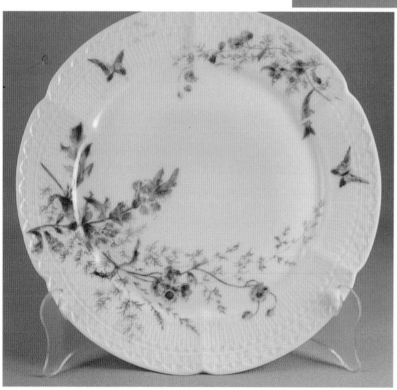

Figure 224. Plate in unidentified shape and pattern, 8½". Charles Field Haviland & Company, 1882. Marks C-3 and C-8. $25-30.

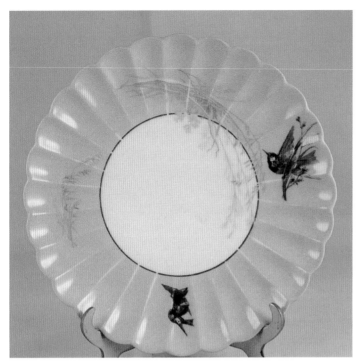

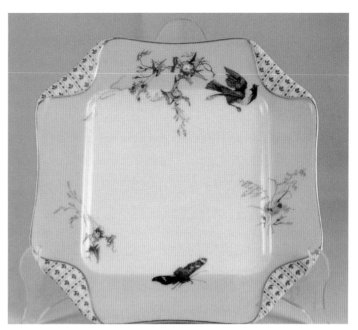

Figure 227. Napkin fold plate with Meadow Visitor pattern, 7". Haviland & Company, 1876-1889. Marks F and g. $50-75.

Figure 225. Plate in Meadow Visitor variation on Torse blank, 7½". Haviland & Company, 1876-1889. Marks D and g. $50-60.

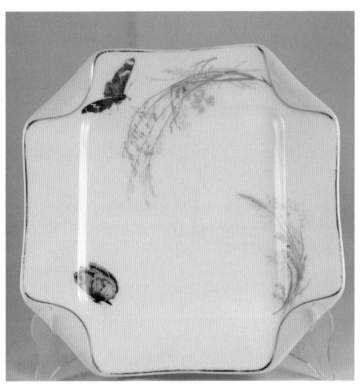

Figure 226. Napkin fold plate with Meadow Visitor pattern, 8½". Haviland & Company, 1876-1889. Marks F and g. $75-100.

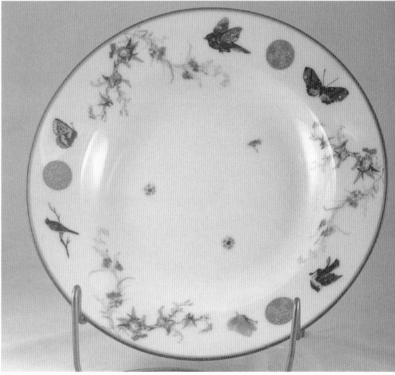

Figure 228. Rimmed soup plate, 9½", on smooth blank in a variation of Meadow Visitor pattern, designed by Felix Bracquemond. Haviland & Company, 1876-1883. Marks F and d. $50-75.

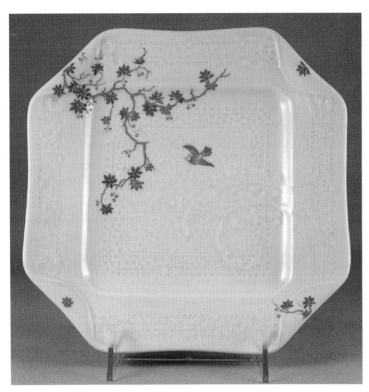

Figure 229. Napkin fold plate with a very Oriental version of Meadow Visitor on the Vermicelli blank, 8". Haviland & Company, 1876-1889. Marks F and g. $60-75.

Impressionism in Clay and Porcelain

At the same time that the Japanese influence was taking Paris by storm, artists were striving for something new and bold for their canvases. Light and color were also playing an important role in the decorative arts. Gone were the stiff portraits and landscapes of the old school. In the spring of 1874, a group of young painters defied the official Salon in Paris and organized an exhibition of their own. This was a great break in established customs and the paintings that were shown were even more revolutionary. This group included Monet, Renoir, Pissarro, Sisley, Degas, Cézanne, and Berthe Morisot. Art critics and visitors alike were shocked at the use of color and design so different from the traditional art they had known. They accused the artists of making fun of them. It was many years before this little group was able to convince the public of their sincerity and of their talent. This group was given the designation of *Impressionists*, coined by a satirical journalist.

Charles Edward Haviland was enthralled with this movement. He spent hours in the company of these artists, and being caught up in their love of nature and their bold style, wanted to try to create this same beauty in pottery. He already had Felix Bracquemond directing his Auteuil studios and had worked with him in designing a type of pottery that would be painted with a combination of *Japonisme* and Impressionist style.

In 1871, Felix Bracquemond had become acquainted with Ernest Chaplet. Chaplet had worked at the Sèvres Manufactory from age 13, and was knowledgeable in pottery making. He had discovered that by using a paste mixed with colored oxides, thinned to the consistency of oil painting, he could create an effect on the pottery called *barbotine*. This made it possible for artists to paint on the pottery as if they were painting on canvas. However, it was a bit more complex than painting in the traditional methods. Only certain colors could be used and mixed in special ways as the colors would change in the firing of the pottery.

Charles Edward Haviland hired Chaplet to work with Bracquemond at the studio in Paris. Along with twenty exceptional artists, they set about making some of the most beautiful and interesting pottery that was ever made. Bracquemond produced brick clay pots that were painted with Chaplet's barbotine technique, then fired with his superior glaze. Some works were given further dimension with the sculptures of flowers, birds, and cherubs applied. This terra cotta pottery was a symphony of nature—flowers, landscapes, cherubs, and portraits painted in deep, moody colors floated beneath a watery blanket of rich, translucent glaze. Painted in the Impressionist broken-brush technique that expressed light and shadow so well, the simple pieces possessed a depth and impact far greater than one would ever expect of a painted pot.

This pottery was produced from 1876 until 1882. Several of the famous artists and sculptors working at the studio at that time were: Marie Bracquemond, Midoux, Renard, Lafond, Couturier, Lambert, Habert-Dys, Edouard Dammouse, Edouard Lindeneher, Girard, Bocquet, Aubé, Delaplanche and others. There was much admiration for this type of pottery at the Philadelphia Exposition of 1876 and at the Paris Exposition of 1878. The Haviland vases were described as coarse but artistic and decorated in quaint and original styles. However, they were too modern for the unprepared customer, and sales were not very good. The Art Nouveau movement was just becoming apparent and Haviland decided to make pieces decorated with figures of nude women. There was not a large market for these vases, as the Victorian woman did not want such pieces adorning her mantle.

By 1882, Charles Edward decided that the pottery was taking up too much time and not making enough money so he sold the pottery workshop to Ernest Chaplet. Chaplet moved the studio to Rue Blomet in the Vaugirard section of Paris. Originally a stoneware maker by profession, he turned to producing much envied *sang-de-boeuf* (ox-blood) glaze of Chinese stoneware—deep red in color. He never divulged the secret of this process. Chaplet's pupil and collaborator was Albert Dammouse, trained as a sculptor before devoting himself to ceramics. Dammouse worked with Chaplet but also developed his own distinctive translucent paste. Paul Gauguin, a friend of Chaplet, came into the studio and designed several pieces. Chaplet was successful at the Union Centrale Exhibition of 1884. In 1887, he sold the Haviland Pottery division, moving to Choisy-de-Roc to continue his research. The Haviland workshop then passed from Chaplet to Auguste Delaherche.

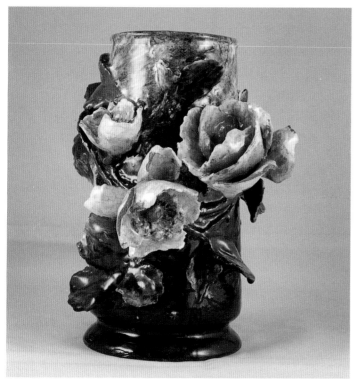

Figure 230. Terra cotta vase with flowers in relief, 8" tall, possibly done by Édouard Lindeneher. Haviland & Company, 1875-1882. Mark V. $1800-2500.

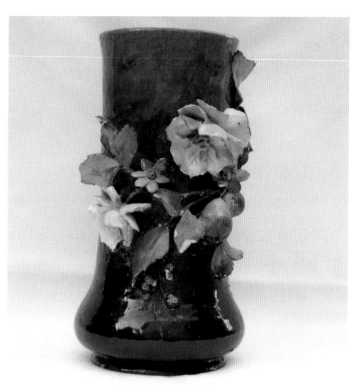

Figure 232. Terra cotta vase with flowers and fruit in relief, 12" tall. Haviland & Company, 1875-1882. Mark V plus the numbers 20 and 3 impressed. $2000-2800.

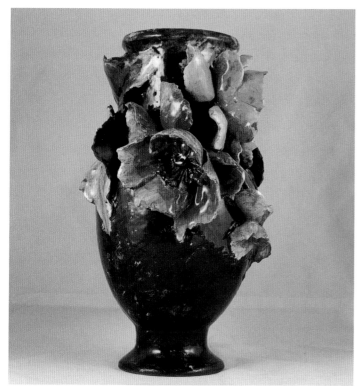

Figure 231. Terra cotta vase, 12" tall. Haviland & Company, 1875-1882. Mark V. $2000-2800.

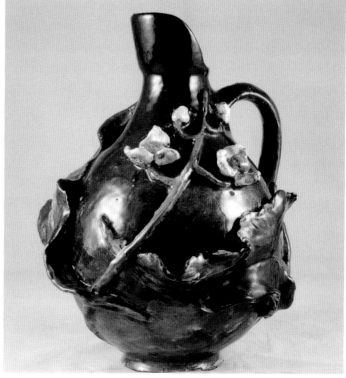

Figure 233. Terra cotta jug, 7". Haviland & Company, 1875-1882. Mark V. $1200-1500.

Figure 234. Terra cotta wall-hanging jardiniere. It is three-sided with holes on two sides to hang in a corner, 8" high. This piece is signed *The Cupids* by factory artist La Fond. Haviland & Company, 1875-1882. Mark V. $1500-2200.

Figure 236. Footed terra cotta ginger jar with lid, 10½" h. x 9" w. Haviland & Company, 1875-1882. Mark W and signed by factory artist Jewel Habert. $1800-2200.

Figure 235. Terra cotta vase, 10". Haviland & Company, 1875-1882. Mark W and signed by factory artist Martinus on the front. $2500-3000.

Figure 237. Pair of terra cotta vases, 7". Haviland & Company, 1875-1882. Mark V. Pair $2500-$3500.

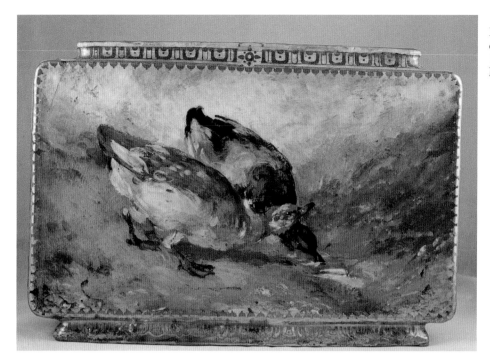

Figure 238. Terra cotta jardiniere with double opening at top, 9" high, 6" wide and 13" long. Haviland & Company, 1875-1882. Mark W. $2200-2500.

Figure 239. Terra cotta vase with three openings in top, 8" wide x 6" high. The painting on the vase is a very good example of the Impressionist Movement of the time. Haviland & Company, 1875-1882. Mark W. $1800-2500.

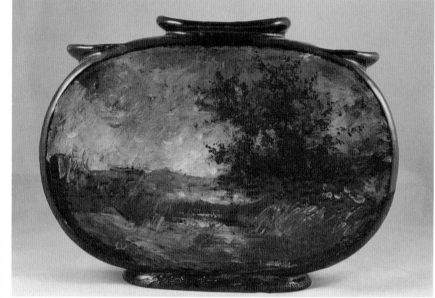

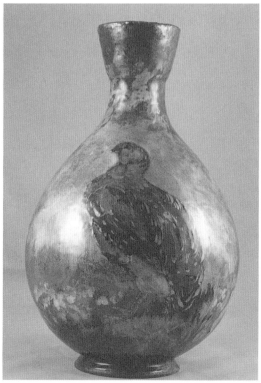

Figure 240. Terra cotta vase, 9" tall. Haviland & Company, 1875-1882. Mark V. $1500-2200.

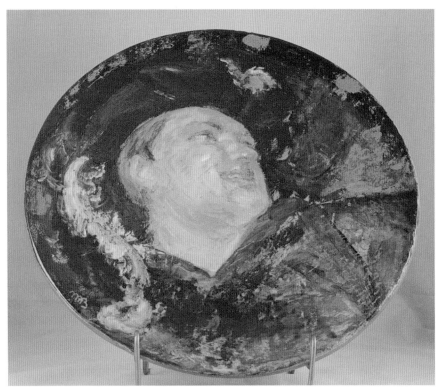

Figure 241. Terra cotta round charger, 13½" diameter. Haviland & Company, 1875-1882. Mark W and signed Marie Bracquemond. $1500-2500.

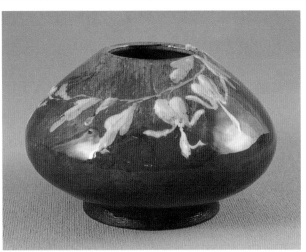

Figure 242. Terra cotta vase, 3". Haviland & Company, 1875-1882. Mark V. $500-600.

Figure 244. Porcelain vase with applied flowers & birds, 12". Theodore Haviland Company, 1912. Mark N. $1500-2500.

Figure 243. Terra cotta handled basket with cutouts, 7", artist signed by Edouard Girard. Haviland & Company, 1875-1882. Mark W. $1500-2200.

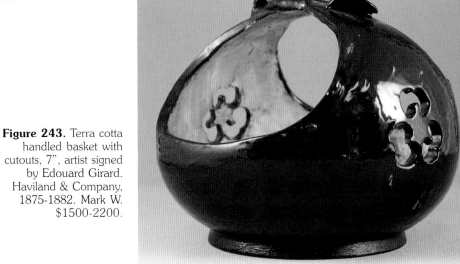

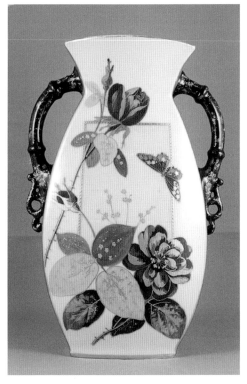

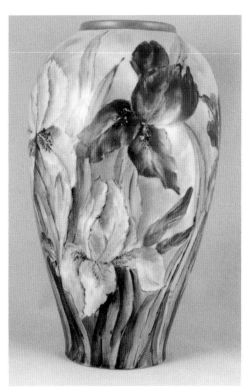

Figure 247. Porcelain vase, 11" with white and purple irises all around the vase. Charles Field Haviland Company, hand painted and signed on front by factory artist D.B.W. plus Marks C-5 and brown mark C-8. $1500-1800.

Figure 245. Porcelain vase, 12". Back view has just one large flower. Theodore Haviland Company, hand painted, 1892. Mark j. $1200-1500.

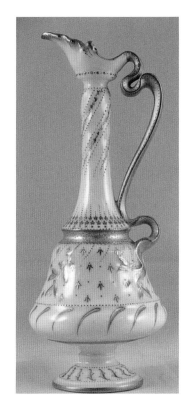

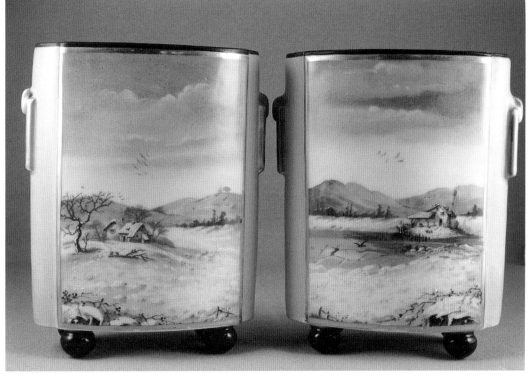

Figure 246. Small decanter, 8". Attributed to Lindeneher. Haviland & Company. Mark H & in gold script *H & Co. 1893.* $1800-2000.

Figure 248. Pair of porcelain vases. Theodore Haviland Company, 1892. Mark j. Pair $1600-2400.

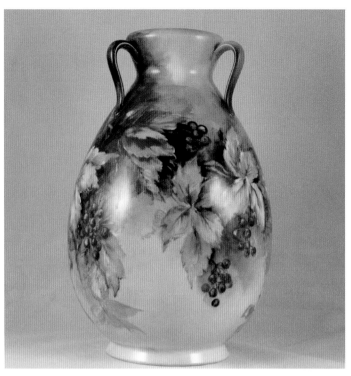

Figure 249. Porcelain hand painted vase, 12". Haviland & Company, 1894-1931. Mark I. $800-1200.

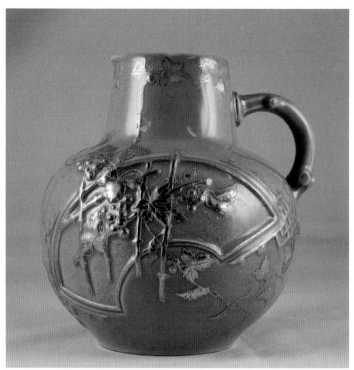

Figure 251. Porcelain handled jug, 6¾". Charles Field Haviland & Company, 1882. Mark C-3. $400-600.

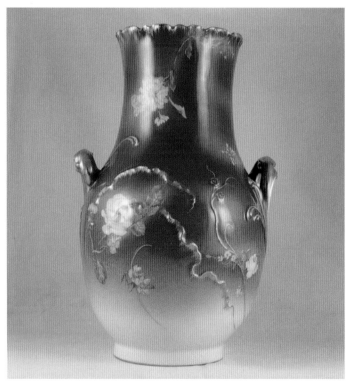

Figure 250. Porcelain vase, 13", in Marseilles blank, Schleiger no. 9. Haviland & Company, 1876-1889. Marks F and c. $1200-1800.

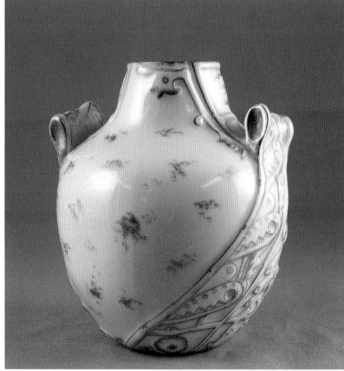

Figure 252. Porcelain vase, 5½". Charles Field Haviland & Company, 1882. Mark C-3. $300-400.

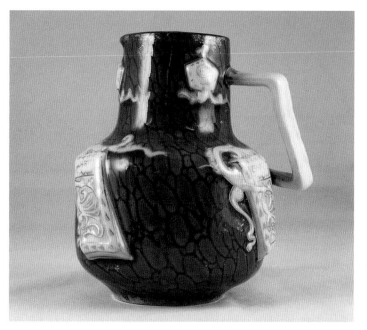

Figure 253. Porcelain jug, 6". Charles Field Haviland & Company, 1882. Mark C-3. $450-600.

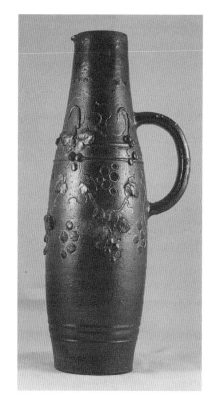

Figure 255. Stoneware jug, 11". Haviland & Company, 1883-1885. Mark X. $1000-1500.

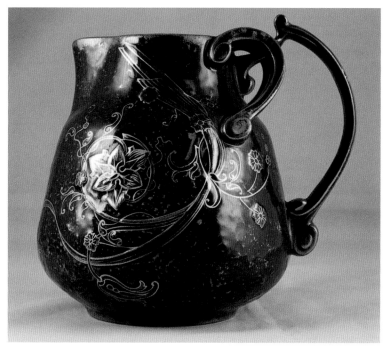

Figure 254. Cobalt and gold pitcher with elaborate handles, 6½". Charles Field Haviland & Company, 1882. Mark C-3. $500-700.

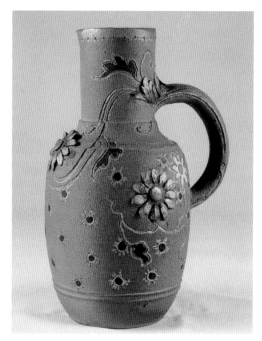

Figure 256. Stoneware jug, 5". Haviland & Company, 1883-1885. Mark X and signed B over C. $600-800.

Decorative and Portrait Art

As with Sèvres Porcelain, the Haviland companies produced artwork as well as dinnerware. From the very beginning of production, David Haviland hired sculptors and artists to create figures, centerpieces and portrait plates. Modelers created the attractively shaped plates with cutout scallops, and the artists painted the marvelous portraits and scenes.

Figure 258. Bisque figurine, 6¼". Haviland & Company, 1910. Mark c plus artist signature Joseph Descomps. $1100-1500.

Figure 257. Bust, 9", *Jenny Lind*, attributed to Magnus, a German artist. In my last book, *Haviland China—Age of Elegance*, pg. 56, Fig. 102, there is a photo of an all white bust. I have since been fortunate to locate a painted *Jenny Lind*. It is professionally painted, but there is no way to tell if it is factory decorated, as there is only a white ware mark. Haviland & Company, 1853. Mark B. $7000-9000.

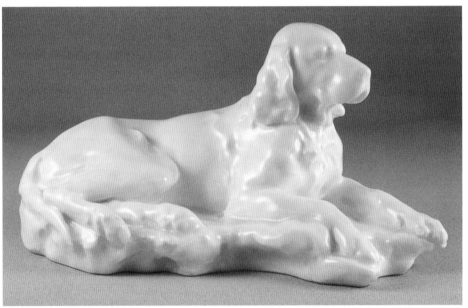

Figure 259. Porcelain dog. Haviland & Company, circa 1925. Mark incised c. $900-1000.

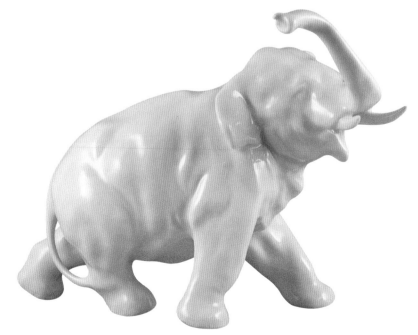

Figure 260. Porcelain elephant. Haviland & Company, circa 1925. Mark incised I on foot. $900-1100.

As with the *Japonisme* and other decorating movements of the day, most of the designs were taken from famous paintings and poets of earlier times. However, people were just realizing that they could incorporate art into everyday decorative pieces to be used and not just admired. Plates were designed in a series, usually one through twelve, and were numbered with titles or verses of poetry on the back. Some plates portrayed scenes from plays or stories, and put together they held a theme or told a story.

An interesting series designed by Charles Field Haviland shows a little chef, riding fish, trying to catch birds, etc. It is a most amusing set and in enough various sizes and shapes of dinnerware to indicate that at one time there was probably an entire service in this theme. I show one plate (Fig. 269) by Haviland & Company that only has the white ware mark and may be hand painted. It follows the same theme but with a slightly different look.

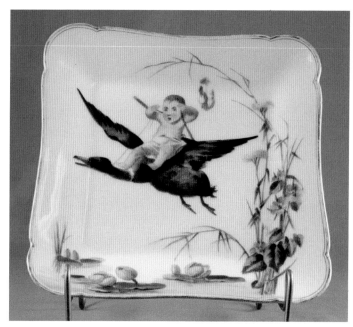

Figure 262. Little Chef series, 8". He is riding on a mallard duck. Charles Field Haviland & Company, 1882. Marks C-3 and C-8. $95-125.

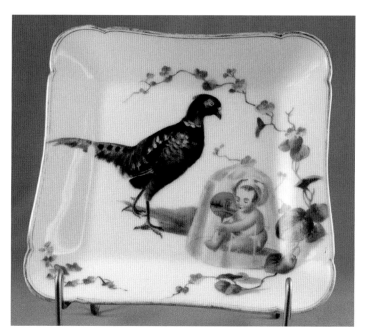

Figure 261. Little Chef with humorous painting pertaining to cooking. This one looks like he is under glass with his pheasant looking on, 8". Charles Field Haviland & Company, 1882. Marks C-3 and C-8. $95-125.

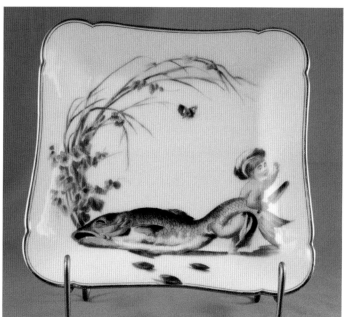

Figure 263. Little Chef series, 8". He is dragging a large fish. Charles Field Haviland & Company, 1882. Marks C-3 and C-8. $95-125.

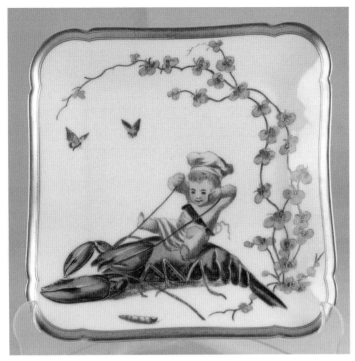

Figure 264. Little Chef series, 7". He is riding a lobster. Charles Field Haviland & Company, 1882. Marks C-3 and C-8. $75-100.

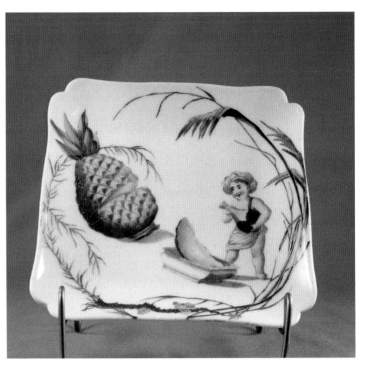

Figure 266. Little Chef series, 8". He is preparing a slice of pineapple. This one seems to be painted by a different artist than the other chefs shown here. Charles Field Haviland & Company, 1882. Marks C-3 and C-8. $95-125.

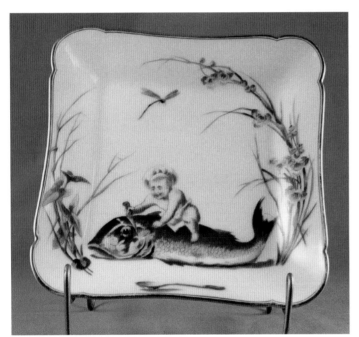

Figure 265. Little Chef series, 8". He is trying to carve a very large fish. Charles Field Haviland & Company, 1882, C-3 and C-8. $95-125.

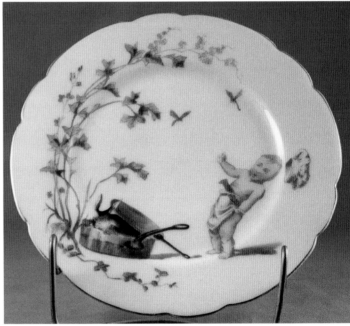

Figure 267. Little Chef series, 8½". He is trying to cook some kind of animal in a copper skillet. Charles Field Haviland & Company, 1876. Mark C-2. $95-125.

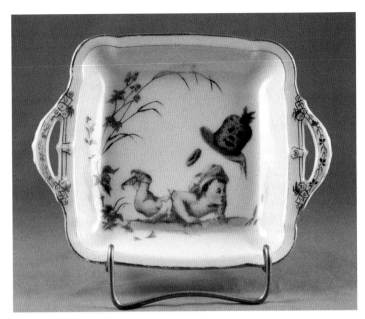

Figure 268. Little Chef series, 5". He has slipped on something and the dish has gone flying. Charles Field Haviland & Company, 1876. Mark C-2. $95-125.

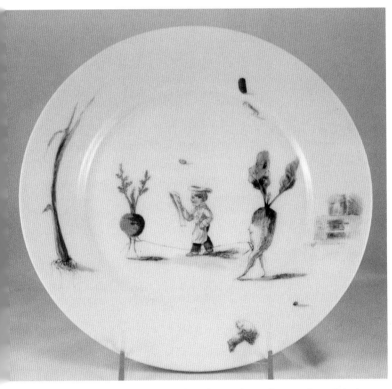

Figure 269. This Little Chef is obviously professionally painted, but does not have a decorator mark, 8". It was done a few years after the Charles Field Haviland & Company Little Chef series, but has the same theme. Haviland & Company, 1876-1889. Mark F. $50-75.

As well as hiring artists full time on the staff at the Haviland companies, they also hired independent artists to work for them. In the 1880s, one such artist named Antoine Soustre did some of the most striking work, which Haviland & Company placed on ornately shaped plates with elaborate gold trim. Portrait plates with his signature command top dollar in today's market.

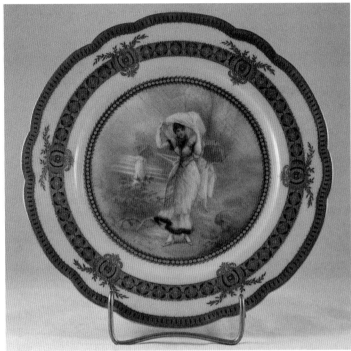

Figure 270. Factory decorated plate, 9½", named *Pluviose* (fifth month of the French Republican Calendar). Hand painted by Antoine Soustre. Haviland & Company, 1877-1889. Marks H and g. $800-1200.

Figure 271. Reticulated factory decorated plate, 9½". Hand painted by A. Soustre. Haviland & Company, 1888-1896. Marks H and c. $800-1000.

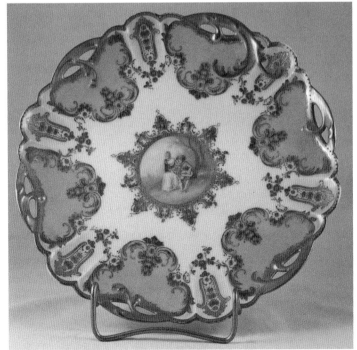

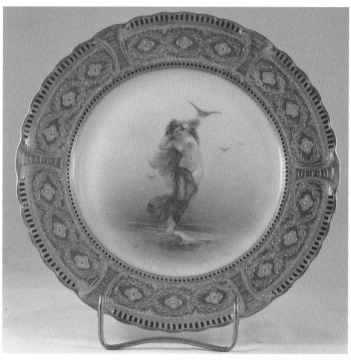

Figure 272. Factory decorated plate, 9½", entitled *La Nuit* (The Night) painted and signed by Antoine Soustre. Haviland & Company, 1888-1896. Marks H and c. $800-1200.

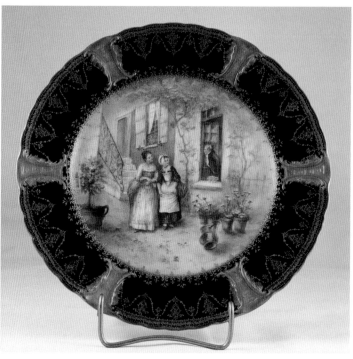

Figure 274. Factory decorated plate, 8½", entitled *'Le Chandelier' Act 1, Scene II, by Alfred de Musset.* Hand painted by Antoine Soustre. Haviland & Company, 1888-1896. Mark H. $900-1300.

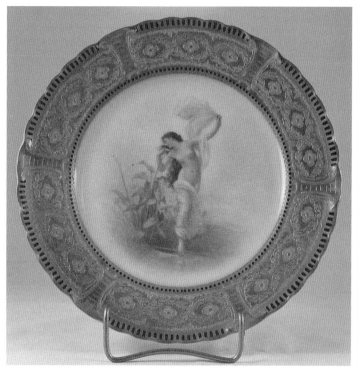

Figure 273. Factory decorated plate, 9½", entitled *Aurore* (Daybreak) painted and signed by Antoine Soustre. Haviland & Company, 1876-1889. Marks F and c. $800-1200.

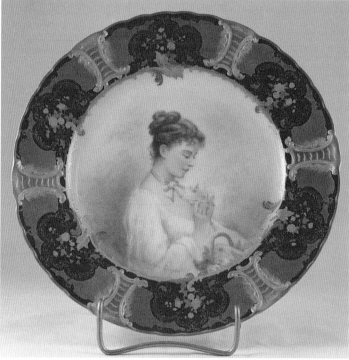

Figure 275. Factory decorated plate, 9½", entitled *Femme Aux Roses* (Woman with roses). Hand painted by Antoine Soustre after a painting by Chaplin. Haviland & Company, 1888-1896. Mark H plus "Made for Bailey, Banks and Biddle of Philadelphia." $800-1200.

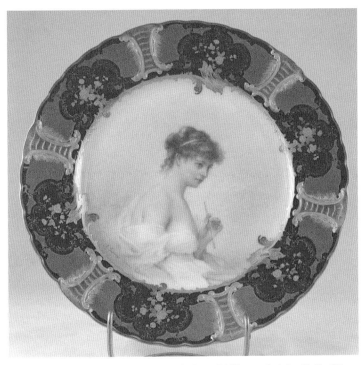

Figure 276. Factory decorated plate, 9½", entitled *La Belle* (The Beauty) hand painted by Antoine Soustre. Haviland & Company, 1888-1896. Marks H and c. $800-1200.

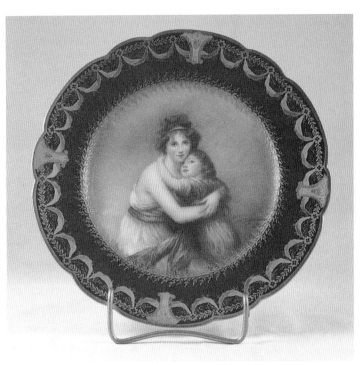

Figure 278. Factory decorated plate, 9½", hand painted by A. Soustre. Haviland & Company, 1876-1889. Marks F and c. $800-1000.

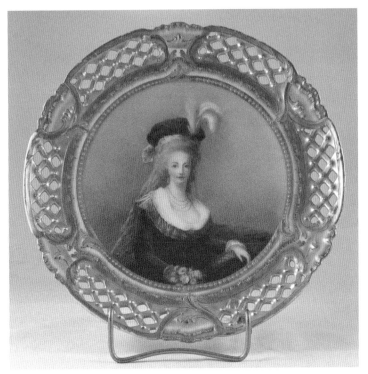

Figure 277. Factory decorated plate, 9½", hand painted by A. Soustre. Haviland & Company, 1876-1889. Marks F and c. $1000-1500.

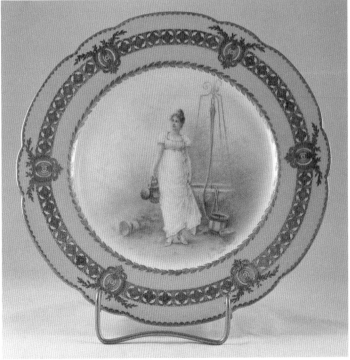

Figure 279. Factory decorated plate, 9½", entitled *Germinal* (seventh month in the French Republican calendar), hand painted by A. Soustre. Haviland & Company, 1888-1896. Marks H and g. $800-1000.

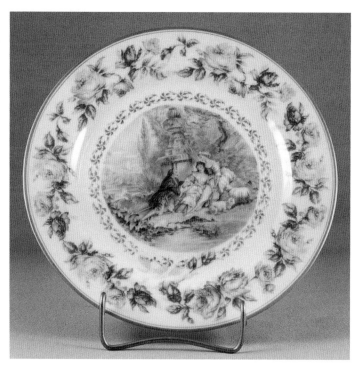

Figure 280. Factory decorated plate, 8½", with border of Schleiger no. 497G. Haviland & Company, 1894-1931. Marks I and c for Bailey-Banks & Biddle Co., Philadelphia, PA. $400-500.

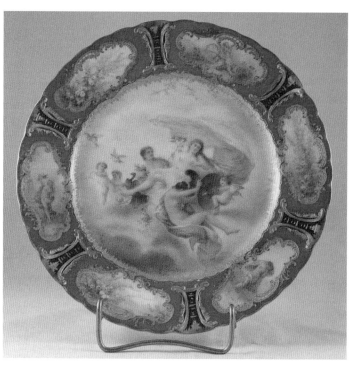

Figure 282. Factory decorated plate, 9½", entitled *Le char de La Paix*, (The chariot of Peace) hand painted by Antoine Soustre. Haviland & Company, 1888-1896. Marks H & g. $1000-1500.

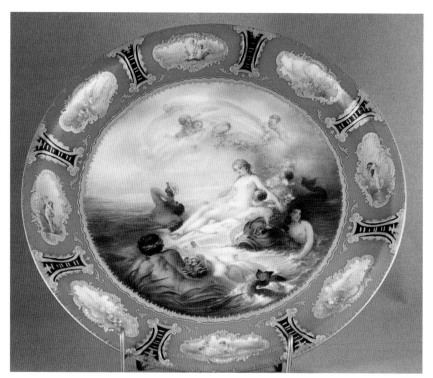

Figure 281. Factory decorated round charger, 13½", entitled *Triomphe d'Amphitrite*. Hand painted by Antoine Soustre. Haviland & Company, 1894. Mark I plus *Haviland Co., Telford Bournemouth* in gold. $2500-3500.

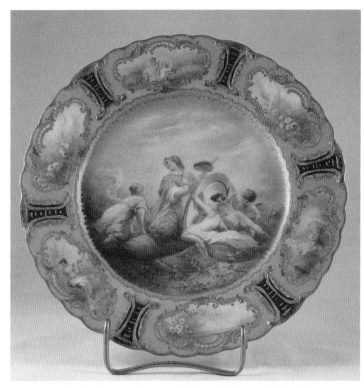

Figure 283. Factory decorated plate, 9½", entitled *La Peinture* (The Painter) painted and signed by A. Soustre. Haviland & Company, 1888-1896. Marks H & c. $1000-1500.

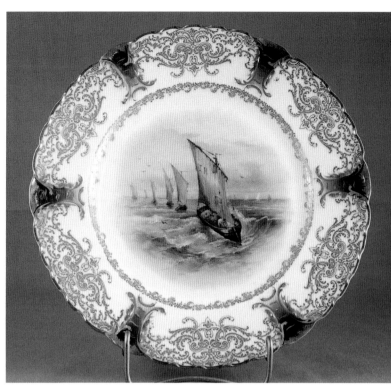

Figure 285. Factory decorated plate, 9¼", hand painted by A. Soustre. Haviland & Company, 1888-1896. Mark H and a, for Tyndale & Mitchell Co., Philadelphia. $800-1000.

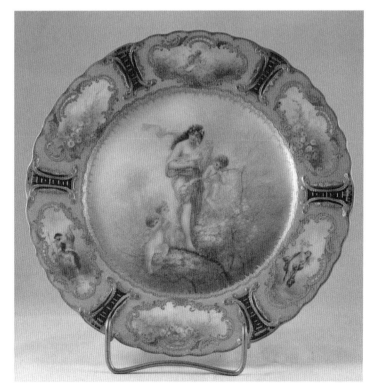

Figure 284. Factory decorated plate, 9 ½", entitled *Le Printemps* (Springtime), painted and signed by A. Soustre. Haviland & Company, 1888-1896. Marks H & c. $1000-1500.

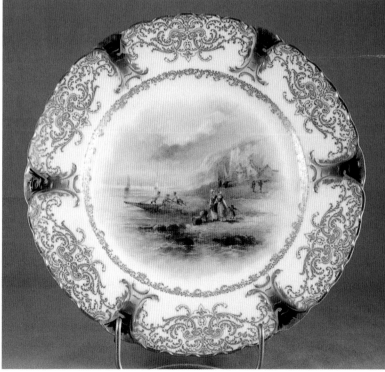

Figure 286. Factory decorated plate, 9¼", hand painted by A. Soustre. Haviland & Company, 1888-1896. Mark H and a, for Tyndale & Mitchell Co., Philadelphia. $800-1000.

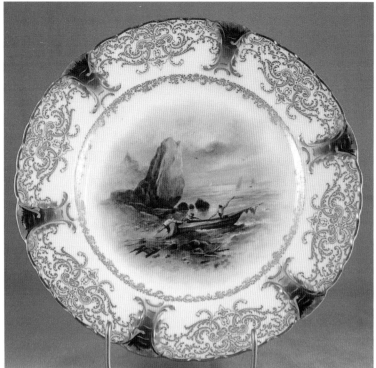

Figure 287. Factory decorated plate, 9¼", hand painted by Antoine Soustre. Haviland & Company, 1888-1896. Mark H and a, for Tyndale & Mitchell Co., Philadelphia. $800-1000.

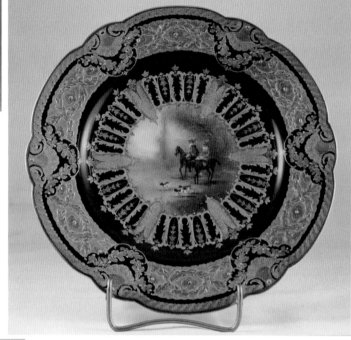

Figure 288. Factory decorated plate, 9½", hand painted by Antoine Soustre. Haviland & Company. Marks H and decorated for Arthur Kay, Louisville, KY, plus in gold script *H & Co., 1893*. $1000-1200.

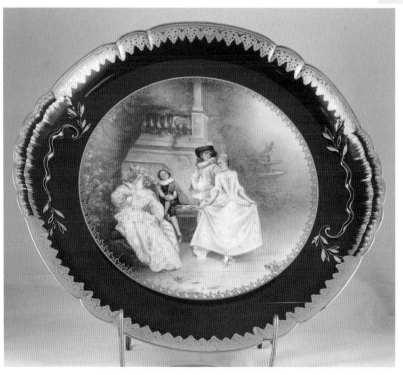

Figure 289. Factory decorated round platter, 12", entitled *Le Menuet*, hand painted by Antoine Soustre. Haviland & Company, 1888-1896. Marks H and c. $1500-2500.

When Theodore Haviland opened his own factory in 1893, he hired several of the top artisans that had previously worked at Haviland & Company. As in any competitive industry, these artisans moved where the work and enticements were.

The dinnerware service from the President Rutherford B. Hayes administration is the most famous service ever made by Haviland & Company. President Hayes wanted to incorporate all of nature and the American way of life in a dinner set. To do this, Haviland hired Theodore Davis, a naturalist, to draw the designs for the porcelain. He subsequently produced watercolors with detailed color notations, which became almost impossible and impractical economically to duplicate. These designs were so difficult to produce on porcelain that Haviland & Company was forced to invent new methods of production. Haviland sold the set in 1880 to the White House for a sum of $3,120.00, but because of the unusual designs for the dinnerware, the cost of manufacture far exceeded this price. There was such enthusiasm for this service that Haviland decided to produce some of the special pieces for sale to the general public.

When Theodore Davis realized how popular his designs were, he immediately took out patents for each of the pieces. He then signed over the rights to Haviland & Company to produce the designs for public and private use for seven years. Pieces of the Hayes china that were marketed for the public were inscribed *DESIGN PATENTED/ AUGUST 10TH, 1880/ N°. 11932*—and subsequent numbers through 11936. These pieces also have the United States coat of arms and the words *FABRIQUÉ PAR/ HAVILAND & CO./ d'après les dessins/ DE/ Theo: R. Davis*, as was on the White House set. However, instead of the artist's initials and the date 1879, the china made for sale to the public has the number and date of the patent.

There are four types of decorating—unpainted white ware, which if molded and designed, can stand alone as a work of art, hand painted, transfer decoration, or a combination of both transfer and hand painting. There are three types of hand painting: factory painted by a professional artist; studio painted by a professional artist; or hand painted by an amateur or nonprofessional. The most valuable plates are those that were done by a factory artist, either an independent or a company worker. Having the decorator mark from the factory elevates the price of the piece.

The next most valuable would be those pieces done by popular decorating studios such as Pickard, Stoeffer, or Brauer. The Arts and Crafts Movement, which started in England in the 1860s, finally began to be recognized for its merit by the 1880s. It was in full swing by the late 1890s and beautiful hand painted porcelain by well-known artists was much in vogue.

This movement began with John Ruskin, an influential art critic, who was very much against mass-produced art and called for a return to craftsmanship with a romantic view of the Middle Ages. He felt that the aesthetic quality of everyday objects could be improved upon with craftsmen and artists working together. William Morris, architect and painter, was a craftsman first and foremost and felt that Ruskin was correct in his thinking.

With the advent of the industrial revolution, so many items were being manufactured in factories. However, as with anything mass-produced, items lose that special quality that only comes with handiwork. Ruskin and Morris inspired painters and architects to merge their activities into the decorative arts—to become craftsmen and to revitalize the art world—not just in paintings, but in furniture, ceramics, sculpture and other pieces of everyday life.

There were large numbers of wholesale and retail firms that had china-decorating departments. W. A. Maurer in Iowa, Burley & Company in Chicago, C. E. Wheelock & Co. in Illinois, Abram French Company in Boston, and several other major companies all produced hand-painted china. However, they primarily painted dinnerware and utilitarian pieces.

Wilder A. Pickard (1857-1939) saw the need for more elaborate china—decorated vases, punch bowls, tea and coffee sets, etc. As these pieces would be special display items, he knew that he would have to hire only the best china painters available. In 1898, Pickard opened his studio and proceeded in buying Limoges porcelain for the majority of his work. He felt he should buy the best product available if he was to sell quality pieces. Many of his pieces were painted on Haviland porcelain, but he also bought from other companies in Limoges if he could get lower prices. Today, Pickard is synonymous with quality hand-painted porcelain. Julius H. Brauer and J. H. Stouffer Company were also producing quality china painting at about the same time. As with the Haviland companies, the major artists moved from company to company, wherever the best work and money was.

Because of the popularity of the Arts and Crafts Movement, amateur hand painting came into vogue. As mentioned above, many companies were selling white ware pieces by catalog for women to purchase and paint in the comfort of their own homes. Mrs. Benjamin Harrison's hobby was china painting, which in turn created a surge of china painters. However, pieces hand painted by amateur painters are usually valued at lower prices than professionally painted pieces, as these were not all at the same level of quality.

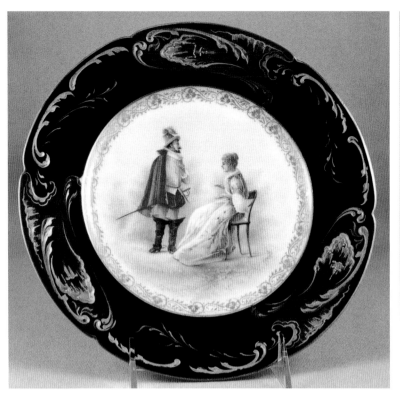

Figure 290. Factory decorated plate, 8½", hand painted and signed by Ahmanto. Theodore Haviland Company, 1892. Mark K for Burley & Company, Chicago. $400-450.

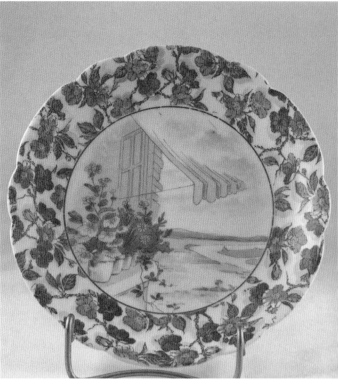

Figure 292. Coupe plate, 7½", with garden scene and floral border. One of a set of six. Haviland & Company, 1876-1889. Marks F and g. $100-125.

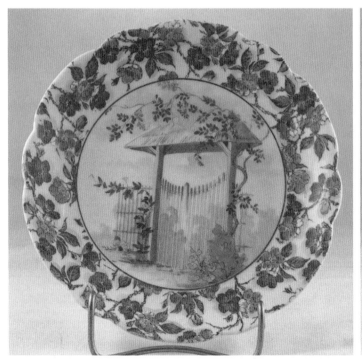

Figure 291. Coupe plate, 7½", with garden scene and floral border. One of a set of six. Haviland & Company, 1876-1889. Marks F and g. $100-125.

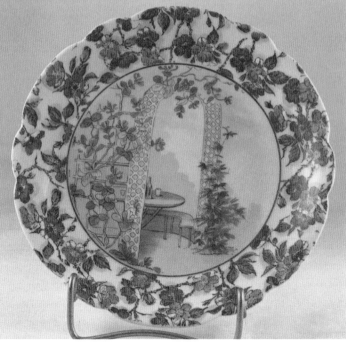

Figure 293. Coupe plate, 7½", with garden scene and floral border. One of a set of six. Haviland & Company, 1876-1889. Marks F and g. $100-125.

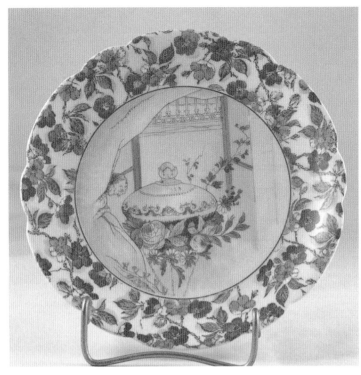

Figure 294. Coupe plate, 7½", with garden scene and floral border. One of a set of six. Haviland & Company, 1876-1889. Marks F and g. $100-125.

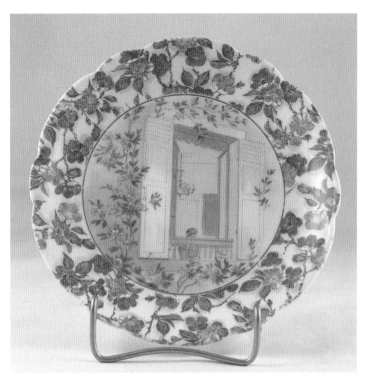

Figure 296. Coupe plate, 7½", with garden scene and floral border. One of a set of six. Haviland & Company, 1876-1889. Marks F and g. $100-125.

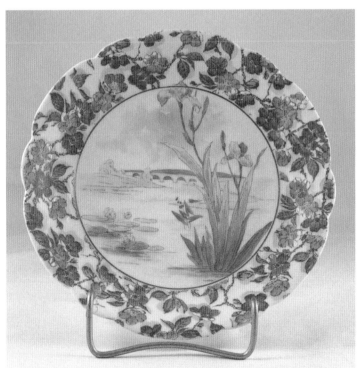

Figure 295. Coupe plate, 7½", with garden scene and floral border. One of a set of six. Haviland & Company, 1876-1889. Marks F and g. $100-125.

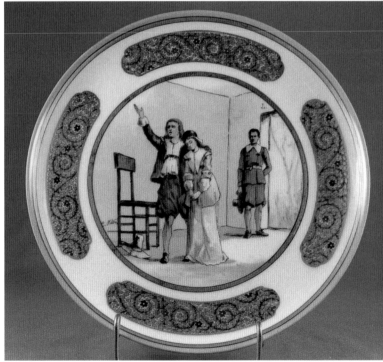

Figure 297. Factory decorated plate, 8½". No. 2 in a series of Longfellow's Courtship of Miles Standish. This plate entitled *The Spinning Wheel VIII*. On the back of the plate "*... John Alden ... clasped almost with a groan, the motionless form of Priscilla, pressing her close to his heart, as forever his own, and exclaiming 'Those whom the Lord hath united, let no man put them asunder!'*" Haviland & Company, 1876-1889. Marks D and g. $250-350.

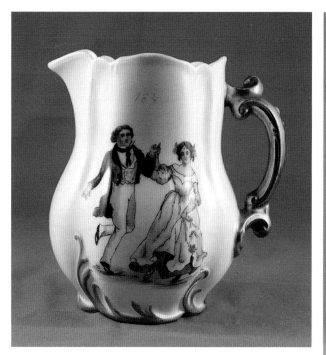

Figure 298. Front of commemorative jug in the Marseilles blank, 7". Haviland & Company. Mark on bottom reads *Made by Haviland & Co., Limoges for W.H. Glenny, Sons & Co., Buffalo, NY on their 50th Anniversary 1840-1890.* $150-250.

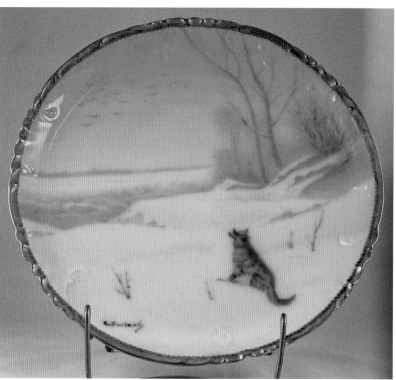

Figure 300. Cobalt charger, Feu de Four, 11¼". Haviland & Company. Marks H and h plus factory artist signature and date, *1885 E. Furlough.* $1000-1200.

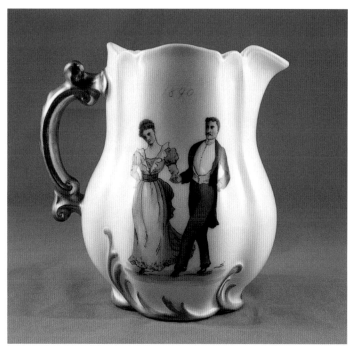

Figure 299. Back view of commemorative jug, Fig. 298.

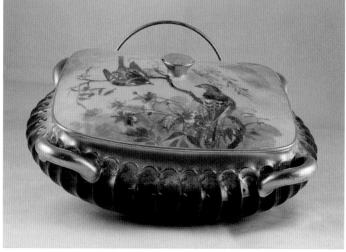

Figure 301. Cobalt and gold covered dish, 8½", on Torse shape, with factory hand painted lid, no artist signature. Haviland & Company, 1876-1889. Marks D and g plus impressed English registry mark. $250-350.

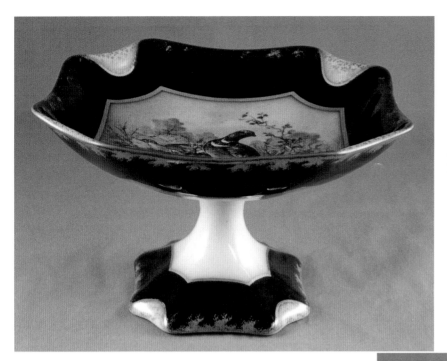

Figure 302. Comport, part of a game set in cobalt and gold in napkin fold shape. Haviland & Company, 1876-1889. Marks F and g. $500-700.

Figure 303. Game plate, 8½", in napkin fold shape with cobalt and gold rim. Haviland & Company, 1888-1889. Marks H and c. $175-225.

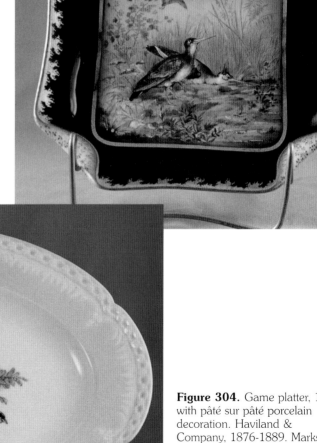

Figure 304. Game platter, 18", with pâté sur pâté porcelain decoration. Haviland & Company, 1876-1889. Marks F and g. $600-800.

 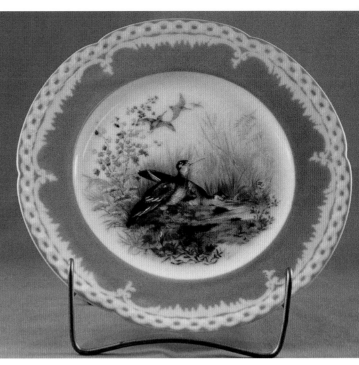

Figure 305. Game plate, 8½", for platter in Fig. 304. Haviland & Company, 1876-1889. Marks F and g. $200-250.

Figure 306. Game plate, 8½", for platter in Fig. 304. Haviland & Company, 1876-1889. Marks F and g. $200-250.

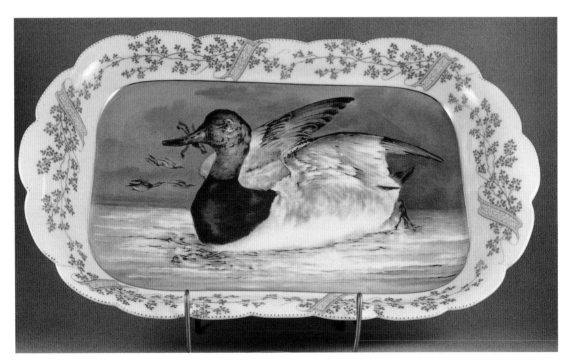

Figure 307. Rectangle platter, 17½", with factory hand painting in center and decals on border. Haviland & Company, 1876-1889. Mark F and g. $600-850.

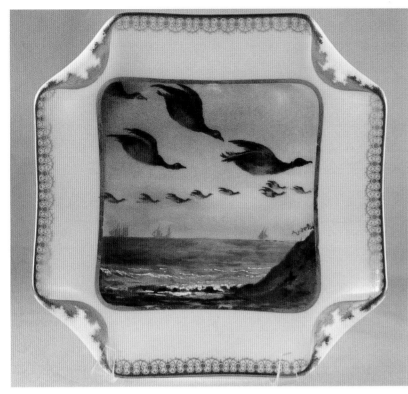

Figure 308. Game plate, 7 7/8", in napkin fold shape. Haviland & Company, 1876-1889. Marks F and g in brown. $175-225.

Figure 309. Game plate, 8½". Haviland & Company, 1876-1889. Marks D and g. $150-175.

Figure 310. Factory decorated plate, 9½". Plate was made by some other porcelain factory, probably before Theodore Haviland had his kilns ready, and then decorated at his factory. Theodore Haviland, 1892, Mark. $250-350.

Figure 311. Factory decorated plate, 9½". Plate was made by some other porcelain factory, probably before Theodore Haviland had his kilns ready, and decorated at his factory. Theodore Haviland, 1892, Mark. $250-350.

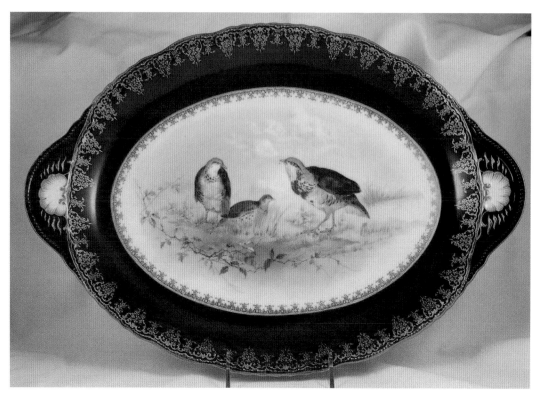

Figure 312. Game platter, 18", hand painted and signed by artist L. Martin. Theodore Haviland, 1903. Mark q. $400-500.

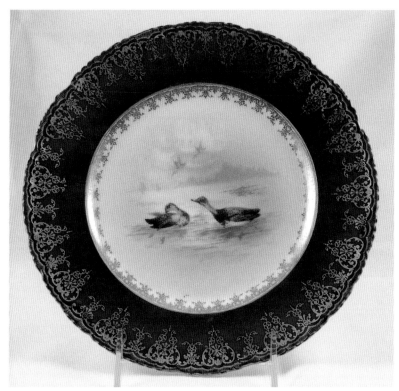

Figure 313. Game plate, 8½". Hand painted and signed by artist L. Martin. Theodore Haviland, 1903. Mark q. $175-225.

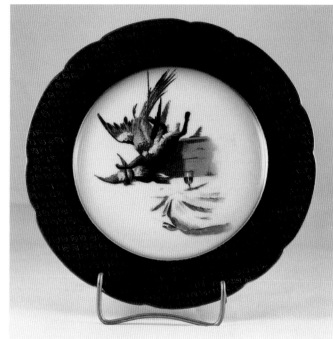

Figure 314. Cobalt game plate, 8½". Charles Field Haviland & Company, 1882. Mark C-8. $200-275.

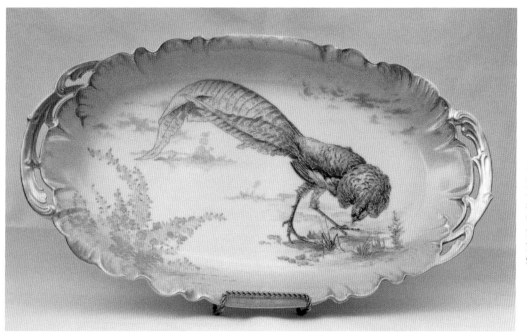

Figure 315. Game platter set with eight plates. Platter, 19½" x 11¼". Fancy gold edge with birds sketched in blue enamel and gold. Charles Field Haviland & Company. Marks C-4 and C-8 in brown, plus Van Huesen Charles & Co. in gold. Set $2500-3500.

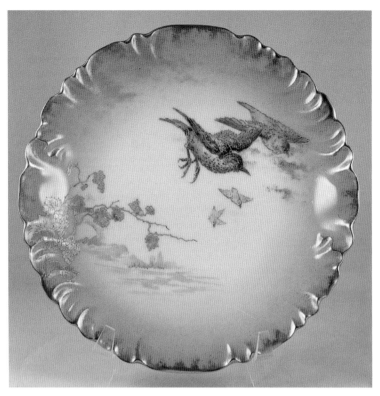

Figure 316. Game plate, 8½", with platter in Fig. 315. Birds sketched in blue enamel and gold. Charles Field Haviland & Company, 1882. Marks C-4 and C-8 in brown plus Van Huesen Charles & Co. in gold.

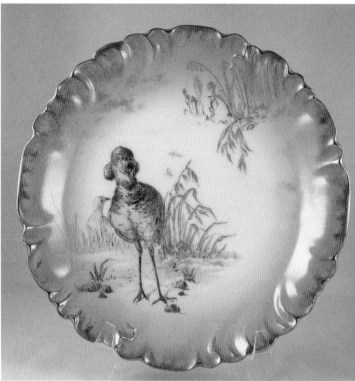

Figure 318. Game plate, 8½", with platter in Fig. 315. Birds sketched in blue enamel and gold. Charles Field Haviland & Company, 1882. Marks C-4 and C-8 in brown plus Van Huesen Charles & Co. in gold.

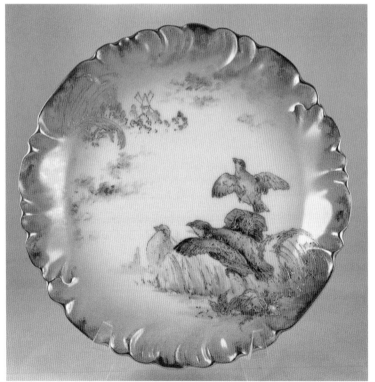

Figure 317. Game plate, 8½", with platter in Fig. 315. Birds sketched in blue enamel and gold. Charles Field Haviland & Company, 1882. Marks C-4 and C-8 in brown plus Van Huesen Charles & Co. in gold.

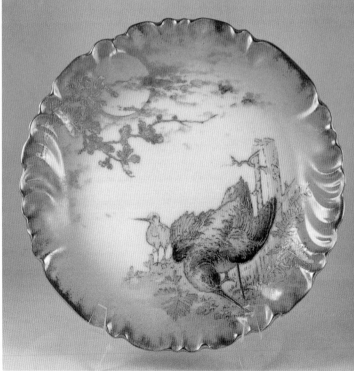

Figure 319. Game plate, 8½", with platter in Fig. 315. Birds sketched in blue enamel and gold. Charles Field Haviland & Company, 1882. Marks C-4 and C-8 in brown plus Van Huesen Charles & Co. in gold.

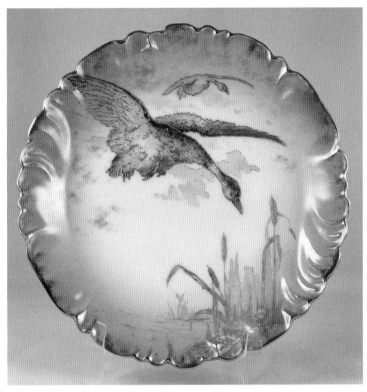

Figure 320. Game plate, 8½", with platter in Fig. 315. Birds sketched in blue enamel and gold. Charles Field Haviland & Company, 1882. Marks C-4 and C-8 in brown plus Van Huesen Charles & Co. in gold.

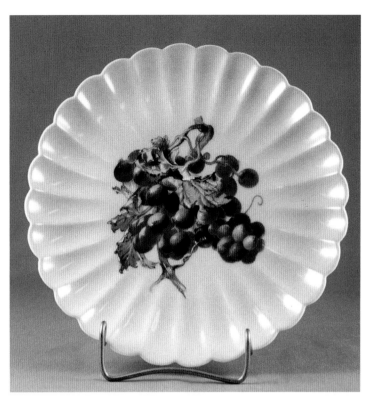

Figure 322. Fruit plate, 9", on Torse blank no. 413. Haviland & Company, 1876-1889. Marks D and g. $75-95.

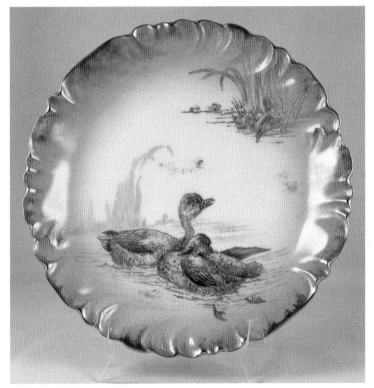

Figure 321. Game plate, 8½", with platter in Fig. 315. Birds sketched in blue enamel and gold. Charles Field Haviland & Company, 1882. Marks C-4 and C-8 in brown plus Van Huesen Charles & Co. in gold.

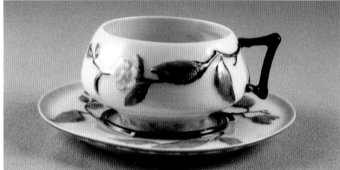

Figure 323. Teacup and saucer from President Hayes White House dinner service, cup measures 2 1/18" high x 4½" wide. It is in the shape of a Mandarin's hat (inverted), the handle being formed by the stem of a tea-plant, the leaves also are used as a decoration on the exterior of the cup. The interior of the cup is tinted a delicate green, the saucer and outside of the cup are further enriched with gold. Haviland & Company, 1880. Marks C and a. $800-1200.

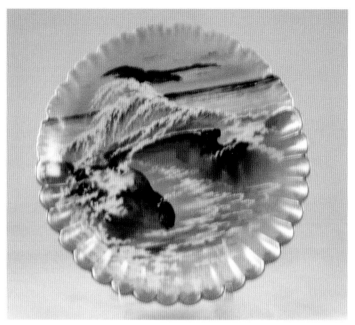

Figure 324. Fish plate from President Hayes White House dinner service, 8½". This plate shows a picture of a Pompano fish, seldom caught north of the Delaware capes. The design shows a fish-hawk hovering over the surf, watching a Pompano on the sand, where the hawk has dropped its prey, having fastened its terrible claws into heavier booty than it could carry away. Haviland & Company. Marks F and a, also signed by Theodore Davis plus the patent date Aug. 10, 1880. $800-1200.

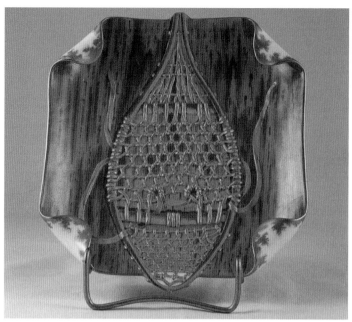

Figure 326. Ice cream plate from President Hayes White House dinner service, 6¾" x 7 3/8". It is in the form of a snow shoe on the napkin fold blank. Haviland & Company. Mark D, also signed by Theodore Davis, Aug. 10, 1880. $1000-1500.

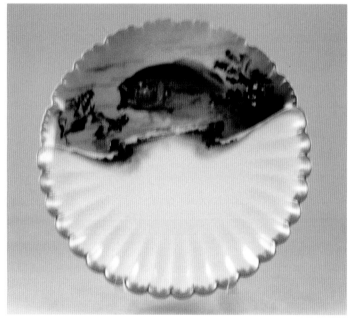

Figure 325. Fish plate from President Hayes White House dinner service, 8½". This plate shows a Red Snapper, a popular sea fish found along the south Atlantic coast. In color it is a brilliant crimson, and in the clear southern waters it can be seen to a considerable depth pursuing small fish. Haviland & Company. Marks F and a, also signed by Theodore Davis plus the patent date Aug. 10, 1880. $800-1200.

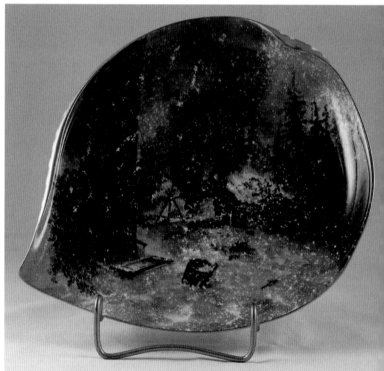

Figure 327. Fruit or dessert plate from President Hayes White House dinner service, 8¼" by 9½". This plate is called *Maple Sugar*, and the shape is modeled on the leaf of the American wild apple. The design shows a sugar camp in the woods. In the foreground is a maple tree, which has a spout inserted and a sap trough for receiving the drops of sweet water to make syrup and sugar. The sap is boiled in a cauldron, suspended over a great log fire, near a shanty that affords shelter for the sugar makers against the driving snowstorms, that accelerate rather than retard the flow of sap. Haviland & Company. Mark D, also signed by Theodore Davis, Aug. 10, 1880. $1200-1800.

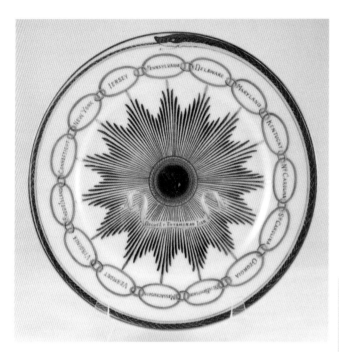

Figure 328. Martha Washington Plate, 8½". The decoration is composed of a circular chain containing the names of the fifteen states of the Union, at that period. The snake, holding its tail in its mouth, is a Chinese symbol of continuity and symbolizes the perpetuity of the Union. The interlaced letters of the monogram, M.W., are set against a sunburst of gold and the Latin motto, on a red scroll, *Decus Et Tutamen Ab Illo* which translates, *Honor and Protection come from Him.* There is some discrepancy regarding the history of this plate. According to a paper that came with a replica that was probably issued in 1976 for the Bicentennial, Haviland & Company was supposedly commissioned to manufacture the plate in 1876, to celebrate the Centenary of the Signing of the Declaration of Independence of the United States of America. However, the backmark of the plate shown here has an impressed M & Theo Haviland, Limoges, France. Mark m, which dates it at 1895. If Haviland & Company had manufactured a plate such as this in 1876, they would certainly not have let Theodore Haviland Company manufacture it in 1895. $200-350.

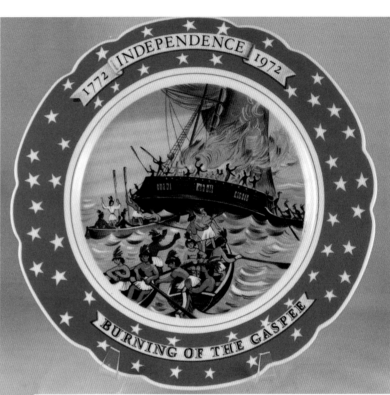

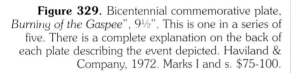

Figure 329. Bicentennial commemorative plate, *Burning of the Gaspee"*, 9½". This is one in a series of five. There is a complete explanation on the back of each plate describing the event depicted. Haviland & Company, 1972. Marks I and s. $75-100.

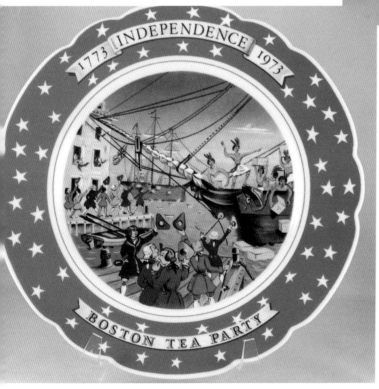

Figure 330. Bicentennial commemorative plate, *Boston Tea Party,* 1973. $75-100.

Figure 331. Bicentennial commemorative plate, *First Continental Congress*, 1974. $75-100.

Figure 332. Bicentennial commemorative plate, *The Ride of Paul Revere*, 1975. $75-100.

Figure 333. Bicentennial commemorative plate, *The Declaration of Independence*, 1976. $75-100.

Figure 334. Coupe plate, 8½". Haviland & Company, 1906-1914. Mark H and hand painted by Stouffer Company. The plate was made by Haviland several years before it was painted by Stouffer Company. $125-150.

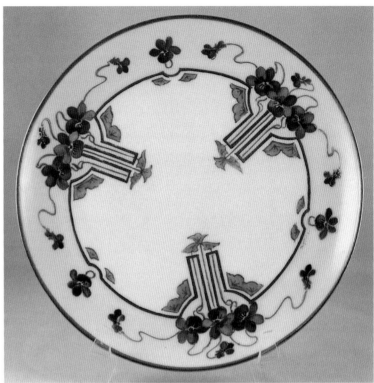

Figure 336. Coupe plate, 8½". Haviland & Company, 1906-1914. Mark C and hand painted by Stouffer Company. $75-95.

Figure 337. Teapot, creamer and sugar, professionally hand painted in Pickard style but no decorator mark. The area above and below the large design is done in the plain encrusted gold design of Pickard. The gold design is called *etched gold* and first introduced by Pickard in 1911. It is a very difficult process involving the use of acid to eat away a certain portion of the porcelain to create the design. Upon removal from the acid bath, the china was rinsed in kerosene, followed by hot baths of soap and a final rinse, then sent off to the artist for decorating with gold. The first layer of gold was applied and fired, then a second layer applied with another firing. Because of the larger and coarser areas of gold in these patterns, a glass fiber burnishing brush would not work. Special burnishing sand was used to bring up the luster on the final coat of gold. Haviland & Company, 1911-1931. Mark I and impressed 5. Set $500-600.

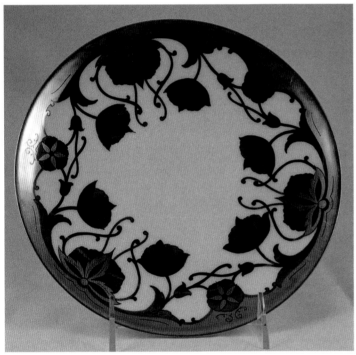

Figure 335. Coupe plate, 8½". Haviland & Company, 1906-1914. Mark I and hand painted by Stouffer Company. $125-150.

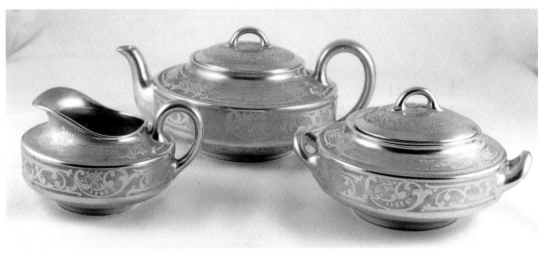

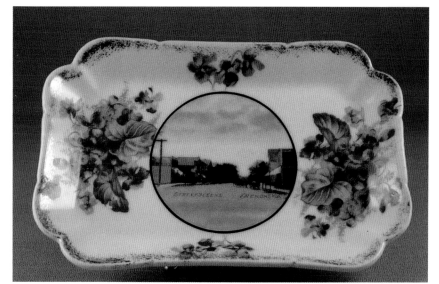

Figure 338. Small Souvenir tray, 5½" x 8½". This piece was bought from Haviland & Company to decorate for a souvenir shop or a fair. The picture in the circle looks like a hand colored photograph. It shows a dirt street, with horse and buggy in the front of a General Store. Across the front is hand printed in brown *Street Scene, Fremont, Wisc.* White ware made by Haviland & Company, 1888-1896. Mark H

Figure 339. Hand painted platter, 12" square, signed F. Villetelle. Charles Field Haviland & Company, 1892. Mark C-3. $500-700.

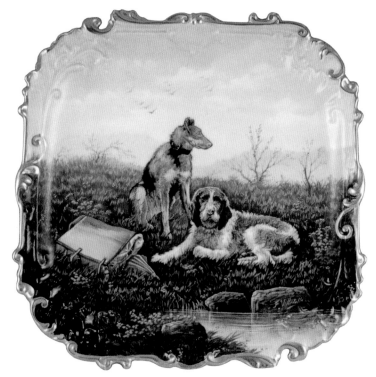

Art Nouveau

Enormous changes in society led to the industrialization of both Europe and America. Europe was at its wealthiest before both world wars and income taxes. Upper and middle classes were prepared to spend enormous amounts of money on expensively produced objects for the home. With all of this money floating around, there was a lack of fine goods widely available to the upper- and middle-class society. The world had changed, but styles had not—until Art Nouveau brought a revolution. Developed in the late 1880s, Art Nouveau rose to its peak by the 1890s—its height coinciding with the height of the golden age of Limoges porcelain from 1880 to 1905. The first style that did not have its roots in European history, it was truly a new style of the century, a precursor to the designs of the twentieth century. There was a stress on aesthetic rather than cost, something fully characteristic of the Art Nouveau movement.

The essence of Art Nouveau is a line, a sinuous extended curve found in every design of this style. It was a more natural movement, curving and flowing—bringing with it a feeling of airy lightness, grace, and freedom. Nature was the ultimate sourcebook of the Art Nouveau artist, especially the plant world. Everything came from a free-flowing botanical source—lilies, irises, and orchids were the favorite flowers used. Artists abstracted form from nature, showing the essence of a flower by its gentle lines and fresh color, rather than by minute description. As with the Impressionist Movement, the threads still ran thick with *Japonisme* into the Art Nouveau movement; which showed itself to have strong roots in oriental art with its capricious mix of past and peculiar style.

The term *Art Nouveau* is derived from a Parisian shop run by a German trader in Japanese art, Samuel Bing. In 1895, he opened his shop as *La Maison de l'art Nouveau*, in which he promoted new artists, craftsmen, and sculptors. Bing was honored with his own pavilion devoted to Art Nouveau at the 1900 Paris World's Fair. In the 1880s, John Ruskin and William Morris inspired painters to extend their activities into the decorative arts. Art Nouveau owed some of its origin to the earlier English crafts revival. It took the best of all the major design eras and created this original fluid idea.

Art Nouveau was often ornate and decorative, leaning on nature for themes or ideas as well as artistic style of the eighteenth-century. It was also austere—covered with structure and function. Art Nouveau meant something different for everyone. For France, it meant more curves, elaborate back-to-nature designs with leaves and

flowers. For Germany, it was more severe and exotic. England was so ensconced in the Arts and Crafts Movement, they practically rejected it. America, like the French, preferred the fresh, more elaborate designs.

France was the center of the Art Nouveau ceramic movement. Gallé, de Feure, Colonna, and others worked in ceramics as well as glass and furniture, but their work was more closely linked to the major porcelain factories. Advanced technical equipment made new artistic effects possible in all mediums. The Haviland workshop was one of great significance during this period, and was responsible for the development of Art Nouveau ceramics, technically through the innovation of Chaplet and Delaherche, and stylistically through Gauguin's experiments. Between the 1880s and the 1890s, there was an avant-garde style of French painting, particularly by Gauguin and his followers. Their strong design was shown in the flatness of the medium. This made the transition from fine to decorative arts easier than at any other time in the nineteenth century. However, the elaborate flourishes and ornamentation of the Art Nouveau style rapidly vanished, moving decorative arts into a Classics phase as we moved into the twentieth century.

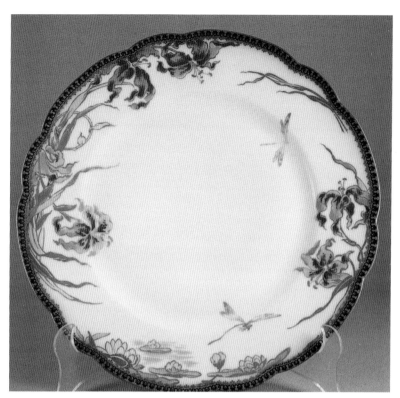

Figure 341. Plate with cobalt and gold edge plus unidentified floral pattern with water lilies, 9½". Haviland & Company, 1894-1931. Marks I and c. $95-125.

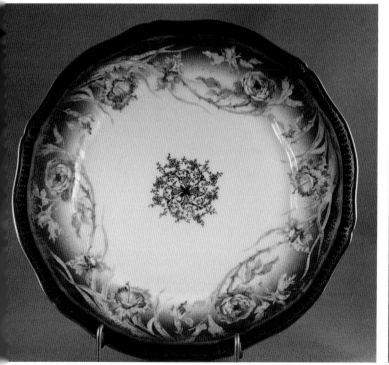

Figure 340. Plate with cobalt and gold edge with unidentified pattern, 9½". Theodore Haviland Company, 1903. Mark p. $95-125.

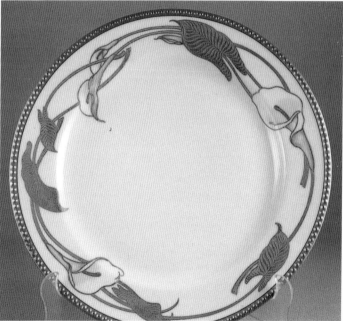

Figure 342. Plate with Art Nouveau styled lilies in gold, 9¾". Haviland & Company, 1894-1931. Marks I and c. $95-125.

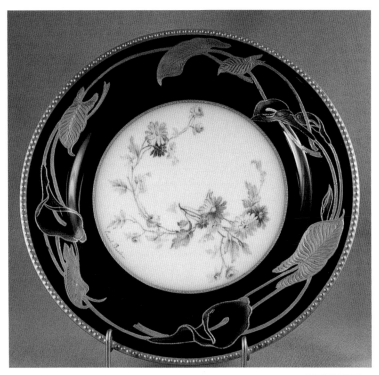

Figure 343. Cobalt rim with gold Art Nouveau styled lilies on border and unidentified floral pattern in plate, 9¾". Haviland & Company, 1894-1931. Marks I and c plus signed by Ernest Barbeau. $150-175.

Figure 344. Two-piece sauce with handle in Schleiger no. 492G on Ranson blank no. 1. Haviland & Company, 1894-1931. Marks H and c. $125-145.

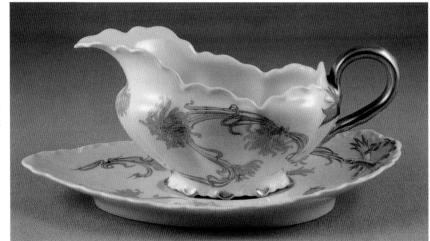

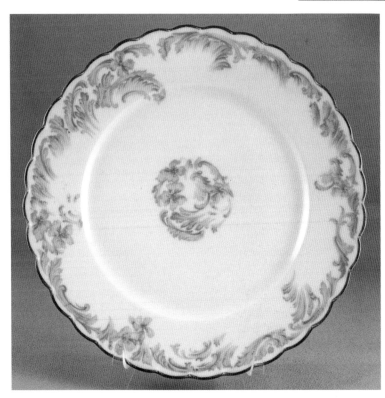

Figure 345. Plate, 9½", in Schleiger no. 706A. Haviland & Company, 1894-1931. Marks I and c. $30-40.

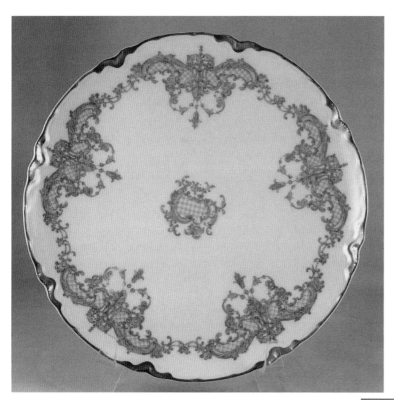

Figure 346. Coupe plate, 8½", in unidentified pattern on Schleiger blank no. 24. Haviland & Company, 1894-1931. Marks I and c, made expressively for The Reeves-Luffman Co.-Schenectady NY. $35-45.

Figure 347. Plate, 8½", with fancy gold scrolling in unidentified pattern. Haviland & Company, 1894. Mark *H & Co.* for Bailey, Banks & Biddle, Philadelphia. $75-95.

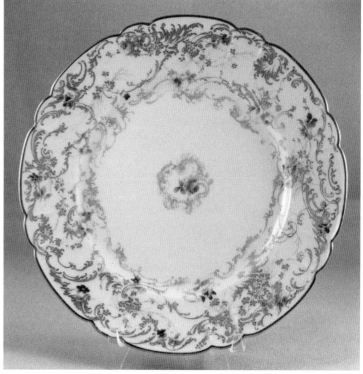

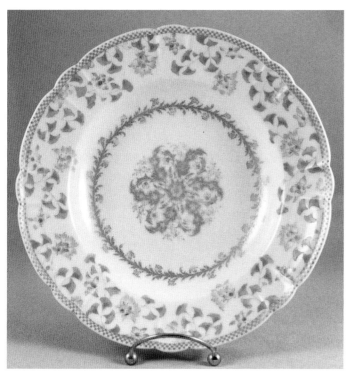

Figure 348. Rimmed soup, 8½", in unidentified pattern. Haviland & Company, 1876-1889. Mark F and *Made expressly for J.E. Caldwell & Co., Philadelphia.* $75-95.

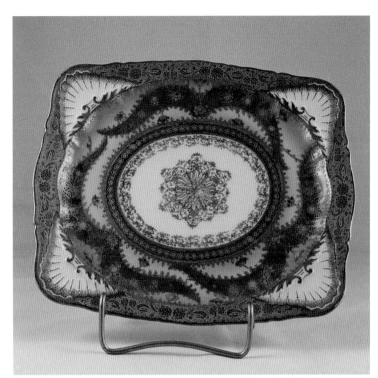

Figure 349. Rectangle unglazed tray, 6" x 8", in unidentified pattern. Theodore Haviland Company, 1903. Marks impressed M and q. $75-125.

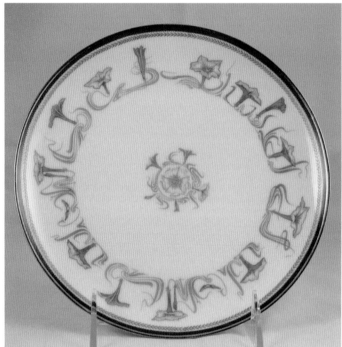

Figure 350. Coupe salad, 7½", in a variation of Schleiger no. 491. Haviland & Company, 1894-1931. Marks I and c. $25-35.

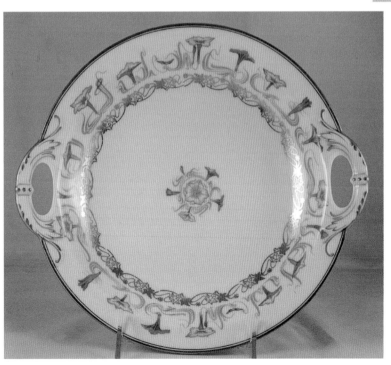

Figure 351. Cake plate, 9", in another variation of Schleiger no. 491. Haviland & Company, 1894-1931. Marks I and c for W.J. Alexander, Troy, NY. $95-125.

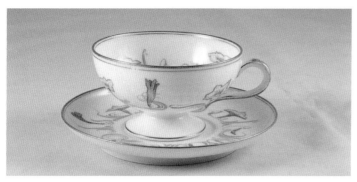

Figure 352. Four o'clock cup and saucer, on pedestal smooth blank, in a variation of Schleiger no. 491. Haviland & Company, 1894-1931. Marks I and c. $45-55.

Aurene Glass

Frederick Carder, born in 1863 in Staffordshire, England, founded the Steuben Glass Works in Corning, New York, in 1903. (The Steuben Glass works is named for Steuben County where Corning is located.) Carder had worked for more than twenty years as a glassmaker for Stevens & Williams in England, and was now excited to start his own company. He originally began making crystal glass blanks for the Hawkes factory to decorate but soon tired of making just the plain glass—he was more interested in the artistic aspect of glassmaking.

Aurene glass was the first of Carder's creations. It was inspired by the shimmering iridescence of Roman glass made from the first to the fourth centuries AD. The name Aurene is of special interest: the first three letters, *aur*, were taken from the Latin word for gold, *aurum*; and the last three letters of *schene* from the Middle English form of *sheen*. Thus in name as well as appearance, Aurene combined its Roman inspiration with the English background of its creator. The name *Gold Aurene* was patented in 1904 and its companion, *Blue Aurene*, appeared the next year. Adding cobalt oxide to the *Gold Aurene* formula makes the *Blue Aurene*. Spraying the glass being fired with a stannous chloride spray, sometimes supplemented with iron chloride, produced the iridescence of both Aurenes. Carder felt that his *Aurene* glass was so beautiful that it needed no other decoration, hence there are very few pieces of decorated *Aurene* glass in existence.

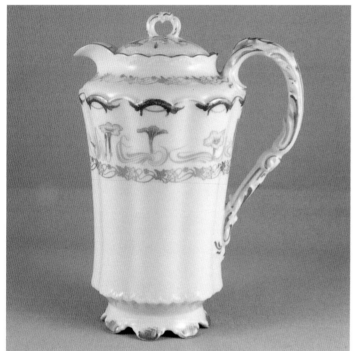

Figure 353. Chocolate pot, 8", in a variation of Schleiger no. 491 on blank no. 646. Haviland & Company, 1894-1931. Marks I and c. $325-425.

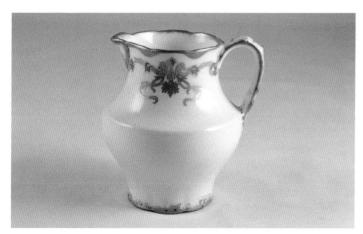

Figure 354. Demitasse creamer, 3¼, in Schleiger no. 1251. Theodore Haviland Company, 1903. Mark p. $45-60.

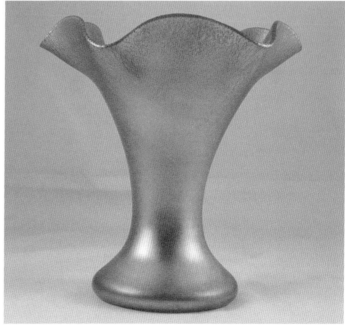

Figure 355. Gold Aurene vase with a touch of blue Aurene at the base, 8". Made by Steuben for Haviland & Company, 1910-1915. Mark c. $1100-1500.

Aurene glass was sold through a few select stores. From about 1910 to 1915, Haviland & Company, who at that time had their offices at 11 East 36th Street, New York City, sold Gold Aurene glass. These pieces are identified by a special mark on the bottom: the words *AURENE* and *HAVILAND & CO.* are stamped in white enamel or in mat acid.

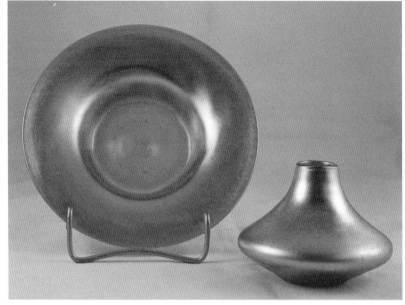

Figure 356. Gold Aurene bowl, 6½", and vase, 2"x 4". Both made by Steuben for Haviland & Company, 1910-1915. Mark c. Bowl $800-1000. Vase $600-900.

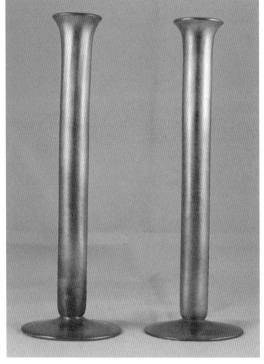

Figure 357. Gold Aurene pair of bud vases, 10". Made by Steuben for Haviland & Company, 1910-1915. Mark c. Pair $1500-2000.

Figure 358. Gold Aurene goblet, 6". Made by Steuben for Haviland & Company, 1910-1915. Mark c. $1200-1500.

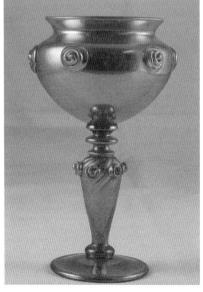

Sandoz Animals

Edouard Marcel Sandoz was born March 21, 1881, in Switzerland. His father had founded the Sandoz Pharmaceutical Company, which is still in existence today. While visiting in Paris with his uncle, Emile David, a talented painter, he was introduced to the Paris Exhibition and decided he wanted to study art. He talked his parents into letting him enroll at a college in Switzerland and began to study not only drawing and sculpture, but also chemistry, physics, anatomy, and botany. His father wanted him to follow into the Sandoz Company, but Edouard was determined to become a sculptor and in 1904 went to Paris to study at the Beaux-Arts.

In 1906, he presented a number of animal sculptures to the Art Salon for judging and drew some attention from the critics in attendance. The Art Nouveau movement was just winding down and people were attracted to his simple lines and to the colors of his animals (to learn the nuances of the animals he was sculpting, monkeys, dogs, fish, birds, etc., he actually brought some of these animals into his home!).

The Theodore Haviland Company hired Sandoz in 1915 to design more of these unique animals. He created all sorts of wonderful

new and unusual animal sculptures and figures for sale. The large department stores in France competed to obtain exclusive rights to sell these figures, but William Haviland wanted the figures to be sold around the world and not at one store only.

Within a few years, the First World War was raging throughout sections of France. Sandoz's neighborhood was bombed and the factory was having difficulty getting coal to fire the porcelain. Many of the porcelain factories in Limoges were forced to close their doors due to lack of combustible material for the kilns. Haviland & Company and Theodore Haviland Company were practically the only two factories that were still able to continue production, albeit on a smaller scale. William Haviland sent a letter to Sandoz stating that with the bombardment in Paris and the lack of need for luxury items, there was no market for his figurines at this time; hence they would not be buying from him for a while, selling only what was on hand.

Sandoz gathered his new pieces together for a showing at an Exhibition in Lyon in 1919, but sales were not very good as money was still scarce in the aftermath of the Great War. This was to be the last exhibition for a while and because of this, there was no market in which Sandoz could sell. The final showing for the Sandoz ani-

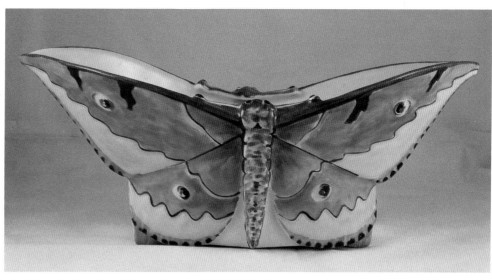

Figure 360. Butterfly jardiniere, 11" wide, open at top with holes on sides for hanging, if desired. Theodore Haviland Company, 1917. Marks are impressed M, p and Sandoz signature, with impressed SDZ. $1200-1600.

mals was at *L'Exposition Internationale des Arts Décoratifs et Industriel Moderne* held in Paris in 1925. His pieces were a great success for the Theodore Haviland Company, but there were disagreements over designs and costs, and he discontinued selling his pieces to Haviland. He continued to design and sculpt in his studio in Paris and died in Lausanne, Switzerland, in 1971. His studio has now been turned into a museum.

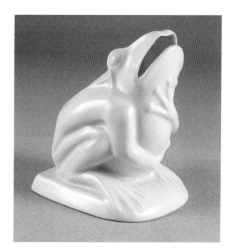

Figure 361. Piggy bank or, in French, *Tirelire*. A frog, 3½", with light celadon glaze over the white porcelain. Theodore Haviland Company, 1916. Marks are impressed M and impressed SDZ. $500-750.

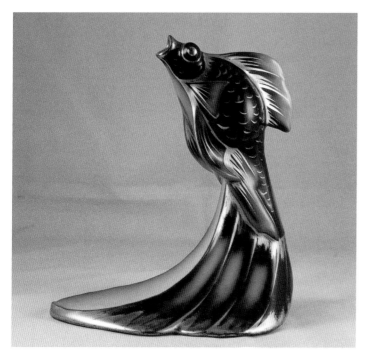

Figure 359. Cobalt fish designed by Edouard Marcel Sandoz, 7". Theodore Haviland Company, 1917. Marks are impressed M, p and Sandoz signature, with impressed SDZ. $1000-1250.

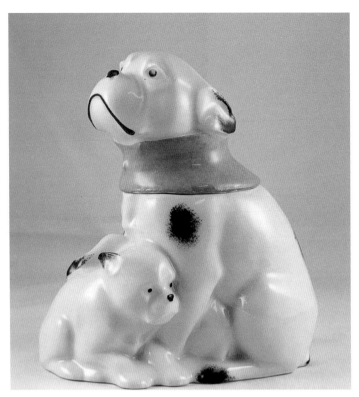

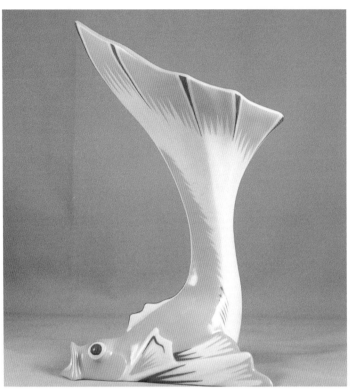

Figure 362. Bulldog and pup candy box, 8". Theodore Haviland Company, 1916. Marks are impressed M and impressed SDZ. $1200-1500.

Figure 364. Limited edition Sandoz reproduction of a fish vase, 6" x 10", made for Tiffany Company. Haviland & Company, 1970s. Marks M and impressed "S" plus *Hand painted from a design of E. Sandoz-edition limitee, n:038/1000.* $200-250.

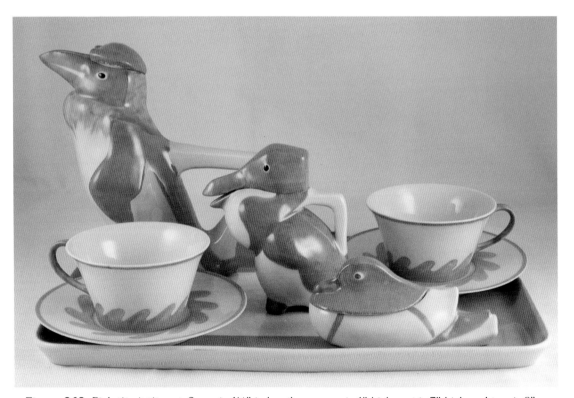

Figure 363. Pink tête-à-tête set. Sugar is 4½" in length, creamer is 4" high, pot is 7" high and tray is 8" x 12½". Theodore Haviland Company, 1916-1917. Marks are impressed M & p with copyright depose, impressed SDZ and Sandoz signature. Set $2200-2600.

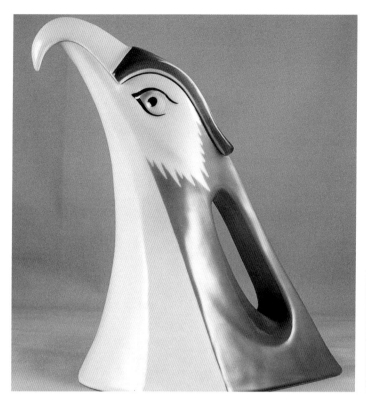

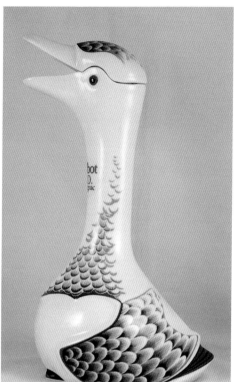

Figure 367. Chabot Armagnac decanter, 12", a reproduction of a Sandoz piece. Haviland & Company, 1983. $150-200.

Figure 365. Limited edition Sandoz reproduction of an eagle pitcher, 7" x 10". Haviland & Company, 1970s. Marks M and impressed "S" plus *Hand painted from a design of E. Sandoz-edition limitee, n:002.* $200-250.

Art Deco

Styles and trends were changing and the 1920s and 1930s were given many labels—*Jazz Age, Age of Bright Young Things, Cocktail Age*, etc. Edwardians had rejected Victorianism and now people in the 1920s were attempting to remove everything old-fashioned. The Arts Décoratifs Exhibition held in Paris in 1925 was the beginning of the Art Deco Period. This exhibition had such a deep and lasting effect on the applied arts that it can also be considered to be the beginning of the contemporary era.

William Haviland, who had inherited the company upon the death of his father, Theodore, wanted to bring the company into the modern age. One of his first steps was to destroy many of the old-fashioned molds to make warehouse space for the dinnerware he was going to create, much to the dismay of long-time employees. But he felt that the new, cleaner styles were going to be around for a long time. He then hired fresh artists to create simple and cheerful designs—Jean Dufy, León Jonhaud, Solange Patry-Bié, and Susanne Lalique, wife of Paul Haviland and daughter of the famous crystal maker.

The pieces shown by the Theodore Haviland Company at the 1925 exhibition created quite a sensation and the *Château de France* design by Jean Dufy won

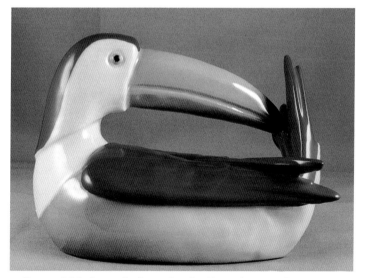

Figure 366. Limited edition Sandoz Reproduction of a toucan bird, 5½" x 7½", made for Tiffany Company. Haviland & Company, 1970s. Marks M and impressed "S" plus *Hand painted from a design of E. Sandoz-edition limitee, n: 12/1000.* $200-250.

the manufacturer an *Ex-Competition, Member of the Jury* award. William Haviland was impressed with the various items offered at this exhibition and set about creating original shapes and designs that had never before been tried in dinnerware. The introduction of colored pastes such as celadon, a pale gray-green color, and geometrical patterns in design gave a whole new look and feel to the Haviland china. Haviland & Company had first produced a celadon in 1878, but William Haviland created a better celadon in 1926-28, using chromium instead of iron and adding 2 percent manganese dioxide.

William Haviland knew what he was doing when he moved Haviland & Company into the modern age, with new plain shapes, colors, and designs. His ideas have only been improved upon, and have never gone back to the intricate, ornate look of the 1800s. Today, however, there is a resurgence of interest in the beauty of the past, and the old Haviland is finding a place on our tables today, right alongside the new.

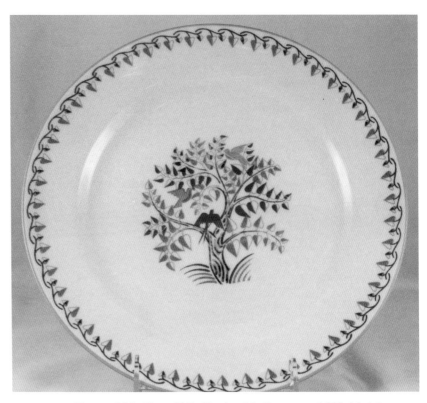

Figure 369. Plate, 9½". Haviland & Company, 1920. Mark I inside of a scrolled box in brown with brown lettering above green mark *Manufactured and Decorated by,* and in black script, *Designed by Robert Bonfils,* plus the factory number 36373 in red. $50-65.

Figure 370. Plate, 7½", teacup and saucer in Art Deco style. Haviland & Company, 1914-1925. Mark I plus *Made in France, Frank Haviland-Stunier & Co., Liverpool, Paris-Limoges.* Teacup and saucer $40-50. Plate $25-30.

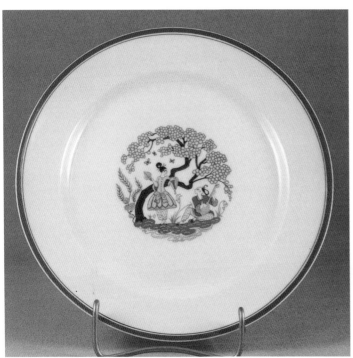

Figure 368. Plate, 8½", in Art Deco design. Haviland & Company, 1925-1929. Marks I and c. $40-50.

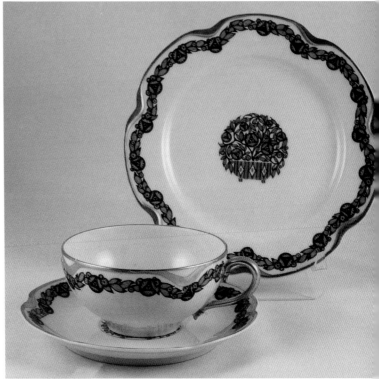

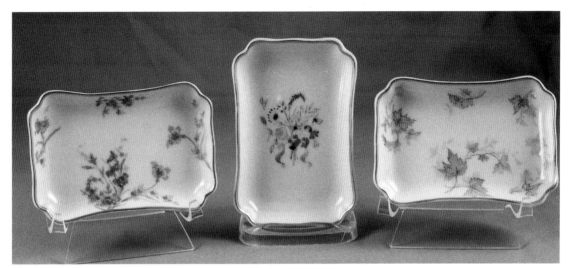

Figure 371. Ashtrays, left to right: *Fleurette* pattern, impressed TH with Marks I and c; factory hand painted and signed *décor de Solange Patry-Bié*, with Marks I & r; *Autumn Leaf* pattern. Marks I and c. Each $40-65.

Figure 372. Ashtray in Art Deco design. Theodore Haviland Company, 1925. Marks I, P and r. $40-65.

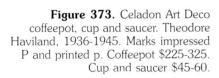

Figure 373. Celadon Art Deco coffeepot, cup and saucer. Theodore Haviland, 1936-1945. Marks impressed P and printed p. Coffeepot $225-325. Cup and saucer $45-60.

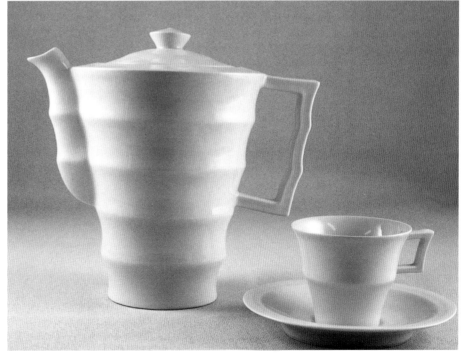

Part 3: Haviland Dinnerware

Trends in Dining

In *Antique Week* magazine (July 24, 1995) there was an article entitled, *China Collectors Cry*. It read: *During World War I, a company of American soldiers was stationed in the Haviland China factory in Limoges. Instead of washing their dishes, they simply tossed the dirty ones out the window, ruining many pieces of what today would be highly collectible china.* Thankfully this was a short-lived trend.

When David Haviland first approached the French porcelain workers in Limoges, he knew that the American people wanted English shapes and designs in dinnerware. Americans preferred simple shapes and colors, unlike the French who liked ornate designs. French sets included huge soup tureens (as main dishes were often soup) and plates that were too small, and no cups or saucers. By designing and making his own molds, David was able to make a product that would be popular in the United States for many years to come. He was the first American to recognize the American public's desire for the quality of French china and to have the courage to make and decorate it in a manner suitable to the American market.

In the early years, 1840 to 1850, exports in Limoges reached only about $100,000 a year. By the 1880s, shipments totaled almost $1,500,000 a year, and by 1900 they had reached $3,000,000 with over 2,500 workmen employed in Limoges—all to be credited to Haviland & Company. Very little porcelain had been exported from France before the American Havilands came to Limoges; but once David started shipping his porcelain to America, the other porcelain manufacturers realized how much profit there was in exporting their product.

Between 1820 and 1899, the American home became the center of nurtured values, and everything revolved around the home and family. Large volumes were written in how to take care of a home and the people therein. One such book entitled, *The Home Instructor, a Compendium of Useful Knowledge Necessary for the Practical Uses of Every-Day Life,* was published in 1885. In his preface, author Thomas W. Handford states: *Great stress is laid on the value of home training, from the deepening conviction that as the home is, so the life will be.* He goes on about how grand and wonderful the *home* is meant to be: *Men are for the most part what their homes have made them; and as men make communities, and communities make states, and states make nations, it follows that the great power molding the destinies of men and nations lies mainly in the influences of home. Whatever, therefore, contributes to the development of this home influence is of vital interest.* This book continues for 540 pages along the same lines, describing in detail how each person in the household is to act and react toward one another. Instructions in cooking and cleaning, plus etiquette in dining, conversing, courting, business, and *every* other daily action were included.

The largest sections in these types of books, however, were devoted to dining and to preparation of the meal. How a person dined was a great status symbol and whom they invited to dine an even greater status symbol. An invitation to dine was the highest mark of respect a person could pay. Attention to the table—with its china, crystal, and silver—was uppermost in importance. The more silver and gold that was shown on the white linen tablecloth, the more affluence and, possibly, a higher social standing.

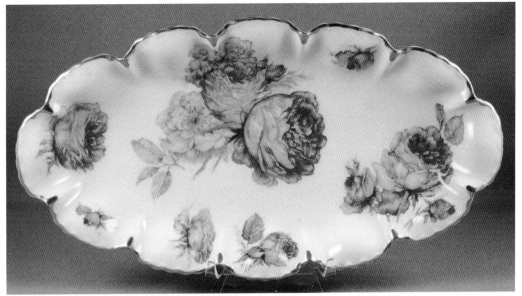

Figure 374. Bread tray in unidentified pattern. Haviland & Company, 1894-1931. Marks I and c. $225-325.

Figure 375. Shallow bowl, 9½", in unidentified pattern. Haviland & Company, 1894-1931. Marks I and c. $225-275.

Fine Dining in the Golden Age

New York City was the home of the very wealthy in the 1870s, just when Haviland china was becoming better known in America,. At the time of the Civil War, there were only three millionaires in the United States; but as soon as the war ended, a new crop of the affluent were ready to flaunt their riches. These were the *Barons of Industry, kings of the new industrial age*; and by 1890, there were 4,000 millionaires. These *nouveau riche*, however, were uncertain of high society manners and were more than ready to put themselves into the hands of someone like Ward McAllister, who over the years had become the arbiter of social ranking. With great fortunes being made overnight, society could easily become dominated by whomever at the moment had the most money. Some guidelines for society had to be established to keep out the *socially unqualified*.

Mrs. William Backhouse Astor II, later to be known as *The* Mrs. Astor, worked with McAllister to establish *The 400*—a list of the most socially accepted. Mrs. Astor's New York ballroom could accommodate only 400 people, hence the number in the social registry. They hardened the lines of social etiquette, raised fiscal requirements and created a caste where money and snobbery would make up for lineal shortage.

This self-appointed queen held court at 350 Fifth Avenue in New York City, moving society into opulent entertaining. She made gastronomy a cult with her weekly dinner parties. Guests stayed at table for three to four hours, working through nine to fifteen courses of a menu. She often had more than one hundred guests, sometimes at a moment's notice.

Dinnerware was an important part of entertaining. A young woman of society was expected to be able to serve one hundred guests at a moment's notice and she would need enough china, crystal and silver to furnish the table adequately. Haviland china played an important part by impressing the dinner guests. Simple floral Haviland china would be used for breakfast, but for dinner the Haviland dinner service dined upon would be encrusted with gold and very elegant.

Some of the very wealthy might use a service trimmed with cobalt and gold and possibly a crest or initial. Others used a different pattern for each course served, but it can be sure that each household had several sets of everyday as well as *good* china. Haviland china was very popular with the royalty in Europe, and Americans as wealthy as the Astors and the Vanderbilts were considered royalty in America. Therefore, Haviland china was very popular among New York Society. And as in Europe, the middle class purchased Haviland china to follow the lead of the upper class society.

Newport, Rhode Island, became the summer home of the rich and famous. By 1893 Newport was taken over by Alva and Alice Vanderbilt, Mrs. Stuyvescent Fish and several other socialites of the time. They took dining into an even grander scale than Mrs. Astor had ever dreamed. Dinner parties and balls were given every night, especially during the summer season.

Several decades earlier, Americans had thumbed their noses at European formality and deportment, and were refreshing in their informality. By the 1890s, however, this society was overcompensating after being criticized by foreign observers. In Newport and in New York, society was the only game: women set the rules and a stranger was either *in* or *out* by the merest social act. The husbands left all of the entertaining and social aspects to the wives. They attended the social functions, but spent the rest of their time conducting business or on their yachts.

In the beginning of the 1890s, approximately $100,000 to $300,000 was spent on parties and entertainment by each household in the six to eight weeks of summer living. This extravagance included only flowers, food, decorations, and clothing; it did not include staff or the running of the households. As the nineteenth century came to a close, a *single* party could cost this amount. Newport Society slipped from Victorian restriction toward Edwardian sensuality and idiosyncrasy, and the summer gaiety in Newport turned increasingly frenetic in its pleasure seeking. The super rich had been restrained in the past, but this was changing. Parties were overly sumptuous, each one more spectacular than the last—everything in excess.

As everyone gradually became tired of the long ponderous dinner parties, Alice Vanderbilt decided that an eight-course dinner should be served in one hour flat, even if slow eaters dropped three courses behind. Mrs. Stuyvesant Fish went even further and would serve her eight- to ten-course dinner in fifty minutes. Each footman was assigned to two guests and was under strict orders to keep the courses moving. Guests remembered having to hold down their plates with one hand while eating with the other. One guest recalled lifting his hand to take a fish bone from his mouth, and before he could put the bone on his plate, the plate was gone!

Even with the solid gold standard dollar of the turn of the century, the amounts spent on entertainment were staggering. Some of the wealthier hostesses spent up to $500,000 during the summer season. Such opulence was never to be seen again. In today's dollars, that would be equivalent to about $6 million. Money was to be used for whatever pleasure was wanted. These lavish parties took on all the aspect of a Broadway production. The excess was almost dizzying to the ordinary wage earner. In 1892, the average worker earned $495 a year. Two thirds of the nation's families had an income of less than $900, and only one in twenty had an income of more than $3,000.

Behind the incessant entertaining and party giving stood a large and industrious group of servants. Little information is given on this backstage crew of English butlers, major domos, French maids, long-schooled French chefs, cooks, servers, cleaners and polishers. This world was as rigid and snobbish as the structure of the society it served. The servants were a mirror image of their masters; each knew his or her place and guarded it carefully. No butler would have thought of soiling his gloves emptying an ashtray.

Keeping the great houses in operating condition called for the services of hundred of servants. Preparing and serving dinner for one hundred guests at the spur of the moment became a major backstairs effort, but the lady of the house took the bows and was credited with being a magnificent manager of her household. One matron insisted, even after a ball for 500, that everything be cleaned up immediately after the event. This meant washing thousands of pieces of china, crystal and silverware and putting everything away after an evening that might end at 4:00 or 5:00 a.m. (The average salary for a servant at this time was from $18 to $35 a year, plus room and board!)

Eventually, this frantic need to spend money came to a halt and the golden age came to an end. The sinking of the Titanic in 1912, with the deaths of so many of the millionaires, told society that it was not impervious to tragedy. Also, many of the American socialite daughters had married into titled families in England and in

Europe, and with World War I came a time of personal worry for the affluent families. Income tax was a final blow and wealth in this scale was not seen again for a long time. That age of elegant dining was at an end.

Figure 378. Shallow serving bowl, 9", in unidentified pattern on Schleiger blank no. 24. Haviland & Company, 1894-1931. Marks I and c. $95-125.

Figure 376. Plate, 8½", in Schleiger no. 257C. Haviland & Company, 1894-1931. Marks I and c. $45-60.

Figure 379. Plate, 8½", in unidentified pattern on Schleiger blank no. 24. Haviland & Company, 1894-1931. Marks I and c. $45-60.

Figure 377. Plate, 8½", in unidentified pattern on Schleiger blank no. 25. Haviland & Company, 1894-1931. Marks I and c. $45-60.

It was vital that everything on the dinner table be in its correct place. I have quoted from both Handford's *The Home Instructor* and Lowney's Cook Book of 1907 in the following guidelines applied for setting a proper table.

Allow twenty inches for every person. Place a ten-inch service plate, having decorations, right side up, in the center of the space, and one and one half inches from the edge of the table. Arrange knives, edges toward plate, in the order in which they will be needed, place soup spoon, bowl up; at the right of the soup spoon, the oyster fork, with tines up; the other forks, with tines up, at the left of the plate, in the order in which they will be needed, beginning with the extreme left. The glass for water should be placed just above the center of the plate, to the right, the wineglasses to the right of the water glass, in the order in which they are to be used. It is a pretty custom to place a little bouquet by the side of each lady's plate, and to fold a bunch of flowers in the napkin of each gentleman, to be attached to the left lapel of the coat as soon as seats are taken at the table. Place the napkins either to the left of the forks, or over the service plate. They should be folded as to hold a bread stick or a dinner roll. The name card is generally placed on top of the napkin or over the plate. A small saltcellar should be placed by each place, also a small butter plate. The space in front of a guest is always occupied with a plate. When the servant removes the course plate with the left hand, he or she places another plate with the right hand.

Before the dessert, everything not needed for this course should be removed from the table. Crumbs are then brushed from the table. Place the dessert dishes from the right. While the dessert is being eaten, the finger bowls, filled one third full of tepid water, with a slice of lemon or a geranium leaf or a flower in it, set on a doily on a plate, may be placed in front and above the dessert plate. When the dessert plate is removed, the finger bowl is moved into the space. If fruit follows the dessert, the guest removes the finger bowl and doily from the plate and uses that plate for the fruit. If coffee is served in the dining room, the finger bowls are not placed until after the coffee, but coffee is usually served in the drawing room.

Figure 380. Plate, 7½", in a variation of Schleiger no. 69 on Schleiger blank no. 22. Haviland & Company, 1894-1931. Marks I & c for Clark Sawyer Company. $25-30.

Figure 381. Plate, 7½", in unidentified pattern on Schleiger blank no. 24. Haviland & Company, 1894-1931. Marks I and c. $25-30.

Figure 382. Coupe plate, 7½", in unidentified pattern on Schleiger blank no. 24. Haviland & Company, 1894-1931. Marks I and c for Yost-Dohrmann Co., Stockton, CA. $25-30.

Figure 384. Coupe plate, 6½", on Schleiger no. 79K. Haviland & Company, 1894-1931. Marks I and c. $22-26.

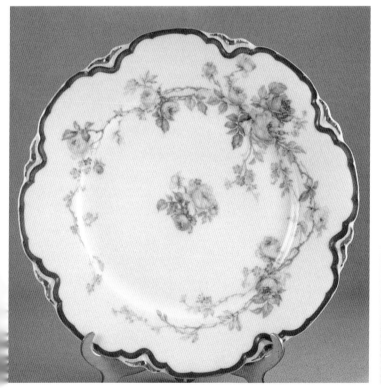

Figure 383. Plate, 8½", in unidentified pattern on Schleiger blank no. 424. Haviland & Company, 1894-1931. Marks I and c for P.D.G. & Co., Indianapolis, Ind. $30-45.

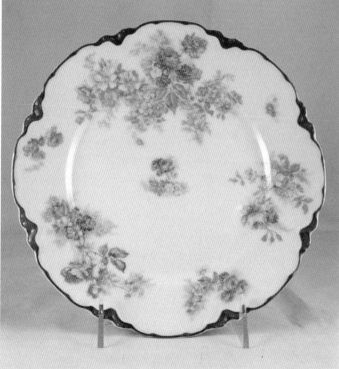

Figure 385. Plate, 8½, in unidentified pattern on Schleiger blank no. 24. Haviland & Company, 1894-1931. Marks I and c for Chas Mayer Co., Indianapolis, IND. $35-40.

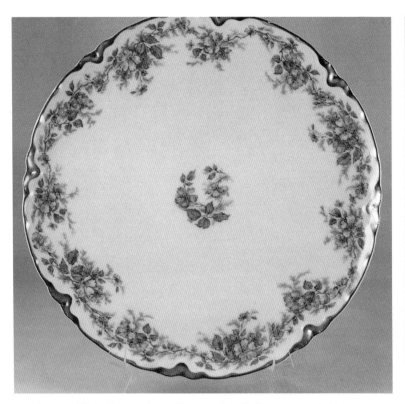

Figure 386. Coupe plate, 9", in unidentified pattern on Schleiger blank no. 24. Haviland & Company, 1894-1931. Marks I and c. $40-55.

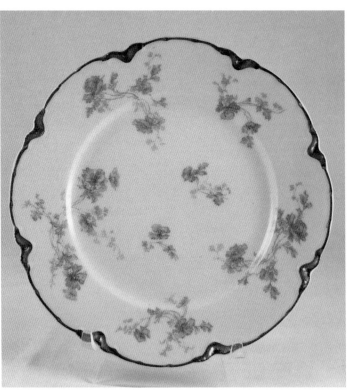

Figure 388. Plate, 7½", in unidentified pattern on Schleiger blank no. 24. Haviland & Company, 1894-1931. Marks I and c. $25-30.

Figure 387. Coupe plate, 7½", in Schleiger no. 466E. Haviland & Company, 1894-1931. Marks I and c. $30-35.

Figure 389. Plate, 9½", in unidentified pattern on Schleiger blank no. 16. Haviland & Company, 1894-1931. Marks I and c. $35-40.

Figure 390. Coupe plate, 7½", in unidentified pattern on Schleiger blank no. 24. Haviland & Company, 1894-1931. Marks I and c. $25-30.

Figure 392. Unglazed flat tray, 15½", in unidentified pattern on Schleiger blank no. 216. Haviland & Company, 1894-1931. Marks I and c. $175-225.

Figure 391. Plate, 7½", in variation of Schleiger no. 252 on blank no. 25. Haviland & Company, 1894-1931. Marks I and "Made expressly for Bailey, Banks & Biddle Co., Philadelphia, PA." $25-30.

Figure 393. Coupe plate, 7½", in unidentified pattern on Schleiger blank no. 418. Haviland & Company, 1894-1931. Marks I and *Haviland & Company pour Wright Tyndale & Van Roden.* $25-30.

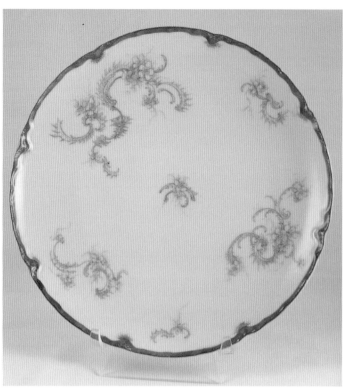

Figure 394. Plate, 8½", in a variation of Schleiger no. 261 with green and gold border. Haviland & Company, 1894-1931. Marks I and c. $35-45.

Figure 396. Coupe plate, 7½", in a variation Schleiger no. 910. Haviland & Company, 1888-1896. Mark H. $25-30.

Figure 395. Plate, 8½", in Schleiger no. 312 on blank No. 591. Theodore Haviland Company, 1903. Mark p. $25-28.

Figure 397. Plate, 8½", in a variation of Schleiger no. 910D. Haviland & Company, 1894-1931. Marks I and c. $30-40.

Figure 398. Serving bowl, 9" x 1¾" in unidentified pattern. Haviland & Company, 1894-1931. Marks I and c for PDG Co., Indianapolis. $75-95.

Figure 400. Plate, 8½", in Schleiger no. 72. Haviland & Company, 1894-1931. Marks I and c. $30-40.

Figure 399. Plate, 8½", in unidentified pattern on Schleiger blank no. 24. Haviland & Company, 1894-1931. Marks I and c. $25-30.

Figure 401. Plate, 6½", in Schleiger no. 146N on blank no. 133. Theodore Haviland Company, 1903. Mark p. $22-26.

Figure 402. Plate, 9½", in Schleiger no. 33 on blank no. 19. Haviland & Company, 1894-1931. Marks I and c, for The Wilson Grocery Co., Greeley, CO. $30-40.

Figure 403. Plate, 9 7/8", in unidentified pattern on Schleiger blank no. 118. Theodore Haviland Company, 1895. Mark n for The Van Heusen-Charles Co., Albany, NY. $30-40.

Figure 404. Plate, 9½", in unidentified pattern on Ranson blank. Haviland & Company, 1894-1931. Marks I and c. $30-40.

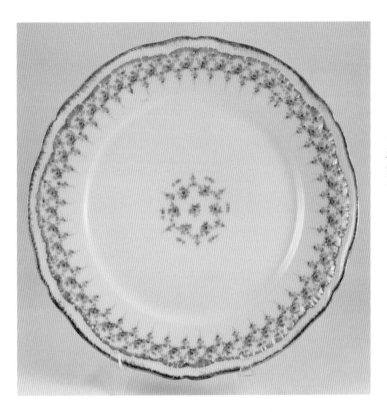

Figure 405. Plate, 8½", in Schleiger no. 349A on blank no. 304. Theodore Haviland Company, 1903. Mark p and Parmelee Dohrman Co., Los Angeles. $25-30.

Figure 406. Plate, 9½", in a variation of Schleiger no. 62 on blank no. 18. Haviland & Company, 1894-1931. Marks I and c, "Made expressly for Bailey, Banks & Biddle, Philadelphia, PA." $30-40.

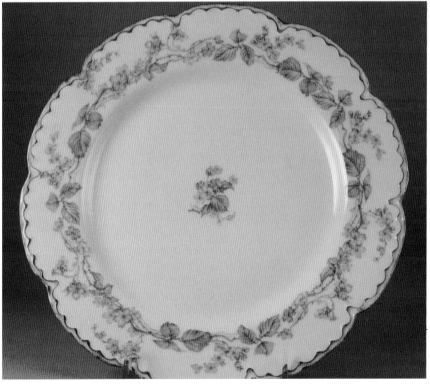

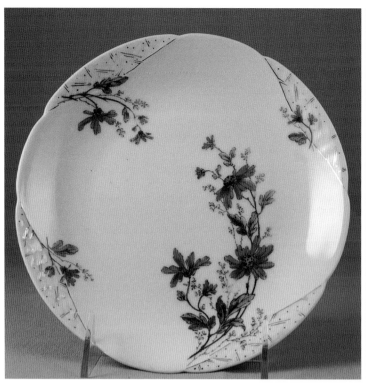

Figure 407. Coupe plate, 7½", in unidentified pattern on Osier blank. Haviland & Company, 1876-1889. Marks F and g. $20-30.

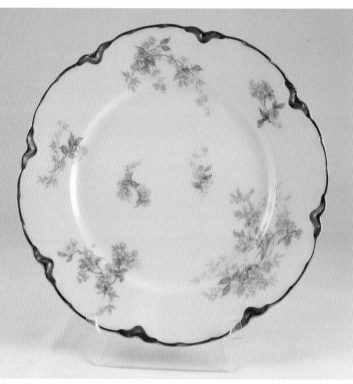

Figure 409. Plate, 7½", in unidentified pattern on Schleiger blank no. 24. Haviland & Company, 1894-1931. Marks I and c for M.F. Kaag & Sons, Fort Wayne, Ind. $20-30.

Figure 408. Coupe plate, 7½", in unidentified pattern on Schleiger blank no. 24. Haviland & Company, 1894-1931. Marks I and c. $20-30.

Figure 410. Plate, 9½", in unidentified pattern on Schleiger blank no. 15. Haviland & Company, 1894-1931. Marks I and c. $30-40.

Figure 411. Plate, 8¼", in unidentified pattern. Theodore Haviland Company, 1903. Marks impressed M and q. $45-65.

Figure 413. Coupe plate, 7½" in Schleiger no. 484A. Haviland & Company, 1894-1931. Marks I and c. $20-30.

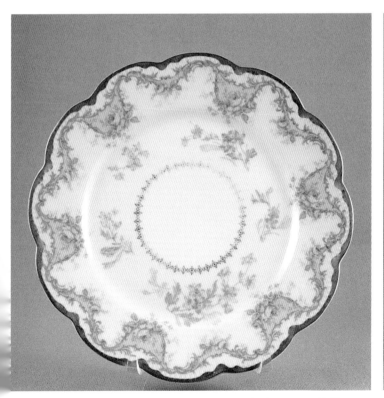

Figure 412. Plate, 8½" with variation of Schleiger no. 484B on blank no. 216. Haviland & Company, 1894-1931. Marks I and c. $30-40.

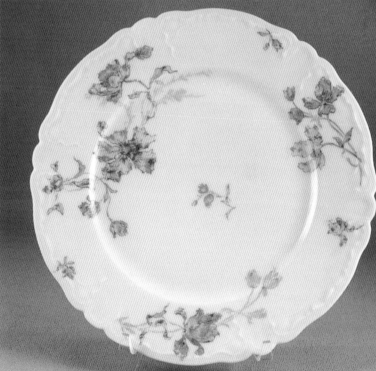

Figure 414. Plate, 8½", in Schleiger no. 234A. Haviland & Company, 1888-1896. Marks H and c. $25-30.

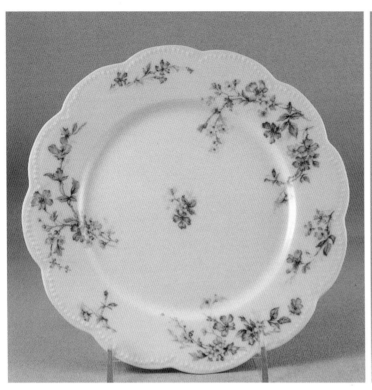

Figure 415. Plate, 8½", in unidentified pattern on Schleiger blank no. 5. Haviland & Company, 1894-1931. Marks I and c, for J McD. and S. Co. $25-30.

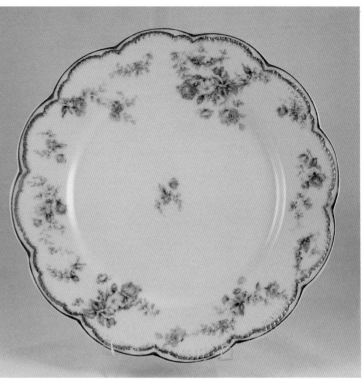

Figure 417. Plate, 9½", in a variation of Schleiger no. 682. Haviland & Company, 1894-1931. Marks I and c. $30-40.

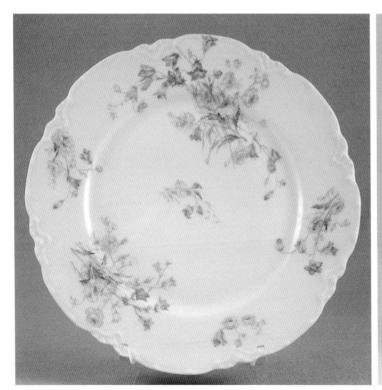

Figure 416. Plate, 8½", in unidentified pattern on Ranson blank. Haviland & Company, 1894-1931. Marks I and c. $25-30.

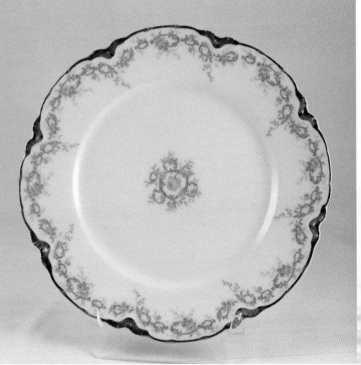

Figure 418. Plate, 7½", in Schleiger no. 269B. Haviland & Company, 1894-1931. Marks I and c, made expressly for H.S. Barney Co., Schnectecdy, NY. $25-30.

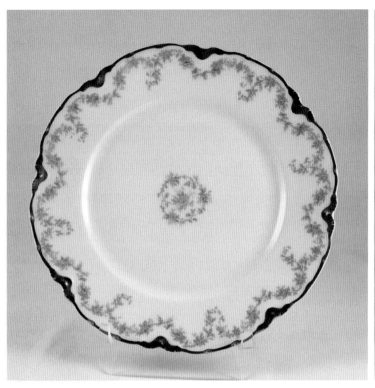

Figure 419. Plate, 7½", in Schleiger no. 976. Haviland & Company, 1894-1931. Marks I and c. $25-30.

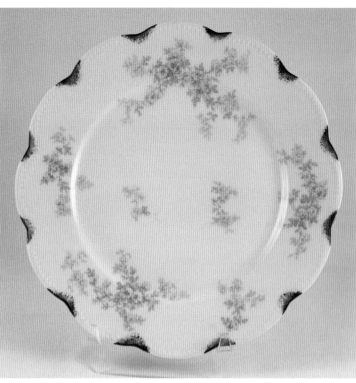

Figure 421. Plate, 8½", in Schleiger no. 67. Haviland & Company, 1894-1931. Marks I and c. $26-32.

Figure 420. Plate, 8½", in Schleiger no. 235H. Haviland & Company, 1894-1931. Marks I and c. $30-35.

Figure 422. Plate, 8½", in unidentified pattern on Schleiger blank no. 23. Haviland & Company, 1888-1896. Marks H & *Haviland & Co. pour Tyndale & Mitchell Company, Philadelphia.* $28-35.

Figure 423. Plate, 9½", in
Schleiger no. 147A. Theodore
Haviland Company, 1903. Mark
p. $30-35.

Figure 424. Coupe plate, 7½", in unidentified
pattern. Haviland & Company, 1888-1896.
Marks H and c for S. R. James (This does not
specify a particular company so may have been
a special order). $25-35.

Figure 425. Plate, 6½", in Schleiger no. 228E.
Haviland & Company, 1894-1931. Marks I and c.
$20-25.

Figure 426. Rimmed oatmeal bowl, 7½", in unidentified pattern. Haviland & Company, 1894-1931. Mark I and *Made expressly for Bailey, Banks & Biddle Co., Philadelphia, PA.* $30-35.

Figure 428. Coupe plate, 7½", in Schleger no. 95A. Haviland & Company, 1894-1931. Marks I and c for Yost-Dohrmann Co., Stockton, CA. $25-35.

Figure 427. Plate, 10¼", in unidentified pattern. Haviland & Company, 1894-1931. Marks I and c. $75-100.

Figure 429. Plate, 9½", in unidentified pattern. Haviland & Company, 1894-1931. Marks I and c. $25-30.

Figure 430. Plate, 7½", in Schleiger no. 788. Haviland & Company, 1894-1931. Marks I and c. $24-28.

Figure 432. Plate, 6½", on Schleiger no. 104. Haviland & Company, 1894-1931. Marks I and c. $20-25.

Figure 431. Plate, 8½", in a variation of Schleiger no. 619 on Schleiger blank no. 805. Theodore Haviland Company, 1903. Mark p. $25-30.

Figure 433. Plate, 9½", on Schleiger no. 520. Haviland & Company, 1894-1931. Marks I and c. $30-35.

Figure 434. Plate, 9", in unidentified pattern on Schleiger blank no. 422. Haviland & Company, 1888-1896. Mark H and *Haviland & Co. pour C.A. Selger, Cleveland.* $50-75.

Haviland China at First Hands and other Advertisements

In the 1880s, *Haviland China at First Hands,* was the primary title of all Haviland advertisements placed in newspapers and magazines. These antique marketing ploys have proved to be treasure houses of information to those of us who come more than a hundred years later. Primarily, they tell us what the company called the various pieces and how they were sold. An 1885 ad stated that there were 300 variations of decorations in stock and new designs were available every week. Dinner sets were sold complete or in courses. Also sold were oyster sets, soup sets, fish sets, roast sets, game sets, salad sets, ice cream sets, fruit plates, and after dinner coffee sets.

An ad from the 1880s showing a large fish platter read, *Especially appropriate for the Lenten Season;* another mentions *Goods suitable for Wedding or Holiday Gifts in great variety.* Parts of sets were displayed in handsome cases especially adapted for gift giving.

Here is a statement from one of the early ads for Frank Haviland, 14 Barclay Street, New York:

"To give an enjoyable dinner or a delightful tea is one of the great pleasures of housekeeping. Good cooking is a first requisite, but good service is almost as important. Poor or gaudily decorated china on the table destroys one's pleasure. You do not like to eat salads and desserts from uninviting dishes. You want delicate cups for bouillon, coffee and tea; substantial and handsome plates for more substantial dishes.

If you want to be sure of getting just the right thing, the latest in design, and choicest in decoration, buy Haviland & Co.'s china. They are the representative makers in the entire world, of the finest and best porcelain ware for the table."

The ad most likely referred to other European dinnerware that came in heavily decorated styles with smaller plates, exactly why David Haviland first created Haviland & Company. In another large ad, Haviland & Company also stressed the awards given to the china at the various international expositions, stressing the fineness of their ware, along with the exquisite taste and great variety of decoration.

Ads in Sears & Roebuck catalogs, Montgomery Ward catalogs, etc., from the late 1800s and early 1900s often show patterns that are recognizable today. In a 1907-08 fall and winter catalog from Olds, Wortman and King from Portland, Oregon, is shown the pattern Schleiger no. 98, commonly known as *Cloverleaf*. In this catalog, however, it is called *Vauray*. A 100-piece set was listed at $40.50 and a 117-piece set at $82.25. It is one of the most complete listing of various pieces available that I have seen for this pattern.

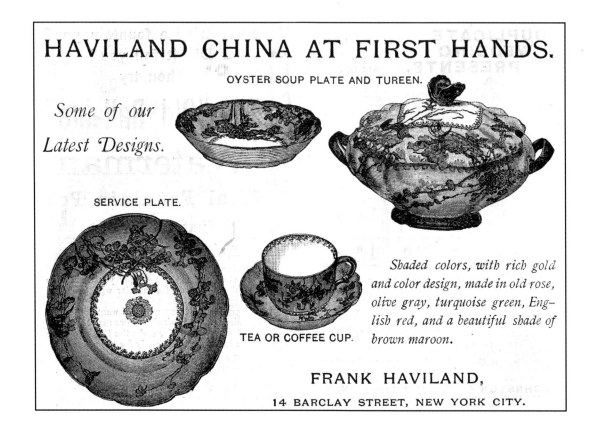

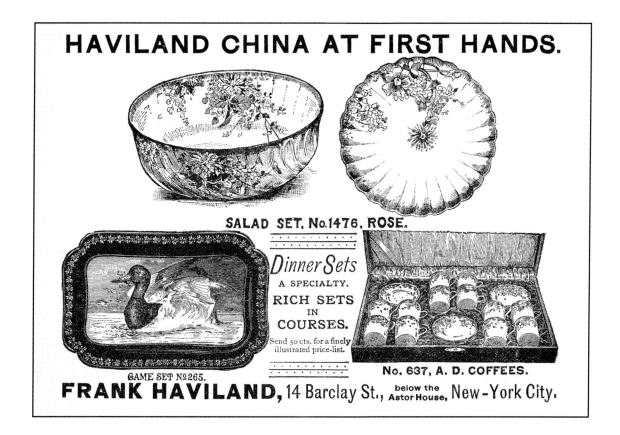

A Dinner Service in *Ranson*

The *Ranson* shape, also known as Schleiger no. 1 (Haviland patterns are commonly identified by Schleiger numbers. These numbers refer to patterns listed in a series of books entitled *Two Hundred Patterns of Haviland China - Volumes 1-7* by Arlene and Dona Schleiger. With a small percentage of the patterns ever named, the Schleiger books have become invaluable in locating patterns.), has been attributed to Paul Ranson, a painter who worked at Haviland & Company from 1890 to 1893. This shape has proven to be one of the most popular blanks ever to be created by Haviland & Company and was in production from 1893 until 1931. Bavarian and Austrian companies copied the shape so closely that collectors will sometimes fill in their dinner sets with the copies.

After *Haviland China-The Age of Elegance* was published, many people wrote or called to ask if I could list the various pieces that were available in their pattern in my next book. I have chosen the *Ranson* shape because so many decorated sets were sold using this blank. I have created my list using several sources: the Olds, Wortman and King catalog; Haviland's catalog of shapes 1927; the white ware catalog by W. A. Maurer, Council Bluffs, Iowa; and the white ware catalog by C. E. Wheelock & Co., Peoria, Illinois. This is a fairly complete list of pieces that were available in the *Ranson* blank, however, I don't think that all of the items listed here were available in every pattern made on this blank. Sizes are listed as found for reference and comparison of pieces. Some pieces are very rare and lists grow as unknown pieces are discovered (I have placed items in categories for easier identification and study).

Plates
10 1/8" service plate
9½" dinner plate
9" coupe plate
8½" breakfast plate
8½" coupe plate
7½" tea or pie plate (we know it as salad)
7½" coupe plate
6½" bread and butter plate
6½" coupe plate
5½" bun plate
4½" roll plate
4" honey plate
3" individual butter plate

Bowls
5" sauce/fruit bowls
5½" sauce/fruit bowls
6" sauce/fruit bowls
6" deep cereal bowl
7" rimmed oatmeal
7½" coupe soup
9" coupe or oyster bowl
9½" rimmed soup

Tea, Coffee and Chocolate pots
2-cup small tea pot
6-cup 7" medium teapot
12-cup 8¼" large teapot

6-cup coffeepot
12-cup coffeepot
6-cup medium chocolate pot
12-cup large 10" chocolate pot

Sugar bowls
2-cup 3½" sugar
6-cup 4¾" sugar
2-cup open dessert sugar
6-cup open sugar

Creamers and Pitchers
2-cup 3¼" creamer
6-cup 4" creamer
3rd size 6¾" jug
2nd size 8" pitcher
3rd size 14¾" lemonade
Wide 8½" pitcher in blank 12, used with Ranson sets

Cups and saucers
1st teacup 2" x 3½" and saucer 5 3/8"
Coffee cup 2¼" x 3¾" and saucer 5 7/8" (also called extra or 2nd teacup in some catalogs)
3rd teacup 1¾" x 3¼" and saucer 4½" also known as a 5 o'clock cup)
1st After-Dinner coffee cup 2¼" x 2¼" and saucer 4¼"
2nd After-Dinner coffee cup (slightly smaller than 1st size but no size available)
Chocolate cup 3" x 4¼" and saucer 4¾"
Bouillon cup 2¼" x 4¼" and saucer 5½"
Covered bouillon cup and saucer
4 5/8" cream soup and saucer
Most cups come in round, flared and footed flared shapes.

Platters
11½" platter
13¾" platter
15¾" platter
17 3/4" platter with gravy well
20¼" platter with gravy well
22 3/8" with gravy well
11¾" round chop platter
12 7/8" round chop platter
14 1/3" round chop platter (Maurer catalog lists one but can not verify)
10¾" round handled cake plate
8 3/8" x 10½" oval cake plate or bacon platter (used for either)
23½" fish platter
14" round turbot fish platter with drain

Serving dishes
10½" covered oval vegetable dish
9¼" covered round vegetable dish
10" oblong uncovered vegetable dish
9" oblong uncovered vegetable dish
Large oval soup tureen

Round soup or oyster tureen
Open gravy bowl with attached undertray
Handled sauce with underplate
4¾" x 8½" covered sauce tureen
4½" x 2¼" bowl (may be finger bowl)
5" waste bowl
6½" bone dish
Three-piece covered butter dish
7" small lobster salad
9½" x 2¾" lobster salad
9½" footed salad
7½" footed salad
5¾" footed salad
5" oval mustard with attached underplate
Round mustard with separate underplate
8½" pickle dish
Olive dish
12" celery tray
Mayonnaise with attached undertray
13 5/8" bread tray
3½" ramekin and 5¼" underplate
Large jelly (no shape available but on same page with ice relish)
Small jelly
5½" ice relish
8½" ice relish
Three-piece pudding set—8 7/8" bowl, 8" liner and 11" underplate with unglazed bottom
9" x 2¾" macaroni dish with 10 1/8" underplate
Individual salt cellar
9" crescent salad plate
6½" cracker or biscuit jar
Tea and toast set
8 7/8" oyster plate
Ash tray
Individual vegetable bowl (also called beaner)
9¼" covered muffin server
9" covered buckwheat dish
Punch bowl
3" tall punch cup
7½" spoon tray
High pedestal fruit bowl
Tall pedestal comport
8" round English comport
Petit fours comport.

There were three different styles of *Ranson* blank created by Haviland & Company: one has bow handles, is more rounded and sits up on a small 1" foot; one has leaf handles and is round with no foot; and one has twig handles with a ruffled ridge toward the bottom of the piece, giving it a squatty appearance. I have not attempted to list every shape of pieces above. By taking information from so many sources, it was also found that names varied for the same piece, especially the relish dishes. I have tried to weed out duplicates, but there are sure to be some mistakes.

Figure 435. Creamer and sugar bowl in Ranson blank, Schleiger no. 1. Haviland & Company, 1894-1931. Mark I. $95-125.

Figure 436. Mustache cup and saucer in Ranson blank. Haviland & Company, 1894-1931. Mark I. $150-175.

Named Patterns — 1920s through 1950s

The names and years listed below were taken from actual advertisements for these patterns. The years listed are the earliest years they appear. Some patterns appear for several years, so this list is an approximation of date. The Haviland Companies, during the last 70 years or so, had a habit of assigning the same name to two different patterns. Names were also duplicated between the French and the American Haviland. One must be very careful in trying to locate a pattern to mention the year of production if known and a description of the pattern.

Shelton, made in France in 1920s, has a gold band while *Shelton, Made in America*, has a heavy embossed platinum band. *Valmont*, also known as Schleiger no. 540 was duplicated in the 1960s in the Torse blank with gray flowers. *Malmaison* with scenic plates from the 1950s

was reissued in the 1980s with a cobalt and gold border plus small flowers. *Autumn Leaf*, popular at the turn of the century, was also so named in the 1940s and 1950s with a gold trim. *Chambord* in the 1920s was on the Pilgrim shape, a blue border with flowers and birds, while *Chambord* in the 1960s is on a plain blank with gold filigree pattern.

Here are a few more names that have two distinctly different patterns with the same name. *Arcadia, Chantilly, Cluny, Concord, Fleurette, Gloria, Marquise* (also known as Schleiger no. 585), *Monceau, Moss Rose, Sheraton, Springtime, Strasbourg, Symphony, Vendome*, and *Versailles*. One needs to be aware that there are probably many more duplicate names from over the past that have not been written here.

Ads from 1921 show the following patterns for sale: *Ambizar, Arcadia* (bird pattern), *Eden, Kim, Paradise, Rajah*, and *Rani*.

Ads from 1923 show the following patterns: *Montméry, Nastursium, Oriental* (Schleiger no. 509), *Paisley*, and *Rosemary*. A 1924 ad showed *Noinville* and 1925 showed *Garden of Allah*.

In 1926 ads show the following patterns: *Chateaudun, Chenonceaux, Chevalier, Cluny, Florence, Narcissus, Parisien*, and *Yale*.

In 1927 ads show the following patterns: *The Albany, Argonne, Azay-le-Rideau, Autumn, Blois, Chambord, Coromandel, Ganga, Gloria, Miami, Normandy, Plaza, Saratoga*, and *Symphony*.

Ads from 1928 show the following patterns: *Aquitania, Burgundy, Concord* and *The Montreux;* and in 1937, *Vendome*.

In 1945, the following *Made in America* patterns were introduced: *Garden Flowers, Pasadena* and *Regents Park* series of flowers.

In 1945, the following *Made in America* patterns were introduced: *Apple Blossom, Cambridge, Gotham,* and *Wilton.*

In 1952, the following *Made in America* patterns were introduced: *Arbor, Bel-Air, Cashmere, Shasta, Shelton,* and *Sylvia.* In 1956, Haviland introduced *Prelude.*

Active patterns listed in 1958 were: *Annette, Autumn leaf, Bagatelle, Chatelle, Clinton* (American), *Concorde, Crillon Blue, Crillon Gold, Crillon Red, Danville, Delaware* (American), *Elysée, Floreal, Madison* (American), *Marnelle, Montméry, Oxford* (American), *Poppy, Rosalinde* (American), *Royale* Blue (American), *Royale Red* (American), *Sanford* (American), *Shelton* (American), *Sheraton* (Louis XIV shape), *Sylvia, Trellis, Varenne* (American), *Versailles,* and *Wilton* (American).

Downsizing of place settings began in the 1920s. A 1937 catalog page from Belknap Hardware & Manufacturing Co. listed the following pieces of *Vendome* for sale: Dinner plates 9 5/8", breakfast plates 7½", salad plates 6½", bread and butter plates 6½", coupe soups 7 5/8", fruits 5", teacups and saucers, after dinner coffee cups and saucers, cream soups 4", teapots, sugar 6 3/8", creamer 4½", round salad or nappie, 11¾" platter, 14" platter, 15" platter, oval vegetable or baker 9½", pickle 8" x 5 5/8", celery tray 12½" x 5 3/8", casserole 9 1/8" x 4½", sauce boat 7½", covered butter 7", and cake plate with handles 9". A twelve-piece place setting was priced at $525.

Patterns and Shapes Through the Centuries

The photographs shown on the following pages tell a story and describe an era of grace and beauty. As a Theodore Haviland ad from 1923 read: *A woman whose taste shows itself instinctively in fine table linen and silver can afford to be no less exacting in her selection of china.*

Shapes and designs of dinnerware have evolved greatly over the past 150 years, and the first 75 years of Haviland china (1842-1925) portray the real evolution of design in the decorative arts. David Haviland started in the 1840s to the 1860s with Classical-styled dinner sets featuring large, even, smooth-edged pieces in a revival of the Greek and Roman forms. In the 1860s, styles became Baroque or Victorian: rims of plates were notched or scalloped, and designs were molded into the white ware.

Patterns and shapes in dinnerware progressed from Japonisme, Art Nouveau, and Arts and Crafts to culminate in a complexity of design in the 1890s, when we entered the Gay Rococo era. However, by 1910, the public tired of this over-ornamentation and the Haviland companies returned to the simplicity of classic patterns and shapes. The twentieth century brought a cleanness of line and color with the beginning of the Art Deco movement in the 1920s, sending us full speed ahead into what we now consider Modern and Traditional design.

And so dinnerware evolves according to the needs and desires of each generation. And the madder and more hurried our complicated modern lives become, the more we need that time to sit and enjoy a beautifully laid table and a good meal. Haviland china is not merely a set of pretty and unique dishes once owned by our grandmothers or great-grandmothers, it is a link to the past—*our* past. No matter how the table spread before us evolves over the years, there will always be that heartfelt longing for beauty and elegance.

Figure 437. Plate, 9½", in unidentified pattern. Haviland & Company, 1876-1878. Marks F and c. $125-175.

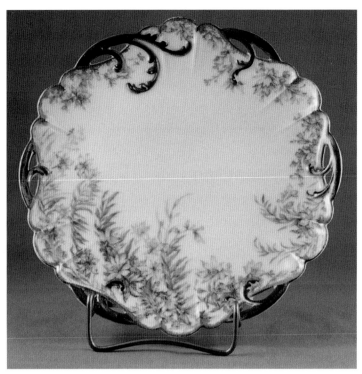

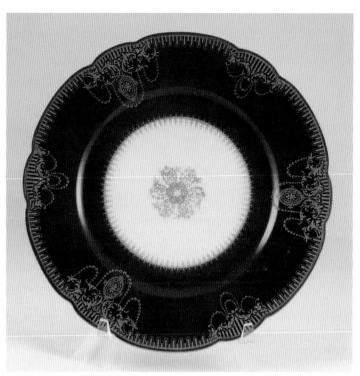

Figure 445. Reticulated plate, 7½", in a variation of Schleiger no. 447. Haviland & Company, 1894-1931. Marks I and c. $150-175.

Figure 447. Plate, 7½", in dark green and gold unidentified pattern. Haviland & Company, 1894-1931. Marks I and c. $50-75.

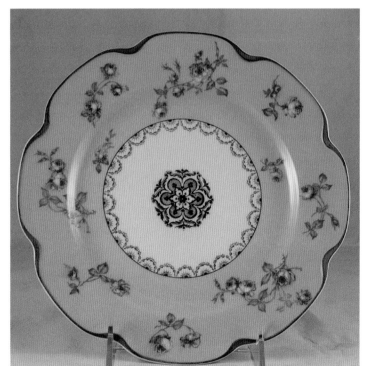

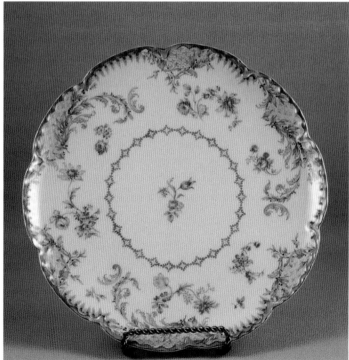

Figure 446. Plate, 8½", in unidentified pattern. Haviland & Company, 1894-1931. Marks I and c for Chas. Mayer, Indianapolis, Ind. $50-75.

Figure 448. Coupe plate, 8½", in unidentified pattern. Haviland & Company, 1888-1896. Marks H and c. $75-100.

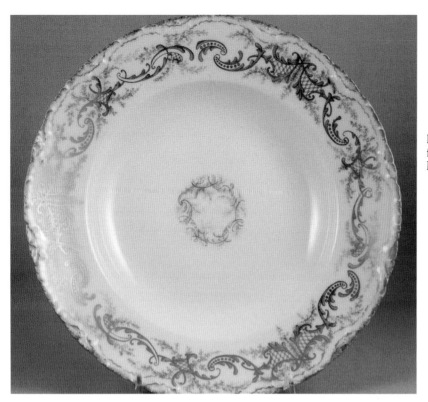

Figure 449. Rimmed soup bowl, 9½", in unidentified pattern. Theodore Haviland Company, 1895. Mark n for A. French Co., Boston. $50-75.

Figure 450. Plate, 9½", in unidentified pattern. This is a salesman's sample and reads *16911, Josephine T..f.* Haviland & Company, 1894-1931. Marks I and c. $75-100.

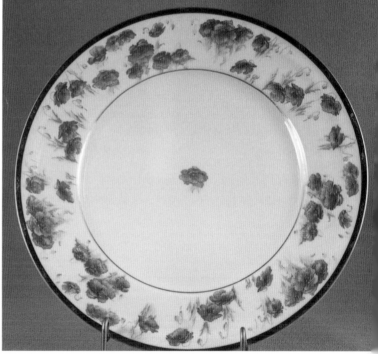

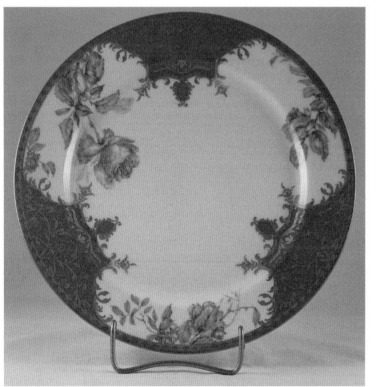

Figure 451. Plate, 10¼", in unidentified pattern. Haviland & Company, 1894-1931. Marks I and c. $100-125.

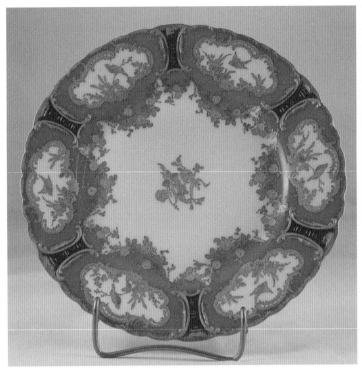

Figure 452. Plate, 8½", in unidentified pattern. Haviland & Company, 1894-1931. Marks I and d, made for J.E. Caldwell & Co. $150-225.

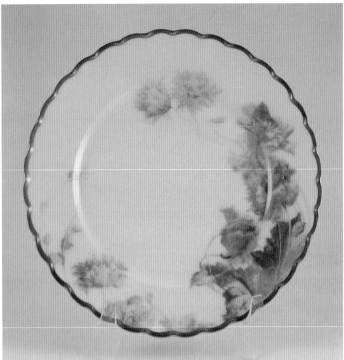

Figure 454. Plate, 8½", in Feu de Four Poppy and Seeds pattern on Schleiger blank no. 12 with gold. Haviland & Company, 1893-1918. Mark I and h. $100-125.

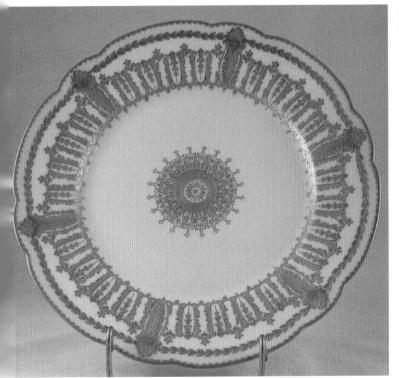

Figure 453. Plate, 9½", in unidentified pattern. This is a salesman's sample and reads *16304...T...1X*. Haviland & Company 1894-1931. Marks I and c in gold. $175-225.

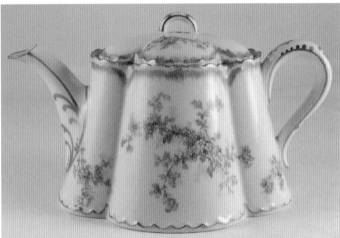

Figure 455. Small teapot, 5" to top of finial, in Schleiger no. 29K on Schleiger blank no. 2. Haviland & Company, 1894-1931. Marks I and c. $200-225.

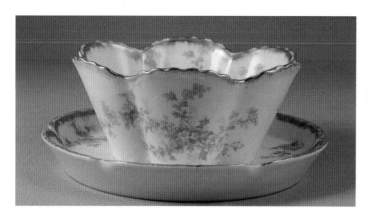

Figure 456. Mayonnaise with attached underplate, bowl 5" on 6½" underplate, in Schleiger no. 29K on Schleiger blank no. 2. Haviland & Company, 1894-1931. Marks I and c. $125-175.

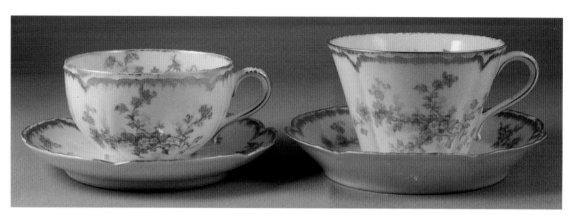

Figure 457. Coffee cups and saucers in Schleiger no. 29K, showing the two different blanks and cup shapes that come in this pattern. From left to right: Schleiger blank no. 13, 3¾" wide x 2¼" high; Schleiger blank no. 2, 4" wide x 2¾" high. Haviland & Company, 1894-1931. Marks I and c. Each $50-60.

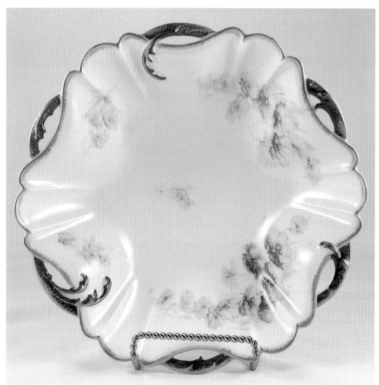

Figure 458. Shallow serving bowl, 9½" x 2½", in a variation of Schleiger no. 665. Haviland & Company, 1894-1931. Marks I and c. $175-225.

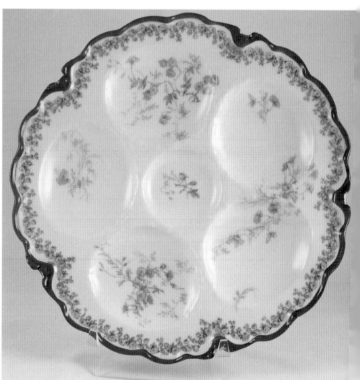

Figure 459. Oyster plate, 9", in a variation of Schleiger no. 459D. Haviland & Company, 1888-1896. Marks H and c. $225-275.

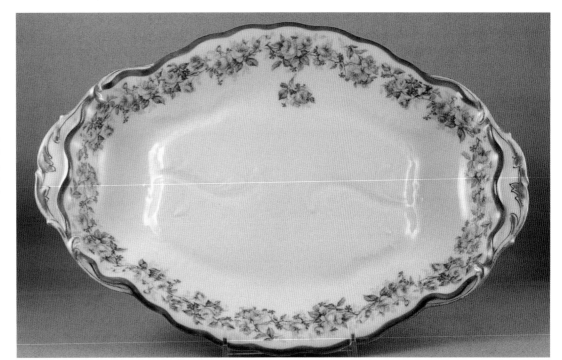

Figure 460. Beef platter, 15", in unclassified pattern. Haviland & Company, 1894-1931. Marks I and c. $350-450.

Figure 461. Small tray, 5½" x 8½", in Schleiger no. 1225. Theodore Haviland Company, 1892. Mark K plus *Saint Cloud and Manufactured by Theodore Haviland Limoges.* $45-60.

Figure 462. Cookie platter, 9½" x 7¾", in Schleiger no. 672D. Haviland & Company, 1888-1896. Marks H and i. $75-85.

Figure 463. Shallow serving bowl, 9" x 7¼", in unidentified pattern on Schleiger blank no. 9, Marseilles. Haviland & Company, 1888-1896. Marks H and c. $75-125.

Figure 464. Two-piece handled sauceboat in the Miramar pattern, 7" from spout to handle, 3" to high part of spout, base measures 8¼" x 4¾". Haviland & Company, 1894-1931. Marks I and c. $125-150.

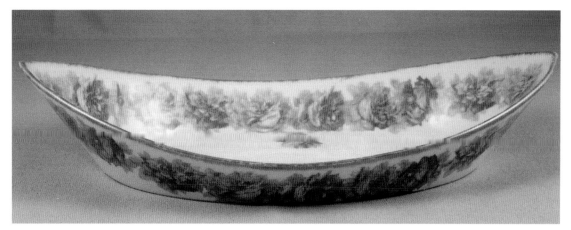

Figure 465. Bread boat, 11¾" x 6", in a variation of the Drop Rose pattern, Schleiger no. 55. Haviland & Company, 1894-1931. Marks I and c. $250-300.

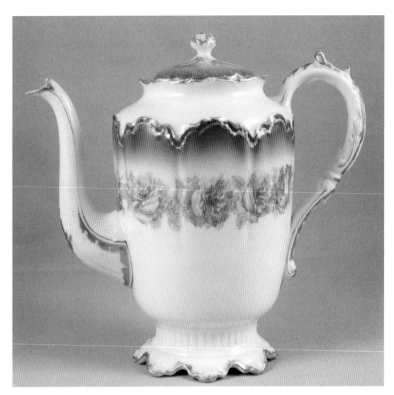

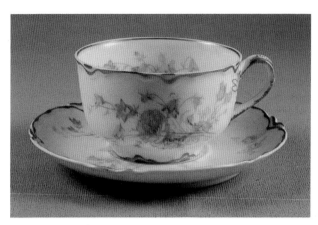

Figure 468. Teacup and saucer in unidentified pattern on Schleiger blank no. 424. Haviland & Company, 1894. Marks I and g for Chas. S. Mayer Co., Indianapolis, IN. $40-50.

Figure 466. Coffeepot, 7", in a variation of the Drop Rose pattern. Haviland & Company, 1894-1931. Marks I and c. $450-550.

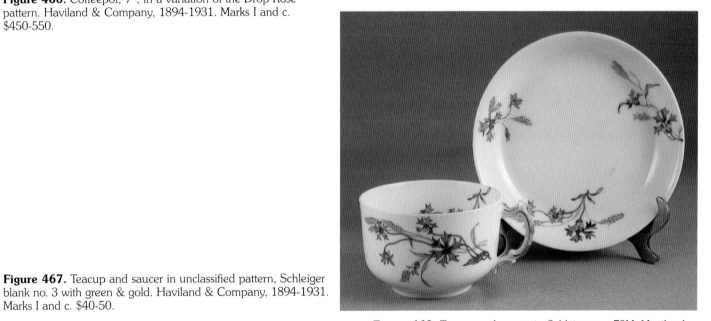

Figure 467. Teacup and saucer in unclassified pattern, Schleiger blank no. 3 with green & gold. Haviland & Company, 1894-1931. Marks I and c. $40-50.

Figure 469. Teacup and saucer in Schleiger no. 73H. Haviland & Company, 1876-1889. Marks F and c. $40-50.

Figure 473. Bouillon cup and saucer in fancy variation of Schleiger no. 52-O on ruffled, footed Ranson blank. Haviland & Company, 1876-1889. Marks F and c. $65-75.

Figure 470. Teacup and saucer in unidentified pattern. Theodore Haviland Company, 1903. Marks are impressed M and p. $40-50.

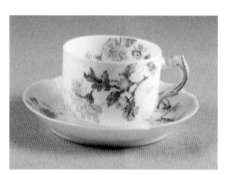

Figure 474. Short after-dinner cup and saucer, 1½" high x 2¼" wide, in Schleiger no. 86. Haviland & Company, 1888-1896. Marks H and c for Meyberg Bros., Los Angeles, CA. $45-60.

Figure 471. Bouillon cup and saucer in unidentified pattern. Haviland & Company, 1894-1931. Marks I and c for *G.R./A.* $50-75.

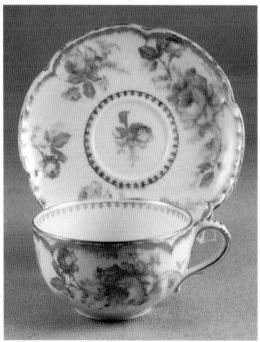

Figure 472. Teacup and saucer in Schleiger no. 257F. Haviland & Company, 1894-1931. Marks I and c. $50-65.

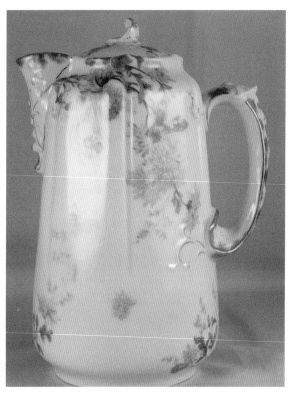

Figure 476. Mug, 3", in an unidentified pattern on Schleiger blank no. 24. Haviland & Company, 1894-1931. Marks I and c. $75-125.

Figure 475. Chocolate pot, 7½", in a variation of Schleiger no. 86. Haviland & Company, 1888-1896. Marks H & c for Wilmirth & Edmonston, Wash, DC. $350-450.

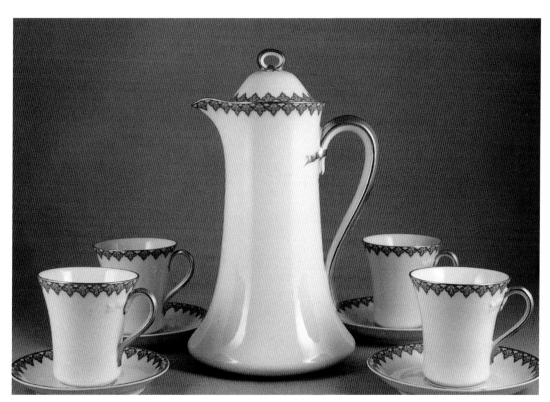

Figure 477. Chocolate set with four chocolate cups and saucers in Schleiger no. 295, The Monaco. Pot is 9" and cups are 2 7/8" high. Haviland & Company, 1894-1931. Marks I and c. $425-525.

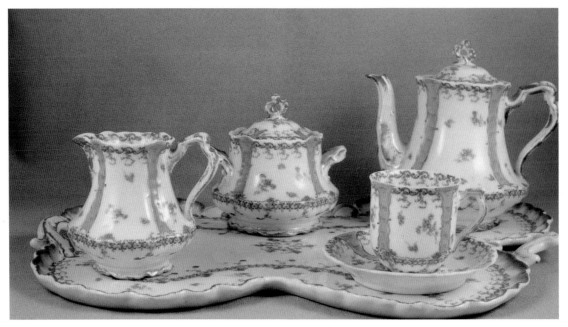

Figure 478. Tête a tête set (one cup missing), pot is 4½", tray has unglazed bottom and is 15" wide. Set is in unidentified pattern on Schleiger blank no. 208. Haviland & Company, 1888-1896. Marks H and c. $1200-1500.

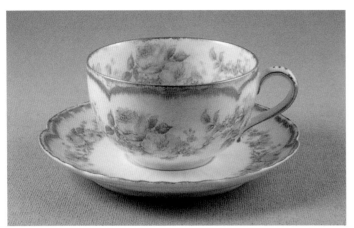

Figure 479. Teacup and saucer in unclassified pattern on Schleiger blank no. 13, gold trim no. 418. Haviland & Company, 1894-1931. Marks I and c. $50-60.

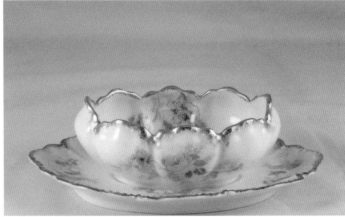

Figure 480. Mayonnaise dish on underplate, in unidentified pattern. Haviland & Company, 1894. Marks I and d *pour Chas. Emerson & Sons, Haverhill, MA.* $125-150.

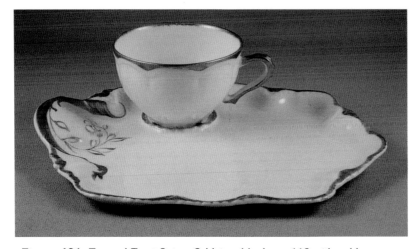

Figure 481. Tea and Toast Set on Schleiger blank no. 118 with gold. Theodore Haviland Company, 1903. Marks are impressed M and p for S & G Gump, S.F. $150-175.

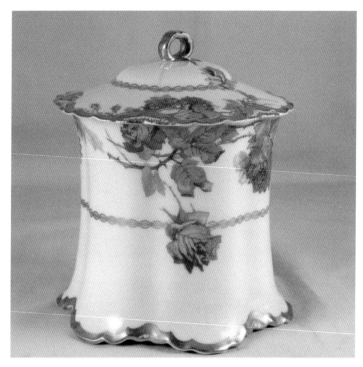

Figure 482. Cracker jar in pattern Schleiger no. 65. Haviland & Company, 1894-1931. Marks I and c plus factory no. 22119. $250-300.

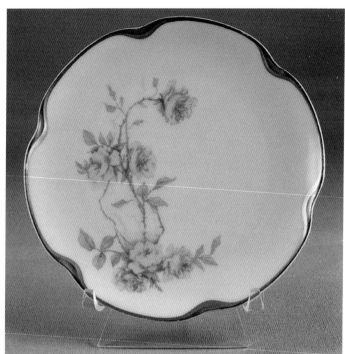

Figure 484. Coupe plate, 7½", on Schleiger no. 1151P, commonly known as Baltimore Rose, Blank no. 19. Haviland & Company, 1894-1931. Marks I and c, "Made expressly for The Reeves-Luffman Co., Schenectady, NY." $55-65.

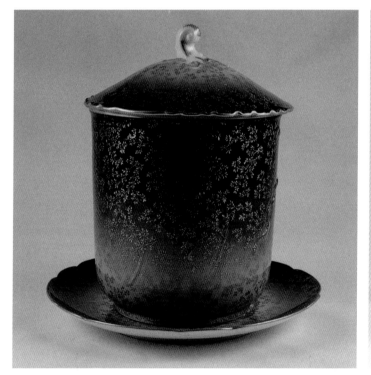

Figure 483. Three-piece cracker jar, sage green shaded to light green with silver and gold design on Marseilles blank no. 9. Jar is 5¼" high, plate is 7¼". Haviland & Company, 1888-1896. Marks H and c, decorated for Olds & Summers, Portland, OR. $450-600.

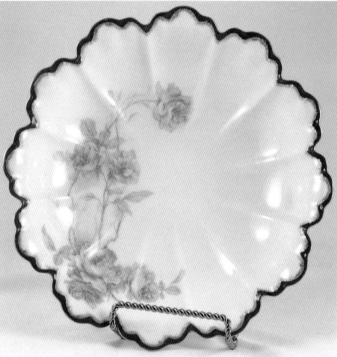

Figure 485. Shallow fruit bowl, 9½" x 2" high, in Schleiger no. 1151Z, Baltimore Rose. Haviland & Company, 1894-1931. Marks I and c. $175-225.

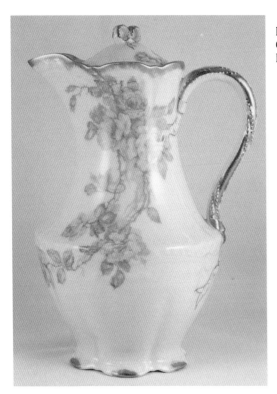

Figure 486. Chocolate pot, 9½, on Schleiger blank no. 124, in a copy of Haviland & Company's Baltimore Rose in yellow. Theodore Haviland Company, 1903. Mark p for Burley & Company. $350-450.

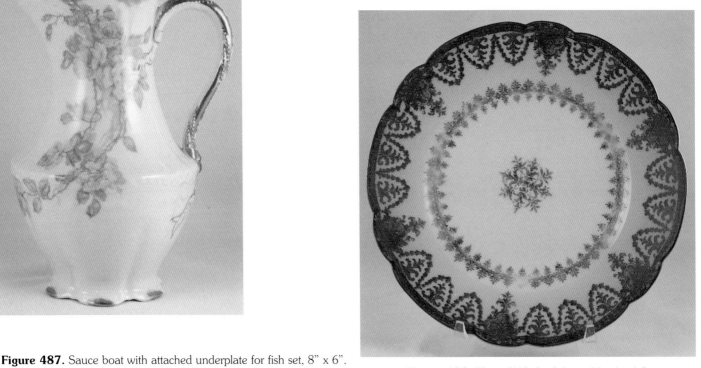

Figure 487. Sauce boat with attached underplate for fish set, 8" x 6". Haviland & Company, 1888-1896. Marks H and c for Burley & Company, Chicago. $250-300.

Figure 488. Plate, 8½", for fish set. Haviland & Company, 1888-1896. Marks H and c for Burley & Company, Chicago. $75-100.

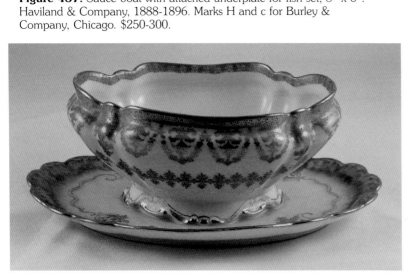

Figure 489. Fish set, platter with silver and gold trim, 22¾" x 8½", and eight plates. See Fig. 490. Haviland & Company, 1876-1894. Marks F and c for French & Potter Company-Chicago. $1500-2000.

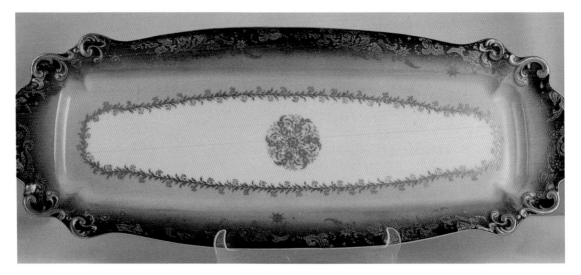

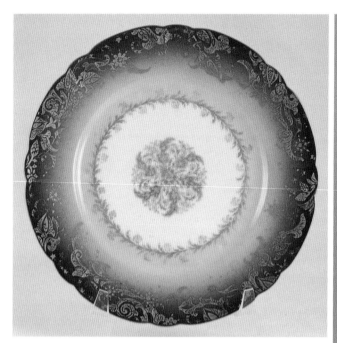

Figure 490. Fish plate, 8½", for fish set, Fig. 489. Haviland & Company, 1876-1894. Marks F and c.

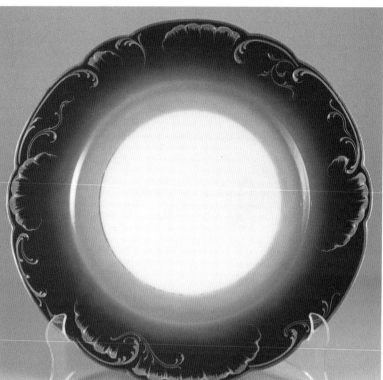

Figure 492. Cobalt and gold plate, 9½", in Marseilles blank. Haviland & Company, 1888-1894. Marks H and c for Frank Haviland, 218 Fifth Ave., NY. $100-125.

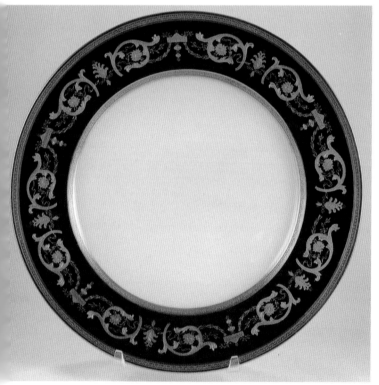

Figure 491. Cobalt and gold plate, 10¼". Theodore Haviland Company, 1903. Mark q. $125-150.

Figure 493. Cobalt and gold plate, 9½". Haviland & Company, 1888-1894. Marks H and c for Meyberg Bros., Los Angeles, CA. $100-125.

Figure 494. Cobalt and gold plate, 9½" with design in center of plate, hand painted and signed by factory artist Jean. Theodore Haviland Company, 1903. Mark p. $125-150.

Figure 496. Plate, 8½", in unidentified pattern with cobalt and gold border. Theodore Haviland Company, 1903. Mark p. $100-125.

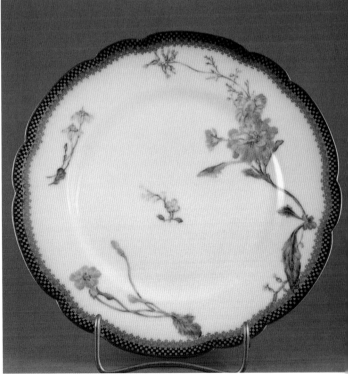

Figure 495. Cobalt & gold plate, 9½", with Schleiger no. 265 pattern in center and musical instruments in gold. Haviland & Company, 1888-1896. Marks H and c. $350-450.

Figure 497. Plate, 8½", in Feu de Four, unidentified pattern, with cobalt and gold border. Haviland & Company, 1888-1931. Marks I and h for J. McD. & S. Co. $125-150.

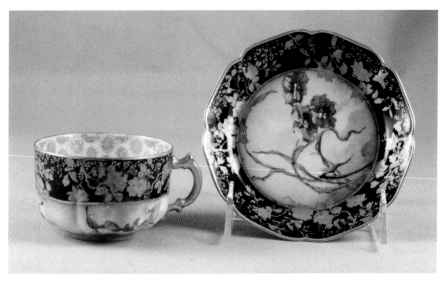

Figure 498. Cobalt and gold teacup and saucer with Parisian floral center. A salesman's sample, back reads *Square pompadour T-56, Round pompadour T-55, +18 doz. For ctrs. & g + doz for insides in cups.* Haviland & Company, 1887-1889. Marks G and g. $175-225.

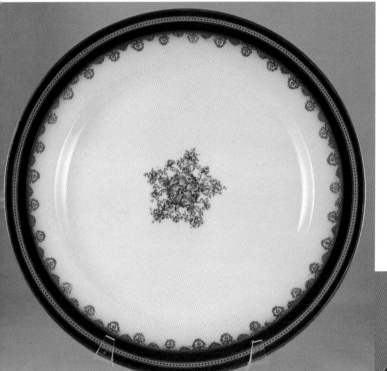

Figure 499. Cobalt and gold plate, 9¾". Theodore Haviland Company, 1894-1903. Marks impressed M and p. $100-125.

Figure 500. Cobalt and gold plate, 9 5/8". Theodore Haviland Company, 1894-1897. Marks M and o. $100-125.

Figure 501. Cobalt and gold plate, 8½". Haviland & Company, 1887. Marks G and Haviland & Co. *pour Wright, Tyndale, Van Roden Co., Philadelphia.* $75-100.

Figure 502. Cobalt and gold plate, 9½". A salesman's sample which reads, *Cannelle ST.* Haviland & Company, 1876-1889. Marks D and g. $125-150.

Figure 503. Cobalt and gold plate, 9½", teacup and saucer. Haviland & Company, 1876-1889. Marks F and g. Three-piece set $200-250.

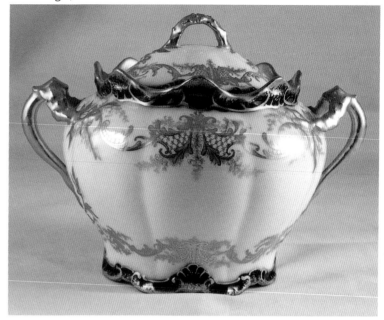

Figure 504. Small leaf-shaped ice cream plate in cobalt and gold, 5". Haviland & Company, 1876-1889. Marks F and g. $75-100.

Figure 506. Large sugar bowl with cobalt and gold trim. Theodore Haviland Company, 1894. Mark m for Abram French Co., Boston. $100-125.

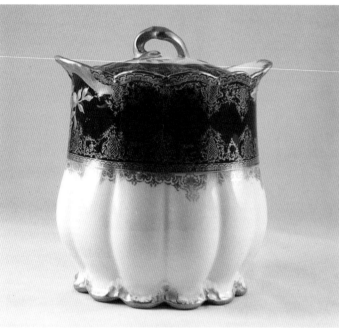

Figure 505. Cobalt and gold cracker jar. Theodore Haviland Company, 1895. Mark n. $450-600.

Figure 507. Cobalt bath set, with wash basin and pitcher with a different flower on each piece. Haviland & Company, 1894-1931. Mark I and h plus Feu de Four. Complete set $5000-7500.

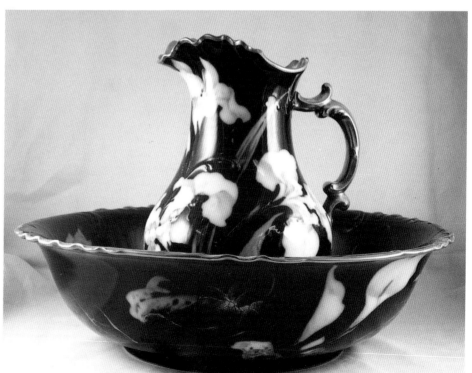

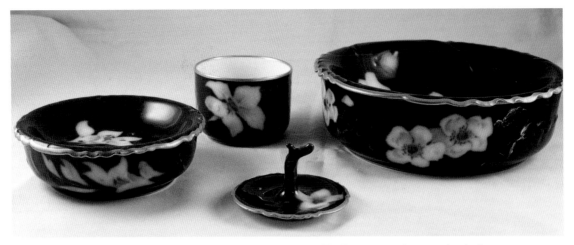

Figure 508. Cobalt bath set, with basin and pitcher in Fig. 507. Four pieces shown right clockwise: sponge bowl, ring holder, soap dish, and cup. Haviland & Company, 1894-1931. Mark I and h plus Feu de Four.

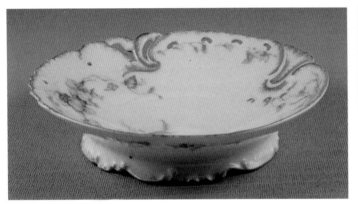

Figure 509. Small footed reticulated *petit four* dish in unidentified pattern. Haviland & Company, 1888-1896. Marks H and c. $75-100.

Figure 510. Small hand painted *petit four* plate, 6" x 1½", on pedestal. Haviland & Company, 1888-1896. Mark H. $65-80.

Figure 511. *Petit four* comport, 8¾" x 1", in a variation of Schleiger no. 56. Haviland & Company, 1894-1931. Marks I and c. $225-250.

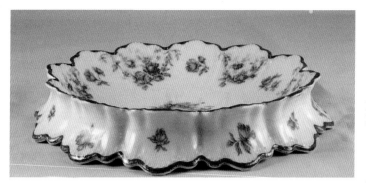

Figure 512. Round footed tea trivet in Schleiger no. 1144. Haviland & Company, 1894-1931. Marks I and c. $150-175.

Figure 513. Oval dish in unidentified pattern. Haviland & Company, 1894-1931. Marks I and c for H.F. Bollmer & Co. $125-150.

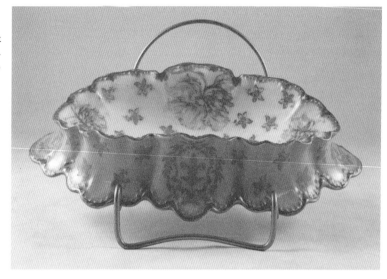

Figure 514. Handled baker with unglazed bottom, 6", in a variation of Schleiger no. 72. Haviland & Company, 1894-1931. Marks I and c. $65-75.

Figure 515. Crescent salad, 9", in Schleiger blank no. 10. Haviland & Company, 1894-1931. Mark I. $65-75.

Figure 516. Candle holder with removable top in St. Cloud blank. Theodore Haviland Company, 1892. Mark K. $125-175.

Figure 518. Large coffeepot, 12", in the Vermicelli blank, Wheat shape. Haviland & Company, 1876-1889. Marks F and g. $450-550.

Figure 517. Bean-shaped plate, 4¼" x 6¼". Haviland & Company, 1876-1889. Mark F. $50-75.

Figure 519. Large soup tureen in unidentified pattern on Wheat shape, 6" high x 11¾" long x 8¼" wide. Haviland & Company, 1876-1889. Mark F *pour Blair & Andree Co., Milwaukee, Wis.* $350-450.

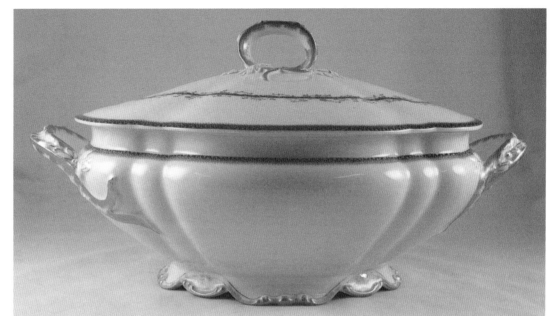

Figure 520. Oval soup tureen in unidentified pattern on Diana shape. Haviland & Company, 1876-1894. Marks F and c. $350-450.

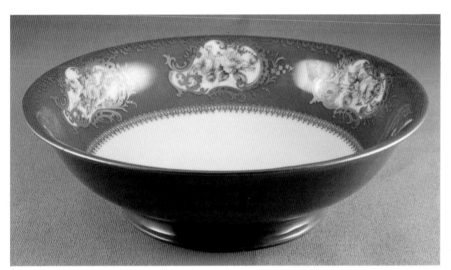

Figure 521 Round open serving bowl in unidentified pattern, 9" x 3". Haviland & Company, 1894-1931. Marks I and c. $250-350.

Figure 522. Round nappy or ice relish, 8", in unidentified pattern. Haviland & Company, 1894-1931. Marks I and c. $250-275.

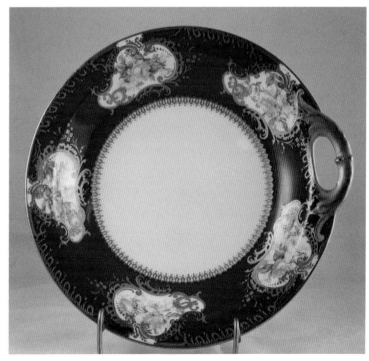

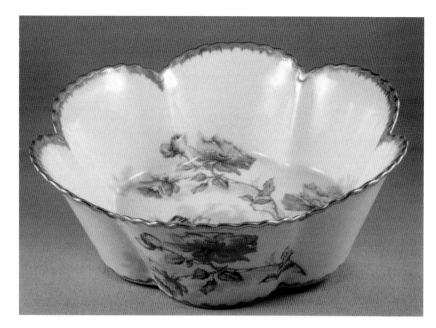

Figure 523. Salad bowl, 9½" x 3½", in unidentified pattern. Haviland & Company, 1894-1931. Marks I and c. $325-425.

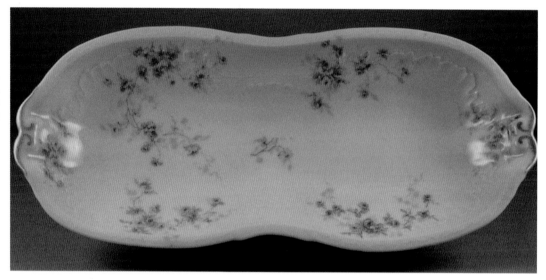

Figure 524. Celery dish in Schleiger no. 150, commonly known as Harrison Rose. Theodore Haviland Company, 1903. Mark p. $95-125.

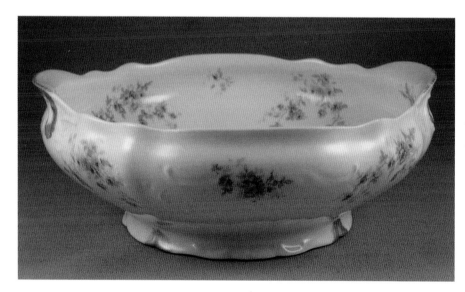

Figure 525. Large salad bowl, 9½" x 3½", in Schleiger no. 150, commonly known as Harrison Rose. Theodore Haviland Company, 1903. Mark p. $125-175.

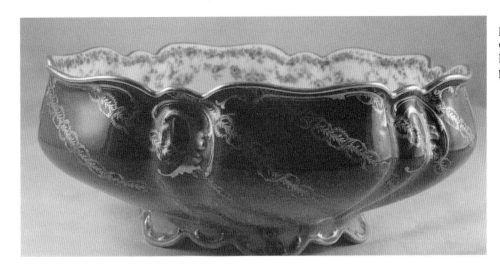

Figure 526. Round open salad bowl, 9½", with inside pattern of Schleiger no. 261A. Haviland & Company, 1888-1896. Mark H plus factory no. 9807. $425-525.

Figure 527. Wash bowl, 15½", in a variation of Schleiger no. 91A. Haviland & Company, 1894-1931. Marks I and c. $1000-1500.

Figure 528. Footed bowl in unidentified pattern on Torse, Schleiger no. 413. Haviland & Company, 1888-1896. Marks H and g. $150-225.

Figure 529. Round bowl, 10" x 3" in unidentified pattern. Theodore Haviland Company, 1903. Mark p. $125-150.

Figure 530. Salad bowl, 10", in unidentified pattern. Haviland & Company, 1894-1931. Marks I and c. $125-175.

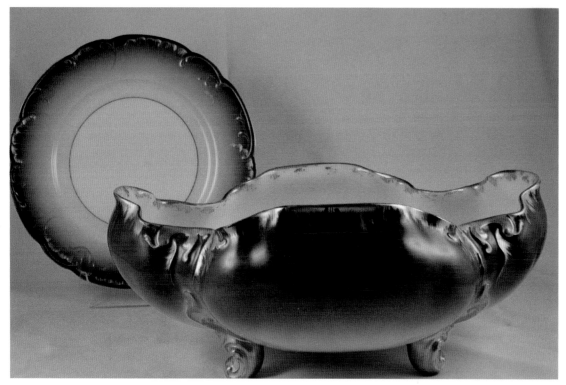

Figure 531. Large footed salad or orange bowl, 9½" x 11½" x 4 ¾", with twelve salad plates in Marseilles blank. Haviland & Company, 1888-1896. Marks H and c. Set $1000-1400.

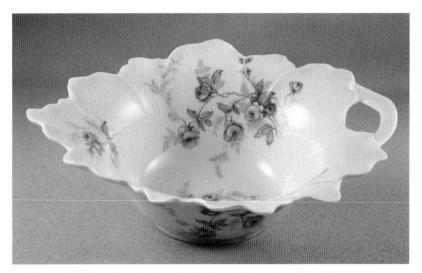

Figure 532. Leaf serving bowl, 3" high x 8¼" x 7", in the *Julia* pattern. Haviland & Company, 1967. Marks R and t. $75-100.

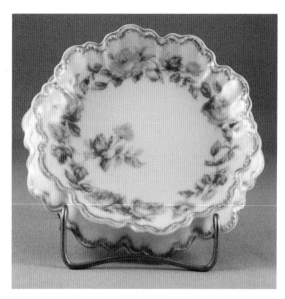

Figure 535. Footed tea trivet in Schleiger no. 497F. Haviland & Company, 1894-1931. Marks I and c for J. McD. & Co. $150-175.

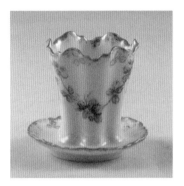

Figure 533. Toothpick holder in unidentified pattern. Haviland & Company, 1888-1896. Mark H. $125-175.

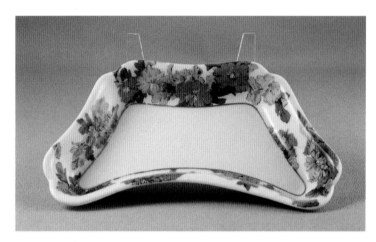

Figure 536. Bone dish, 3½" x 7¼", in a variation of Schleiger no. 84. Haviland & Company, 1876-1889. Marks F and g. $25-35.

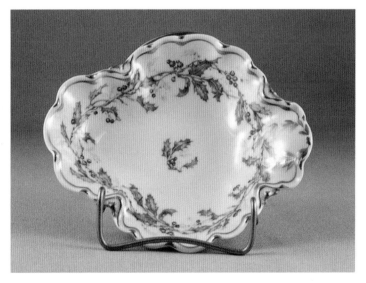

Figure 534. Nappy or ice relish, 5", in Schleiger no. 514, Haviland's Holly. Haviland & Company, 1894-1931. Marks I and c. $65-75.

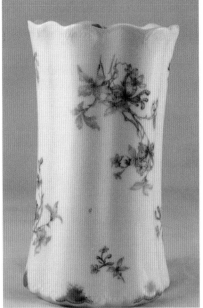

Figure 537. Vase, 6", in Schleiger no. 36-I. Haviland & Company, 1894-1931. Marks I and c. $225-275.

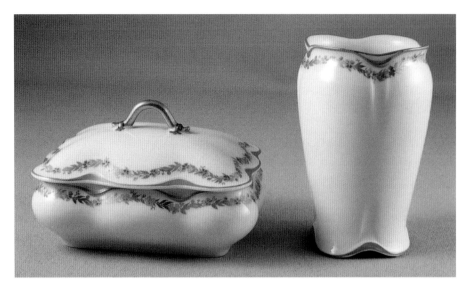
Figure 540. Covered box , 5" x 3½", and vase, 4½", in unidentified pattern. Haviland & Company, 1894-1931. Marks I and c. Set $225-250.

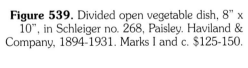
Figure 538. Mayonnaise with attached tray and unglazed bottom in Schleiger no. 268, Paisley. Bowl is 6½" x 4¾" x 1¾" high. Haviland & Company, 1894-1931. Marks I and c. $150-175.

Figure 539. Divided open vegetable dish, 8" x 10", in Schleiger no. 268, Paisley. Haviland & Company, 1894-1931. Marks I and c. $125-150.

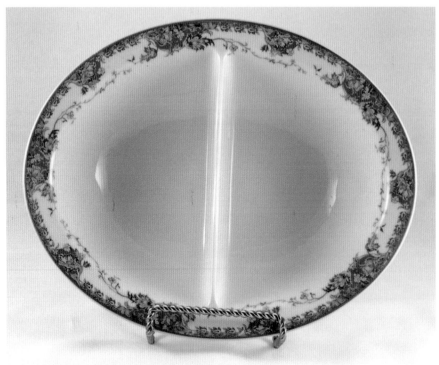

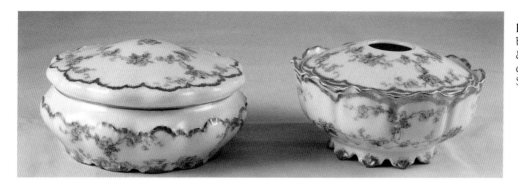

Figure 541. Hair receiver and puff box in unidentified pattern. Haviland & Company, 1894-1931. Marks I and c for P.D.G. & Co., Indianapolis, Ind. $300-350.

Figure 542. Ice cream set with 8 coupe plates, 7½" and platter, 15¼" x 8¾", in unidentified pattern. Haviland & Company, 1876-1889. Marks F and g. $825-850.

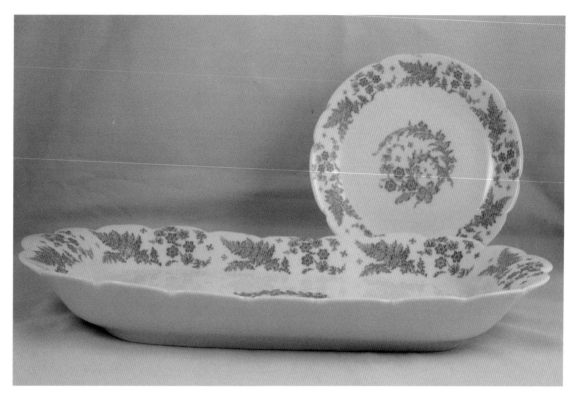

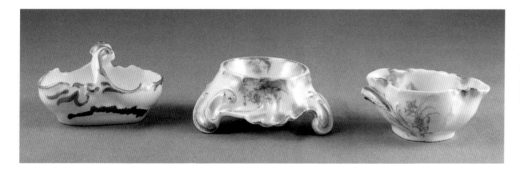

Figure 543. Three master salts in variations of Marseilles shape. Haviland & Company, 1888-1889. Marks left to right: H and is hand painted, H and c, and I and c. Each. $95-125.

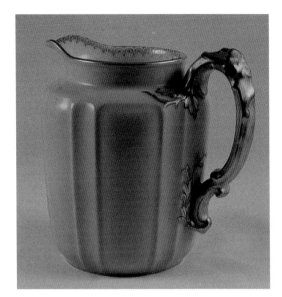

Figure 544. Milk pitcher with gold and silver handle, 6". This is a salesman's sample and reads *(88) 1 Cannele...T-51, other shapes...T-50.* Haviland & Company, 1876-1889. Mark F. $200-250.

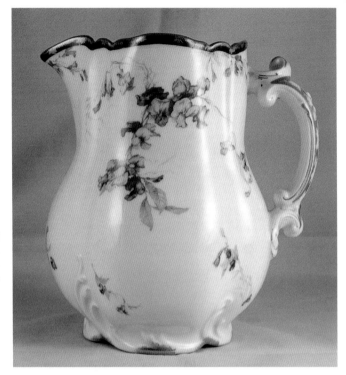

Figure 545. Water pitcher, 8", in unidentified pattern. Haviland & Company, 1894-1931. Marks are impressed 2 plus I and c for Chas. S. Mayer Co. $250-350.

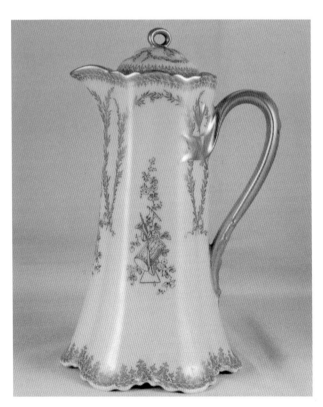

Figure 546. Chocolate pot, 8", in yellow with musical instruments in gold on Ranson blank. Haviland & Company, 1888-1896. Marks H and c. $350-450.

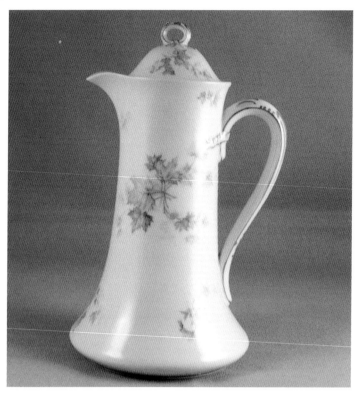

Figure 547. Chocolate pot, 9", in Schleiger No. 60, The Autumn Leaf. Haviland & Company, 1894-1931. Marks I and c. $275-325.

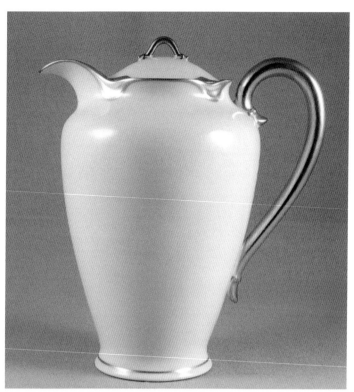

Figure 549. Chocolate pot, 8", in Schleiger no. 19, Silver, but commonly called Silver Anniversary. Haviland & Company, 1894-1931. Marks I and c. $250-350.

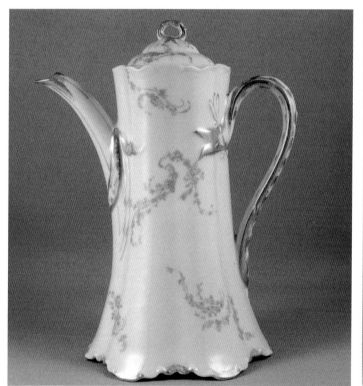

Figure 548. Coffee pot, 9", on pattern Schleiger no. 233, The Norma. Haviland & Company, 1888-1896. Marks H and c. $350-450.

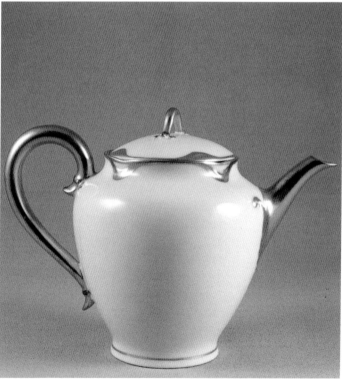

Figure 550. Teapot, 6", in Schleiger no. 19. Haviland & Company, 1894-1931. Marks I and c. $225-325.

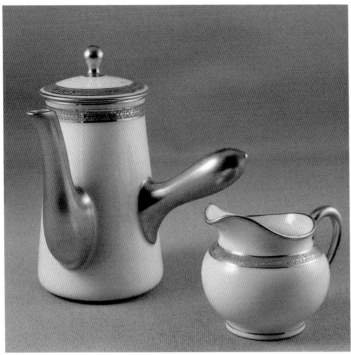

Figure 551. Individual French coffee pot, 5", and creamer, 2¼", in Schleiger no. 1106. Theodore Haviland Company, 1903. Marks are impressed M and p. Pot $225-250 Creamer $45-65.

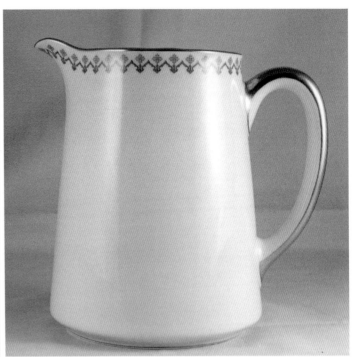

Figure 553. Water pitcher, 7", in Schleiger no. 670. Haviland & Company, 1894-1931. Marks I and c. $175-225.

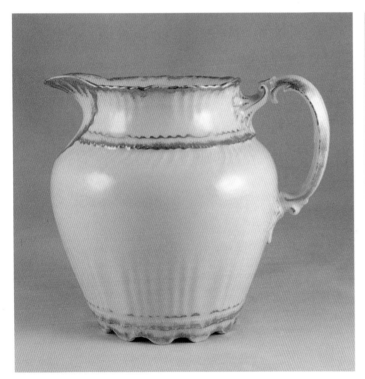

Figure 552. Water pitcher, 6¼". Theodore Haviland, 1894. Marks are impressed M and o. $175-225.

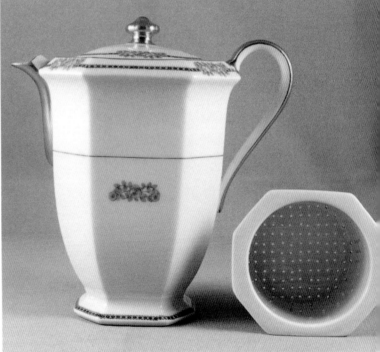

Figure 554. Coffeepot with filter insert in Schleiger no. 636B. Theodore Haviland Company, 1920-1925. Marks O and r. $300-400.

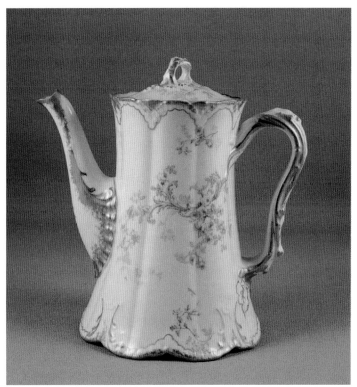

Figure 555. Small coffee pot, 8", in Schleiger no. 144F. Theodore Haviland, 1903. Mark p. $250-350.

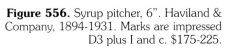

Figure 556. Syrup pitcher, 6". Haviland & Company, 1894-1931. Marks are impressed D3 plus I and c. $175-225.

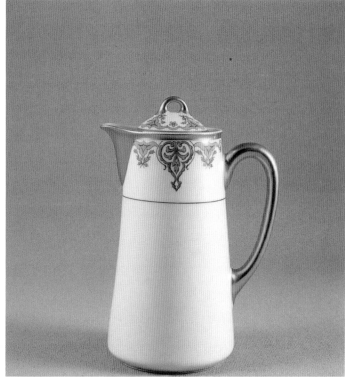

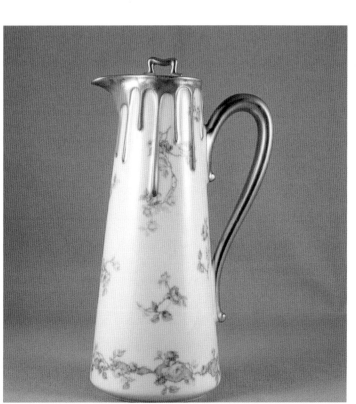

Figure 557. Chocolate pot in variation of Schleiger no. 31 with an unidentified border pattern on unusual smooth blank. Haviland & Company, 1894-1931. Marks I and c for J. A. Caldwell Co. $275-375.

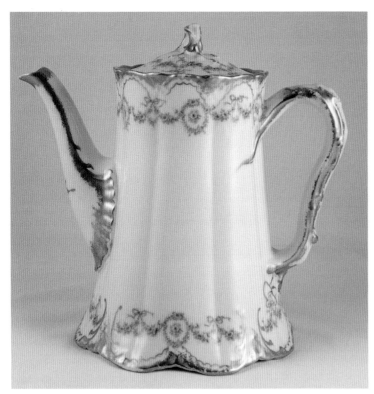

Figure 558. Coffeepot in Schleiger no. 330. Theodore Haviland Company, 1903. Mark p. $350-450.

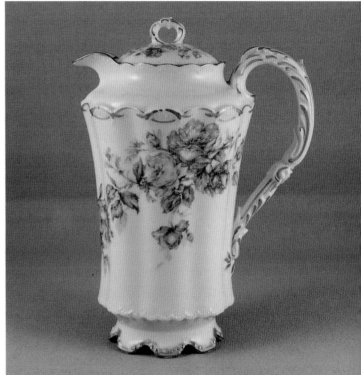

Figure 559. Small teapot, 4", in a variation of Schleiger no. 635. Theodore Haviland Company, 1903. Marks are impressed M and p. $200-225.

Figure 560. Chocolate pot, 8", in unidentified pattern. Haviland & Company, 1894-1931. Marks I and c. $325-425.

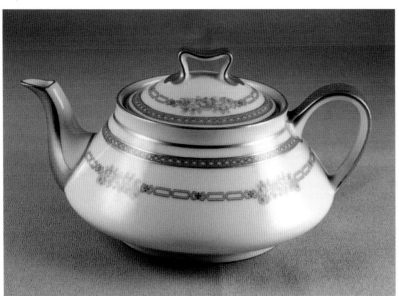

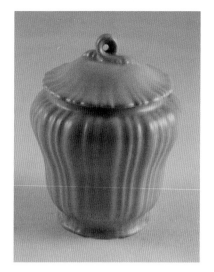

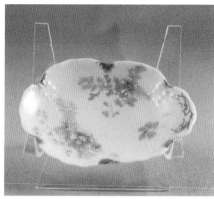

Figure 562. A white ware catalog lists this as an ashtray, 2 7/8" x 4 1/8", in Schleiger no. 52F on Schleiger blank no. 208. Haviland & Company, 1888-1896. Marks H and c. $75-125.

Figure 561. Dresser jar, 4½", in Saint Cloud shape. Theodore Haviland Company, 1894. Marks are impressed M with *Set Saint Cloud Patent applied for*. $100-125.

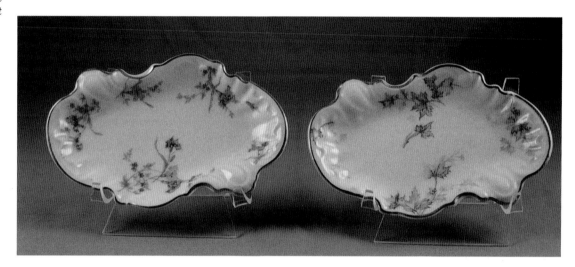

Figure 563. Two pin trays, l to r: Fleurette pattern and Autumn Leaf pattern. Haviland & Company, 1945. Mark Q. Each $45-60.

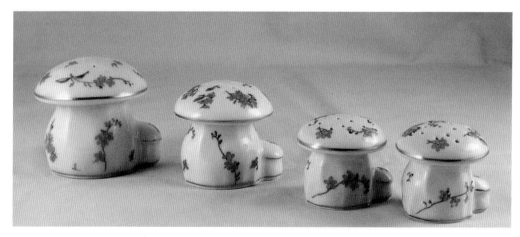

Figure 564. *Les Salières*. A series of salt shakers in Montmery pattern inspired by the French mushroom *Cêpes* originally designed by Eduoard Sandoz. Left to right, 3" muffineer is for sprinkling sugar and cinnamon, 2½" great salt for Jamaican pepper, and salt and pepper. Theodore Haviland Company, 1958. Muffineer $300-350, great salt $250-300, salt and pepper set $400-600.

Figure 565. Small unidentified piece on attached base, top measures 2" high x 2" wide. Haviland & Company, 1894-1931. Marks I and c. $50-100.

Figure 566. Ramekin cup and saucer in Schleiger no. 340D. Theodore Haviland Company, 1903. Marks are impressed M and p, for Simmons Hardware, St. Louis, MO. $45-55.

Figure 567. Handled bonbon, 5" x 3½", in a variation of Schleiger no. 39. Haviland & Company, 1894-1931. Marks I and c. $150-200.

Figure 568. Handled basket, 4½" x 7", hand painted in Marseilles blank. Haviland & Company, 1876-1889. Mark F. $175-225.

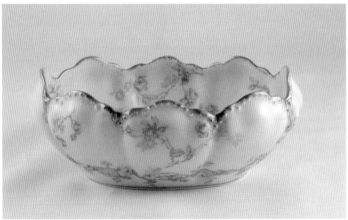

Figure 569. Small bowl, 7½" x 5¼" x 2" high, in a variation of Schleiger no. 31. Haviland & Company, 1894-1931. Marks I and C for Willard J. Welch. $100-150.

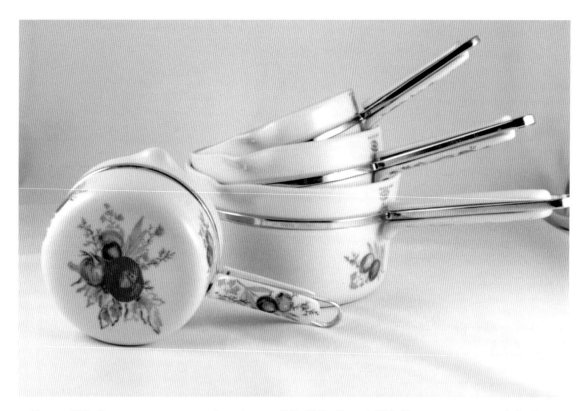

Figure 570. Four sauce pans in graduated sizes, 4½", 5¼", 6", and 6¾". These pans were made by René Frugier Manufacturing Company. In the early 1900s, he produced a line of pots, pans and cooking ware made of porcelain that was able to withstand high temperatures. In 1958, Haviland & Company purchased the Frugier Company. These pieces are no longer being made as they were very expensive to manufacture. Marks are Haviland in straight line in green plus Aluminite, Frugier, Limoges, France. Set of four $400-600.

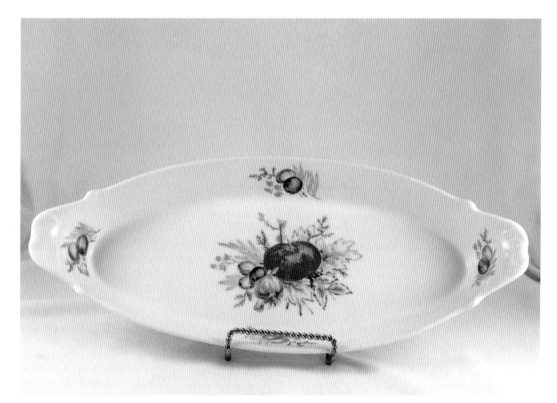

Figure 571. Baking dish, 7½" x 16", with unglazed bottom. Haviland & Company, 1958. Marks are Haviland in a straight line in green plus Aluminite, Frugier, Limoges, France. $150-250.

Haviland Blank and Decorator Marks

HAVILAND & CIE. 1842-1931

BLANKS:

Mark A — HAVILAND DEPOSE — 1853
Incised on Tablet

Mark B — HAVILAND H&Co — 1865
Incised

Underglaze Green Marks

Mark C — H&Co — 1876-1879

Mark D — H&Co — 1876-1886

Mark E — H&Co — 1877

Mark F — H&Co / L — 1876-1889

Mark G — H&Co / DEPOSE — 1887

Mark H — H&Co / L / FRANCE — 1888-1896

Mark I — Haviland / France — 1894-1931

DECORATOR MARKS:

Varied Colors Overglaze

Mark a — — prior to 1876

FABRIQUE PAR HAVILAND &Co / POUR / J.W. BOTELER & BRO. / WASHINGTON

HAVILAND & Co / LIMOGES

Mark b — — 1876-1878

Mark c — HAVILAND&Co / Limoges — 1876-1878/ 1889-1931

Mark d — HAVILAND & Co — 1879-1883

Mark e — H&Co / ELITE — 1878-1883

Mark f — H&Co / SPECIAL — 1879-1889

Mark g — HAVILAND / LIMOGES — 1879-1889

Mark h — Haviland & Co / Limoges / Feu de Four — 1893-1931

Mark i — Décoré par / HAVILAND&Co / Limoges — 1905-1930 (America) 1926-1931 (France)

HAVILAND & Co. 1875-1885

Haviland Pottery and Stoneware

Mark V — H & Co / L — 1875-1882

Mark W — HAVILAND & Co / Limoges — 1875-1882

Mark X — H&Co † — 1883-1885

Mark Y — — 1883-1885

H & Co / L HAVILAND HAVILAND & Co / LIMOGES